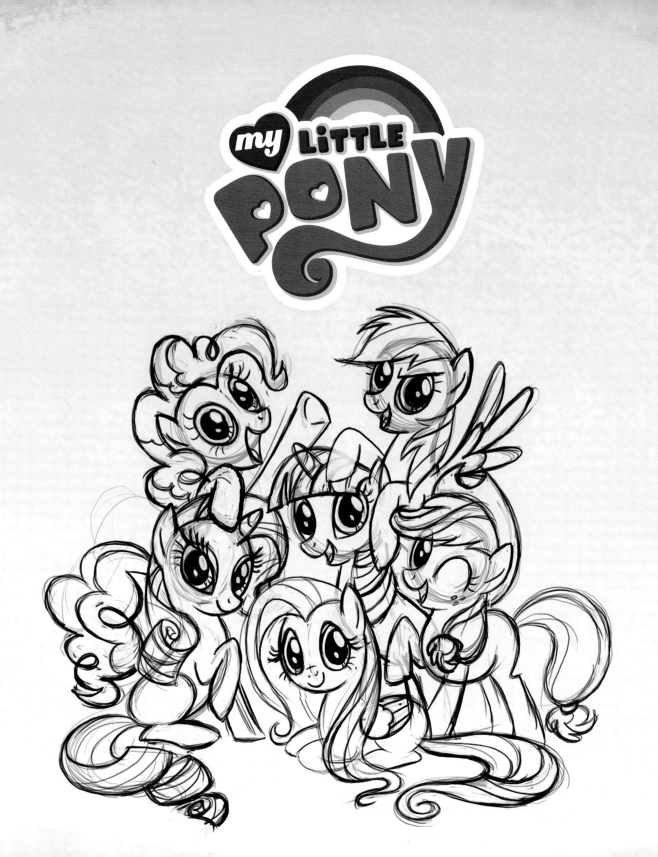

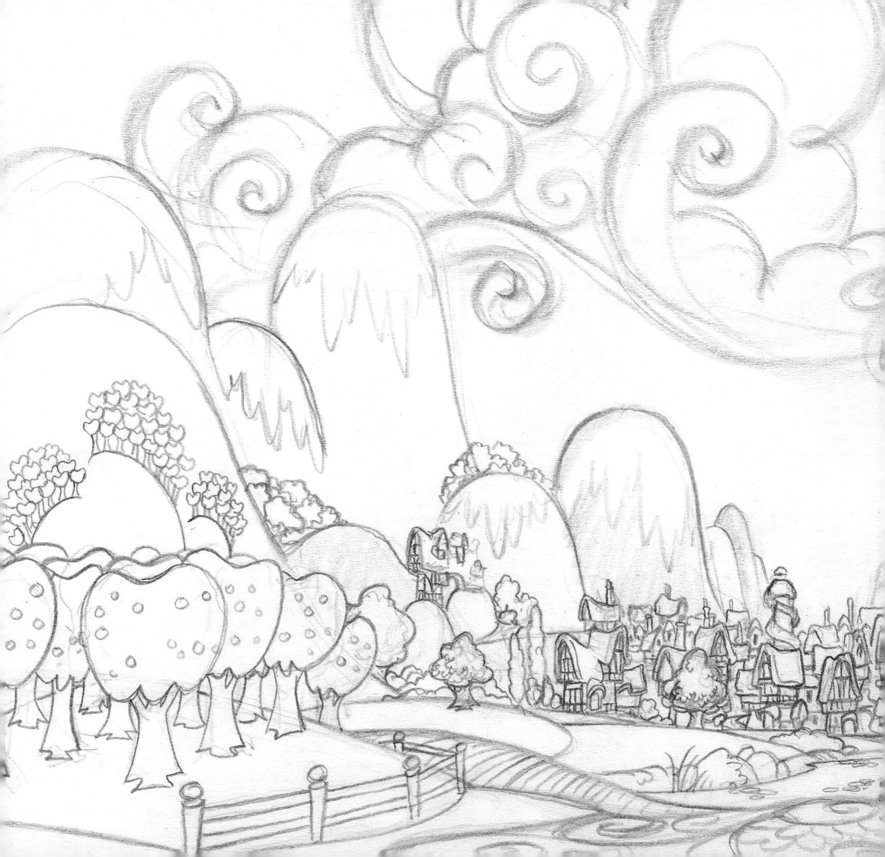

THE ART OF EQUESTRIA

Abrams, New York

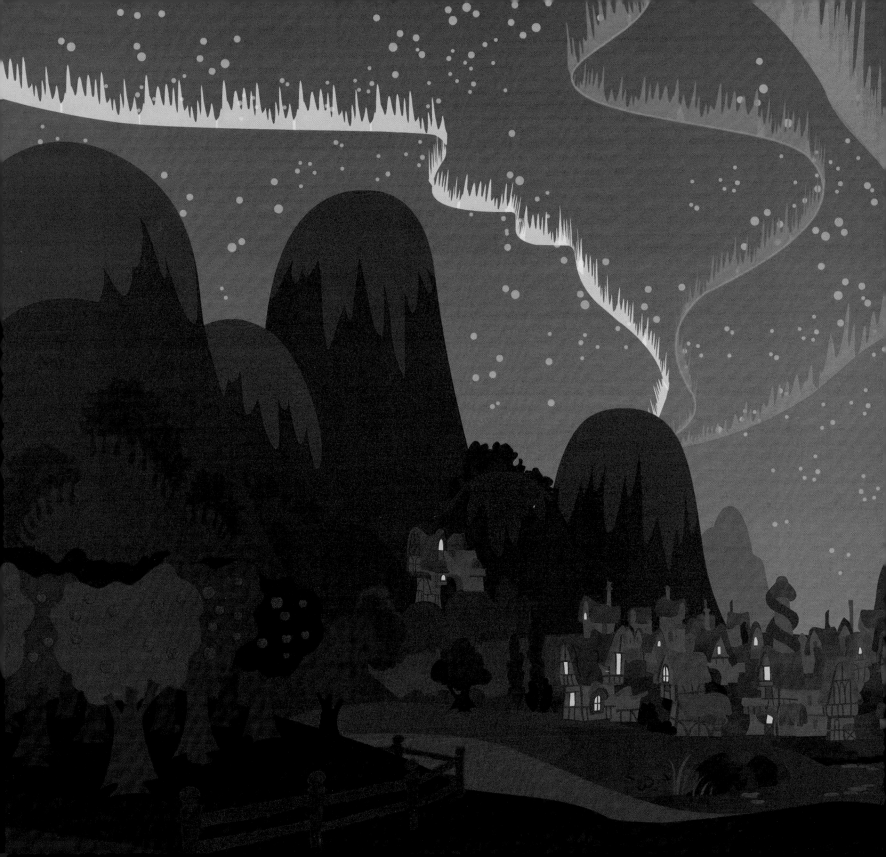

CONTENTS

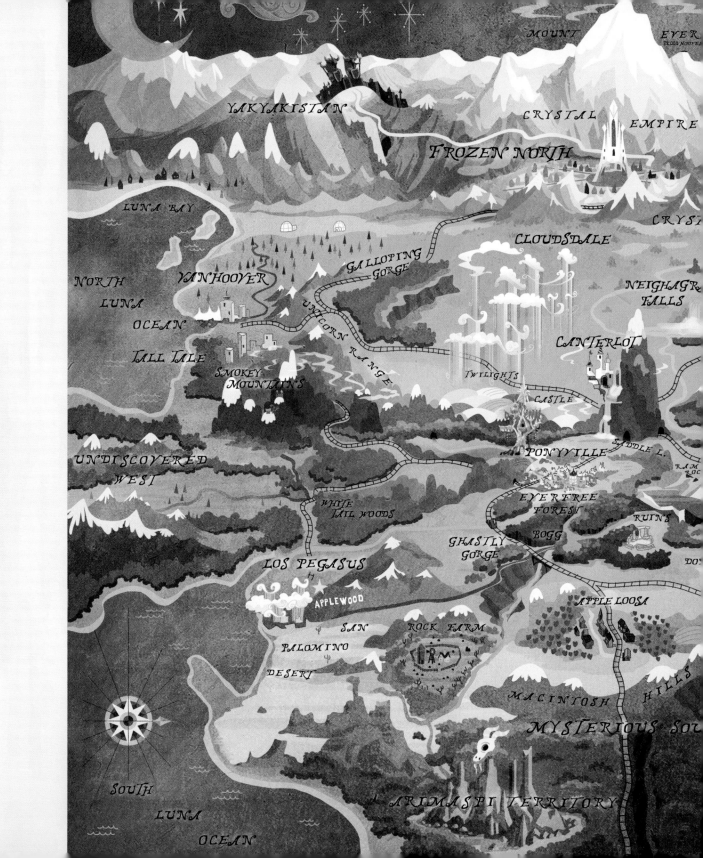

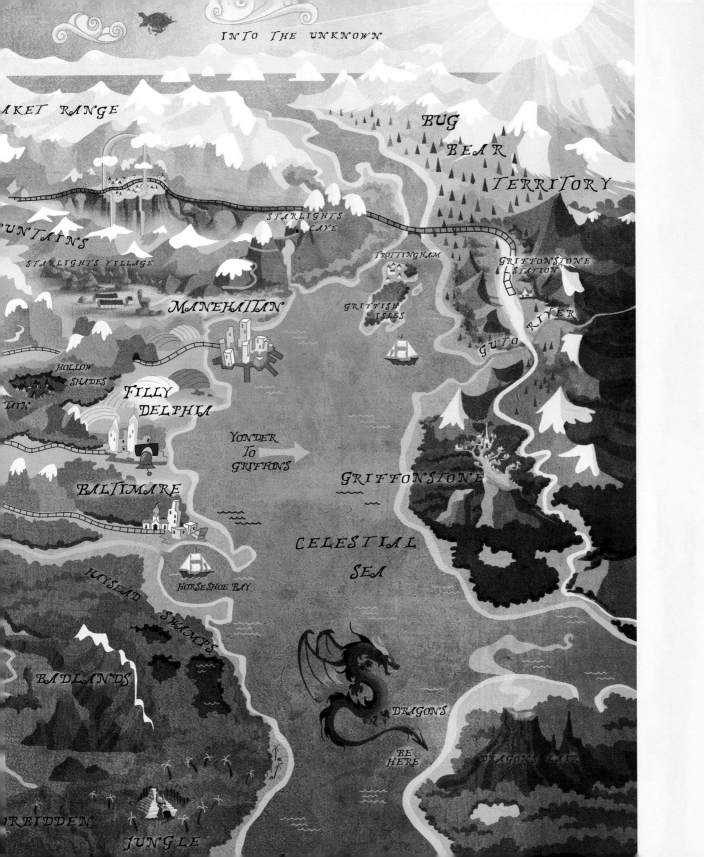

INTO THE UNKNOWN

...KET RANGE

BUG
BEAR
TERRITORY

...UNTAINS

STARLIGHTS
CAVE

STARLIGHTS VILLAGE

TROTTINGHAM

GRIFFONSTONE
STATION

MANEHATTAN

GRIFFISH
ISLES

...UTO RIVER

HOLLOW
SHADES

FILLY
DELPHIA

YONDER
TO
GRIFFONS

...TAIN

BALTIMARE

GRIFFONSTONE

CELESTIAL
SEA

HAYSEED
SWAMPS

HORSESHOE BAY

...ADLANDS

DRAGONS

BE
HERE

DRAGON'S LAIR

...RBIDDEN

JUNGLE

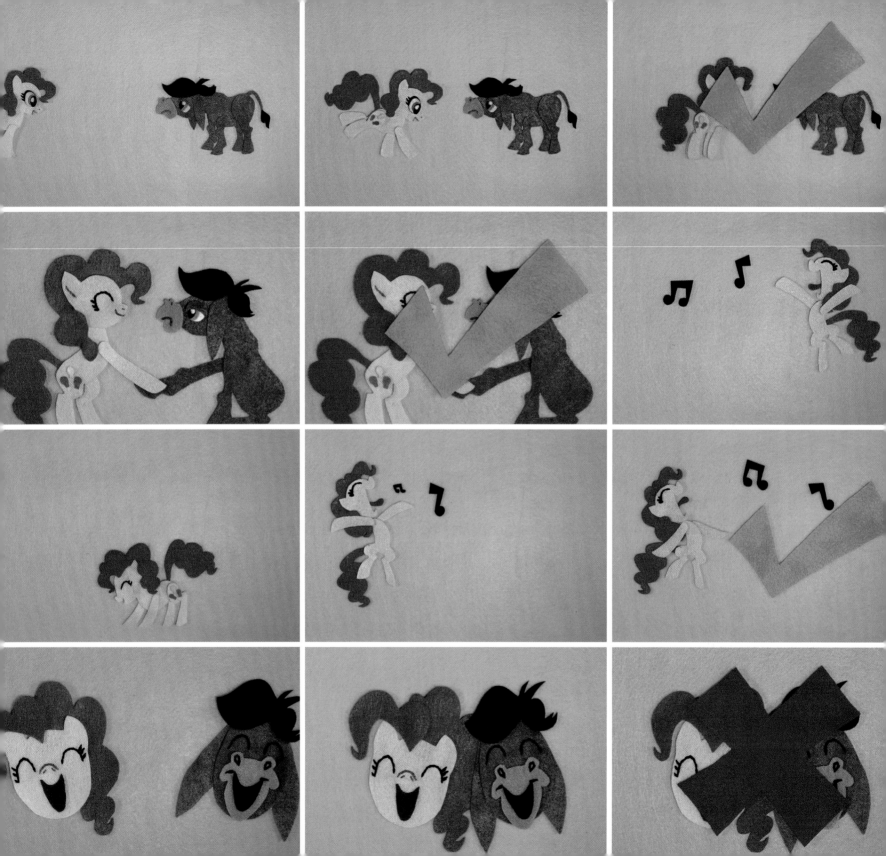

FOREWORD

BY JAYSON THIESSEN
SUPERVISING DIRECTOR AT DHX MEDIA

We deal in the creation of fantasy worlds and characters: histories, environments, and creatures that cannot exist in any sort of physical sense that we are aware of. Everything you see on screen has to be invented from scratch by different minds at different stages of production. How do we keep it all making sense and feeling cohesive? Well, we start by considering Equestria to be an actual place, with real dimensions and real (cartoon fantasy) physics that follow real laws and logic (that we made up). By sticking to this way of thinking, we can more easily stay consistent across the board (mostly).

Equestria is a land where the dominant sentient life-forms are derived from the genus *Equus*—basically, horse-like creatures. Since there are no humans in Equestria, everything that was ever designed or built in this world had to be done by ponies, for ponies. Tables, chairs, doorways, props—all have to work in a way that befits a world existing under this pretense. Naturally, there are a lot of horseshoes and saddles blended into the details on buildings and decor. But we also think about the social order of their society and the level of wealth and importance a city or region represents.

There are three basic types of ponies: Unicorns, Pegasus ponies, and Earth ponies. Unicorns, as we all know, are horses with a single horn on their forehead that can cast magic. They are the upper-class elite who live in the mountains. Their cities are made of more robust and expensive materials: stone, granite, and marble. Everything is polished and shiny. Pegasus ponies are winged; they fly and live in the clouds. So their cities are literally made of clouds and are built with fliers in mind: No stairs are needed, and roofs are optional since it doesn't rain above the clouds. There is a distinctly ancient Greek aesthetic about it, with all the architecture, and this is a nod to the Greek mythological character for which they are named. Finally, there are the Earth ponies, who keep their hooves planted firmly on the ground. They are regular ponies without any fancy appendages who live in more traditional-looking houses and towns like we are used to seeing and deal mostly with earthbound issues such as agriculture and animals. All of this is kept in mind when we're designing locations to ensure that it feels logical that those characters would actually live in the environment they are placed in.

Another major factor that determines the design choices we make is the level of modern technology. Equestria is a fantasy storybook world that sits somewhere between the medieval period and the Edwardian era of the very early 1900s, if we had to specify. So all the technology that exists is limited to what could exist in that period. Every once in a while, we will break the rules to allow a piece of technology to exist that we wouldn't normally, due to the necessities of the story—or joke. These are few and far between, and even then we limit how advanced it can be. We are strict about this, to keep the world consistent and to force ourselves to think more cleverly when problem solving.

Which brings me to the biggest world-consistency rule: Keep it pony. The ponies don't have hands, they don't walk on two legs, they aren't aware of humans or the human form; their world is truly pony-centric. From the way the locations are designed, to the way the characters move, to the way they talk, everything has to revolve around the simple fact that they are four-legged, hoofed mammals. This is the way Lauren Faust originally envisioned the show, and it's a rule we will continue to enforce for as long as we make the show.

INTRODUCTION

BY MARY JANE BEGIN

When Hasbro asked me to write and illustrate picture books for *My Little Pony*, I had no idea what an amazing world of fantasy and fandom I was about to discover. Like any decent writer and illustrator, I did my homework. When creating the story for *My Little Pony: Under the Sparkling Sea*, the *Friendship Is Magic* TV series was in its infancy, with the first episode not yet aired. Like Alice on a journey through Wonderland, I tumbled into the land of Equestria with little more to guide me than a set of colorful toy ponies and a style guide. I wrote the story, unsure if it would fit with the brave new world of *MLP*, but thanks to Meghan McCarthy and her amazing team of writers, each script I read allowed me to visualize the characters and their world with vibrant clarity.

When I was asked to write and organize *My Little Pony: The Art of Equestria*, there were plenty of final animations to watch, so I decided to re-watch every episode while working out the layout of the book. Often, I was enjoying the story line so much that I would get lost in the world and had to remind myself that this was RESEARCH! The animations inspired plenty of questions for the people who create it, and as an artist and storyteller, I couldn't wait to discover the "secret sauce" of *My Little Pony: Friendship Is Magic*.

The story of this book starts with the history of the brand, from the several generations of the toy to the early development of the core cast by Lauren Faust. Her sketchbook reveals insights into the hearts of the characters and their world, and in her interview she graciously and eloquently shares her thinking, passion, and inspiration. Her early drawings that are included express a raw energy that speaks to the core of visual creation and, for me, depicts the electricity that ignites this generation of *My Little Pony*. The fantastic world and mythical creatures were further developed in sketches and fabulously detailed drawings by Dave Dunnet, Martin Ansolobehere, Paul Rudish, and Lynne Naylor.

While interviewing Hasbro and DHX Media about the making of the show, I was struck by the many layers of talent that touch and tweak the stories once the scripts are complete. Consistency in storytelling is considered and debated down to the last detail, and this is apparent in every action and behavioral trait of the animated core cast. So much consideration goes into each new character developed: The character designers explore expression, movement, and costume in the development of new pony characters, mythical beasts, and the foes that populate their world. The regions of Equestria developed by the environment artists are stylized with color, clever turn-of-the-century machines, and playful inventions that are truly unique to *MLP*. Humor and breakout characters burst forth from the imaginative expression of the storyboard artists as they interpret the action and meaning behind each script. It was such a joy to hear the DHX Media team explain their artistic decision-making and creative processes; it was so clear that they love what they do and have a seriously good time doing it. In creating this book, I reviewed hundreds of Adobe Flash files, animatics, and preliminary sketches, choosing episodes and artwork that speak to their creative and collaborative expression.

What was also fascinating to me was the realization that the fans of *My Little Pony: Friendship Is Magic* not only are

passionately committed to the show, but also are creative makers themselves. When I interviewed Matt Mattus, Principal designer, Girls, at Hasbro, about being a true fan, I was surprised and delighted to find out that the show inspires adult fans, as well as kids, to make art. Music, paintings, costumes, sculptures—the sky's the limit for the *MLP* fandom! The fan design contest hosted by WeLoveFine at the time of this writing is a shining example of the explosion of creative invention fueled by Equestria's tales.

Stories define our humanity: They confirm who we are as individuals, as a culture, as a world. Narrative is the connective tissue that binds our collective imagination and instills our passionately held beliefs. To quote Joseph Campbell, "Myths are public dreams. Dreams are private myths." Hasbro, the writing team, and the team at DHX Media invent the mythology of *My Little Pony: Friendship Is Magic*, the public dream we all experience. Because they so completely believe in the world they create, they convince the rest of us that it truly exists. This book is a testament to the extraordinary artwork they collectively create to bring each episode to life. Humbled and honored to be a part of this magical creation, I'm excited to invite you to step through the looking glass and join me on this fantastic visual journey through, as Pinkie Pie might say, THE BEST ART BOOK EVER!

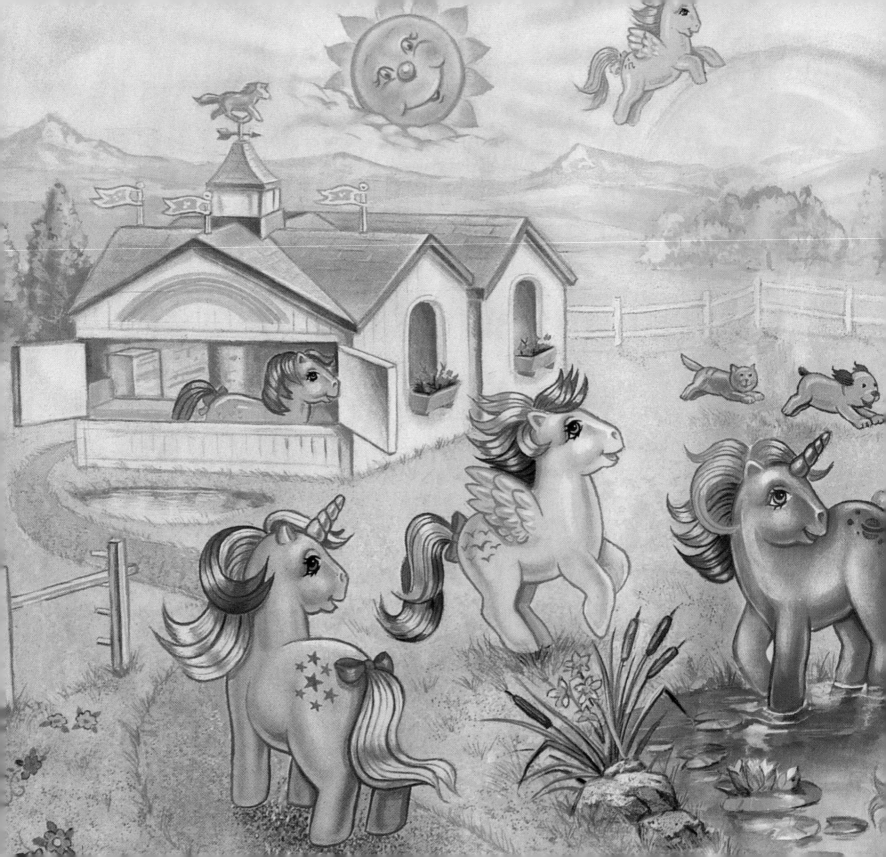

1
PONY EVOLUTION

CHILD OF THE '80s

The My Little Pony brand was launched by Hasbro in 1983 as a toy line designed primarily for three- to six-year-old girls. It quickly became a favorite of millions of children around the globe and soon began expanding beyond toys into lifestyle products.

In 2003, Hasbro reintroduced the My Little Pony brand worldwide with new characters and new body shapes. Within this generation of redesigned pony forms, Hasbro began creating special collector's editions inspired by pop art called Art Ponies.

Six years later, in 2009, Hasbro came up with a new design for the ponies featuring an increase in head size and eye proportion as well as a smaller body. At this stage, the focus of the brand was on seven core characters, each of them having a distinct profile and personality.

In 2010, Hasbro Studios created a new vision of the brand for the animated series *My Little Pony: Friendship Is Magic*. The stylization and storytelling of the ponies and their environment made a dramatic shift both graphically and in narrative tone.

(above) Art Pony, released 2009

(opposite) 1980s Hasbro toy packaging art

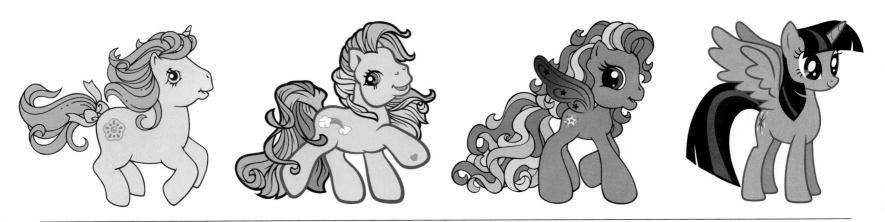

| 1983 | 2003 | 2009 | 2013 |

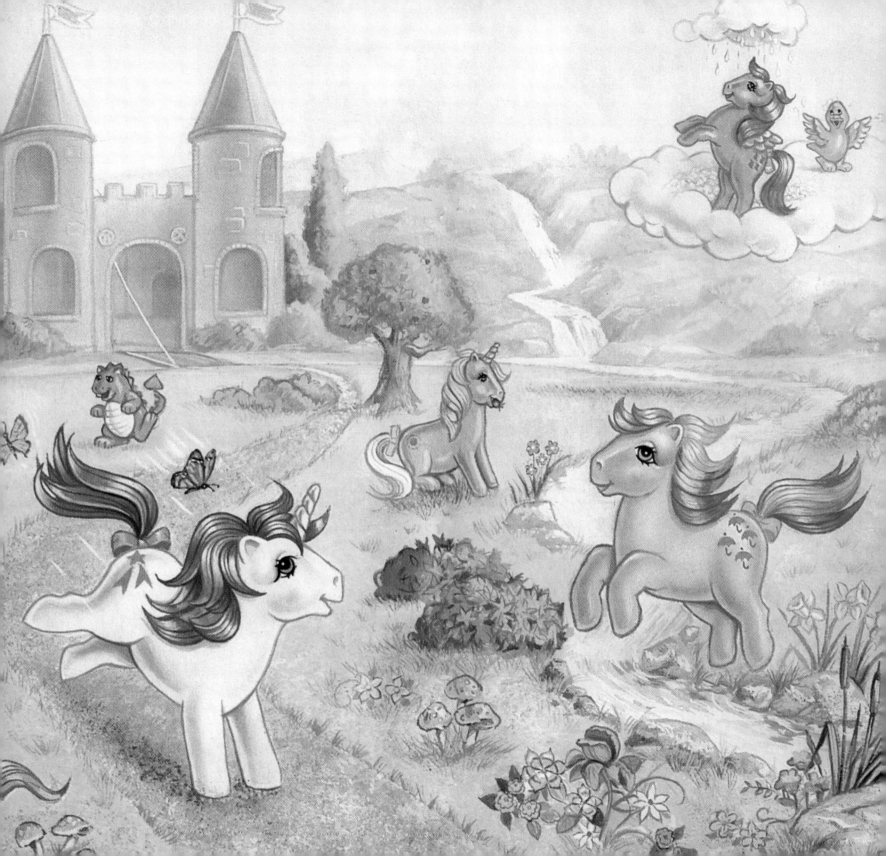

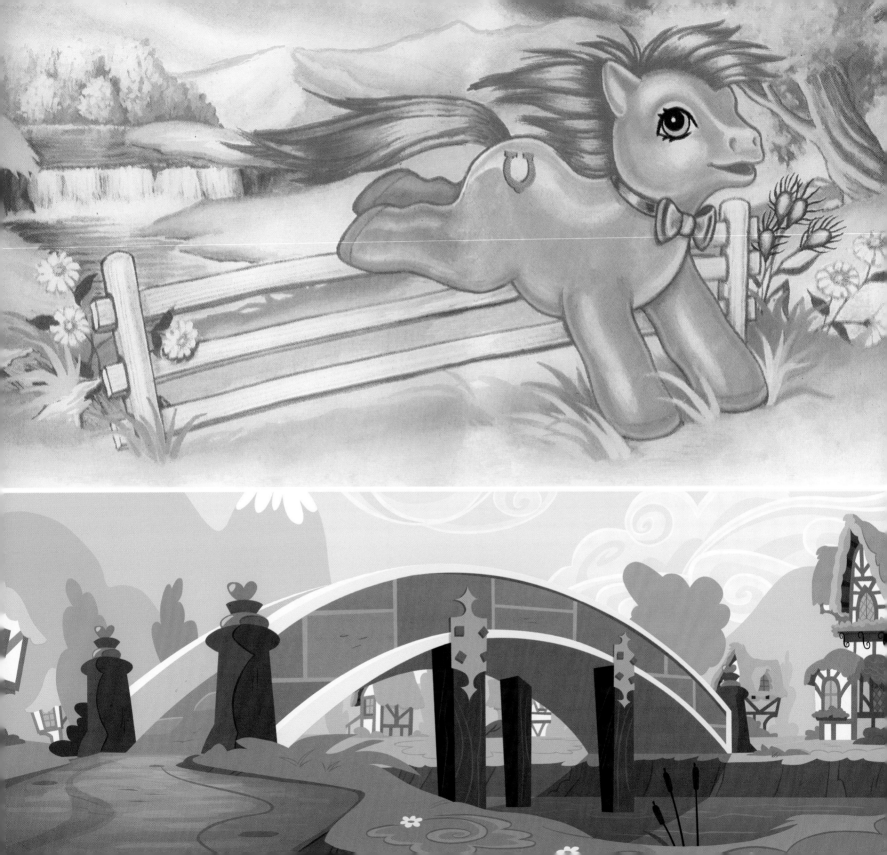

DAWN OF EQUESTRIA

My Little Pony may have begun as a toy brand created by Hasbro for little girls, but during the more than thirty years since its inception, it has grown into a global phenomenon. *My Little Pony: Friendship Is Magic*, the TV series that launched a thousand ponies, so to speak, has generated fans all around the world. Much of its success is due to the exceptional scriptwriting, according to Matt Mattus, principal designer, Girls, at Hasbro, who has worked on the My Little Pony brand since 1987. "I really give all the credit to Lauren Faust and the amazing writers," says Mattus; "it all started there. Suddenly there was a real context against which every creative contributor could measure everything they wanted to create. The context provides a purpose for every flower, cupcake, bluebird, or creature to exist or not. These nuances make good storytelling believable, so there's no need to be blatant or obvious about any messaging."

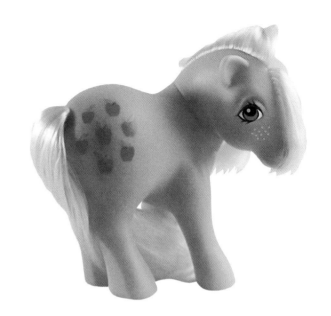

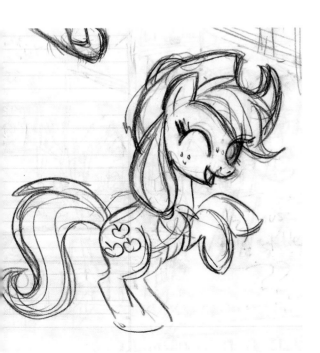

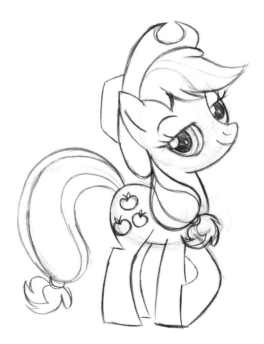

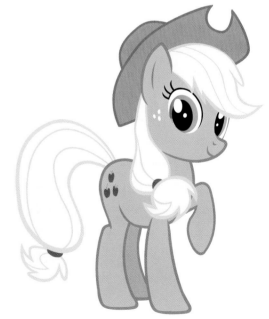

Other than a cleaner line with color and a slightly smaller Cutie Mark, Applejack's design remained nearly identical to the original sketch by Lauren Faust.

EARLY DEVELOPMENT ART

Hasbro worked with animator and producer Lauren Faust to reimagine the My Little Pony brand for the creation of *Friendship Is Magic*. Lauren was the executive producer for the first two seasons of the series. Although Lauren's vision paid homage to characters and locations from the My Little Pony heritage, her design ideas incorporated new ways of seeing the ponies as horses who eat hay, live in barns, pull carts, wear saddles, and pick up things with their mouths—characteristics that were avoided in the past. The expansive world of *My Little Pony: Friendship Is Magic* was not built in a day, or even a year. About two years were spent creating the foundation for what is now five seasons of television and five years of consumer products.

Lauren's pitch bible and sketchbook provide exciting insights into the early seeds of ideas for *My Little Pony: Friendship Is Magic*. Her exploratory drawings and notes capture the birth of the core cast.

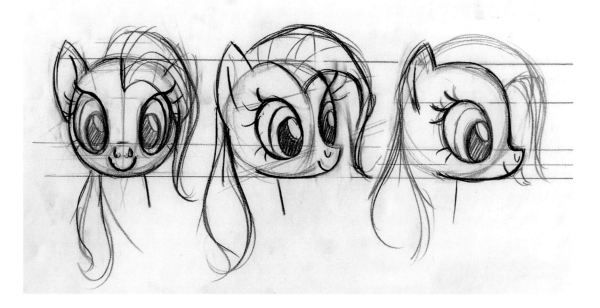

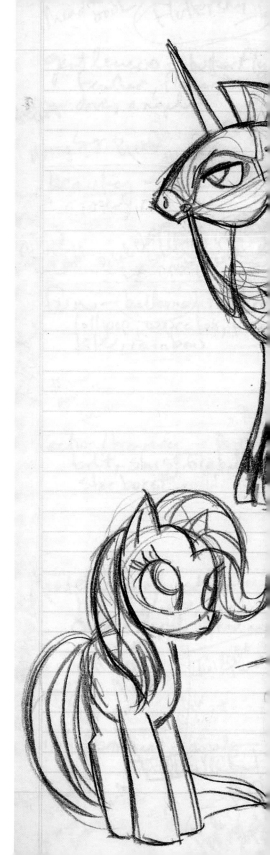

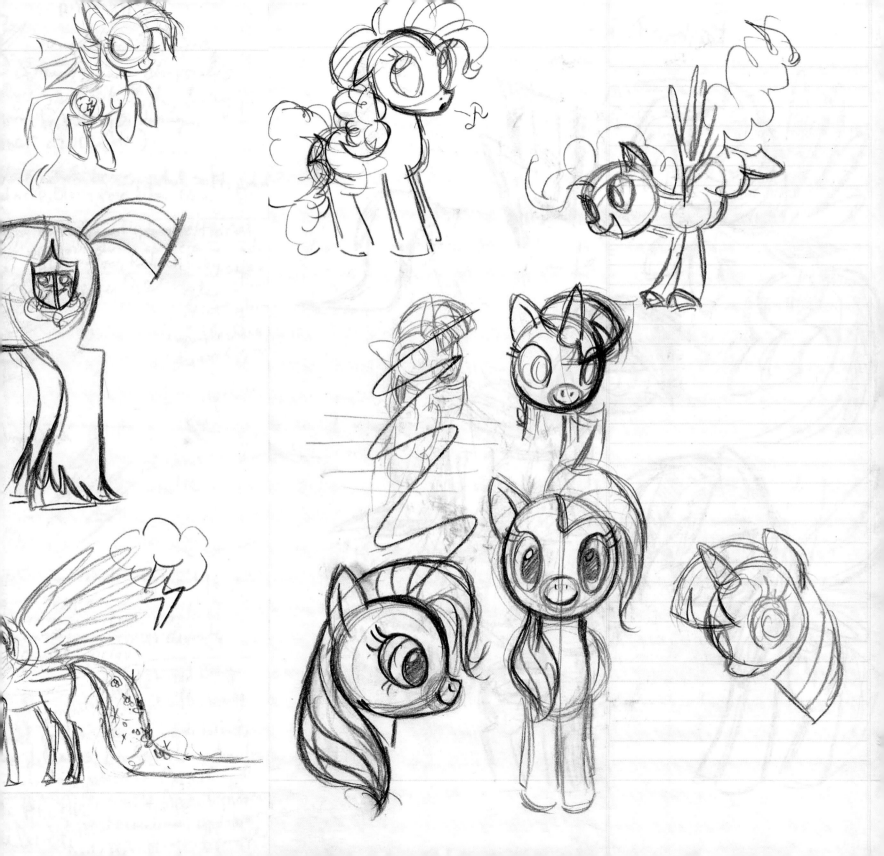

SPARKS OF MAGIC

AN INTERVIEW WITH LAUREN FAUST

WITH MARY JANE BEGIN

Mary Jane Begin: Did you make art as a child, and who in your life supported your interest in art?
Lauren Faust: Yes I did, quite a bit! And so did my brothers . . . I come from a very artistic family. My mother was an elementary school teacher before she started having her family. Because of her work, she would always keep art supplies around the house. She likes to joke that when we were being too loud, annoying, mischievous, or naughty . . . she'd pull out the paper and the crayons, sit us down, and get us to all be quiet with drawing. That was like our early art training! If I remember right, the materials I used in early childhood were paper, crayons, colored pencils, and coloring books, though in preschool and kindergarten I enjoyed painting with tempera paints. I do remember Mom letting us play with Play-Doh once in a while if we weren't too messy with it!

What did My Little Pony mean to you as a child? Do you think your life as

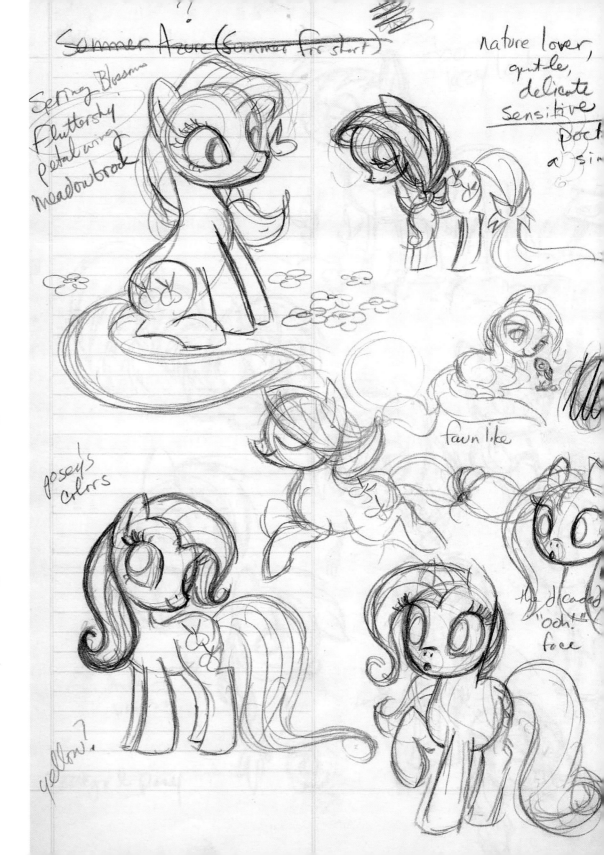

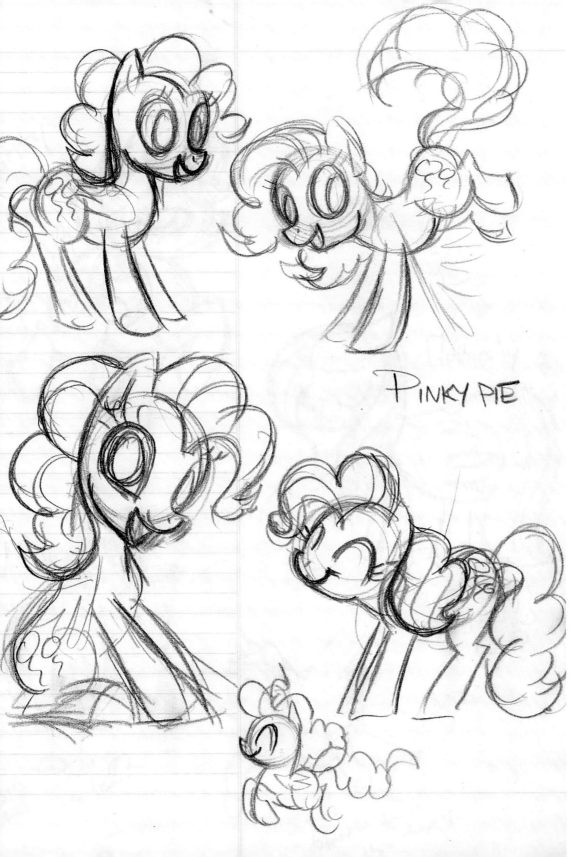

PINKY PIE

a creative visual storyteller stems directly from the play experience with the pony toys?

My Little Pony was absolutely my favorite toy. I was a child of the '80s, and I was a horse girl, so it was really about the combination of two of my favorite things: horses and magic. I loved The Chronicles of Narnia and *The Wizard of Oz* and My Little Pony brought those two things together. Looking back at my childhood, the influences that led me to be a creative person really started there. I put all of the money I earned as a little kid aside to buy My Little Ponies. It was a bit of a habit! I intended to collect all of them. That was difficult, but that was my big goal. I had a ton of them and I had all the play sets, so I would sit in my room and make up characterizations for each of them. Each pony had a personality that revolved around the little picture that was on their flank. In creating all these personalities and spending hours and hours in my room, I would create scenarios for them to live out and adventures for them to have. I think playing with them in that way very early on in my life shaped and primed my brain for storytelling. It wasn't so much about combing their hair or putting on outfits for me, it was about the stories I made up for them to be in. It was about getting lost in my imagination, and that's what these toys did for me. I know now as an adult

and a storyteller that I'm accessing that part of my brain to invent stories.

I totally understand what you're talking about. For storytelling, I access the same kind of experience from childhood of playing in my room for hours and making up stories the whole time.

Yes!! Playing and pretending and making stuff up—that's what we carry over into our careers as creative people. It's the same brain space! It's not the same brain space you're using at the grocery store, you know, checking off lists for all the things you need to get done. It's a completely different part of the brain—and I think as a kid, I exercised that muscle a lot.

What kind of animation, illustration, movies, or books have influenced you artistically?

I showed a love [for] and an interest in cartoons and animation very early on, and I think as a child I thought ALL kids liked cartoons. It's just that I kept liking them after all the kids my age stopped watching them or got interested in other things. I think my biggest influence is the old, classic Disney movies. They were by far the greatest influence on what I've spent my life doing: creating stories and characters. There were television cartoons too—like the Warner Brothers' Bugs Bunny. Comic books were also a big influence for

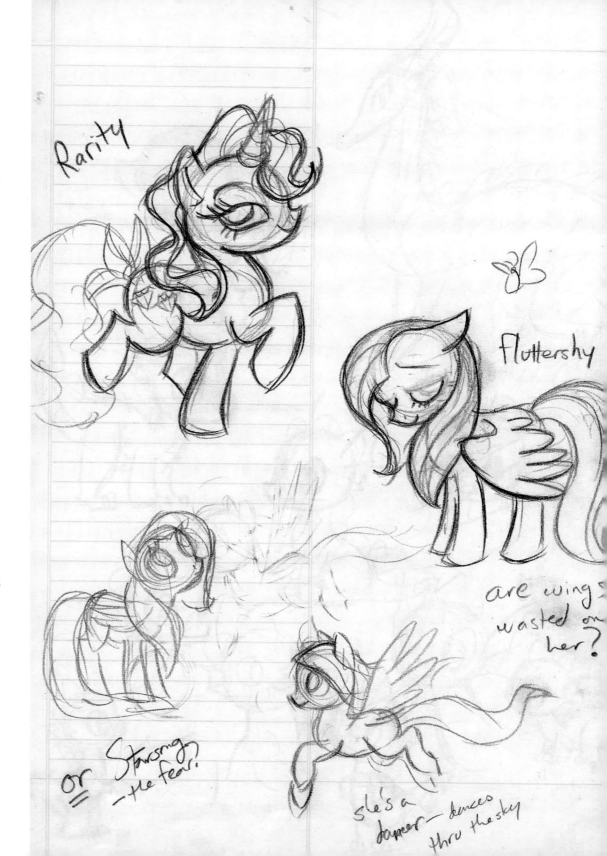

Rarity

Fluttershy

are wings wasted on her?

or Starsong? —the fear!

she's a dancer—dances thru the sky

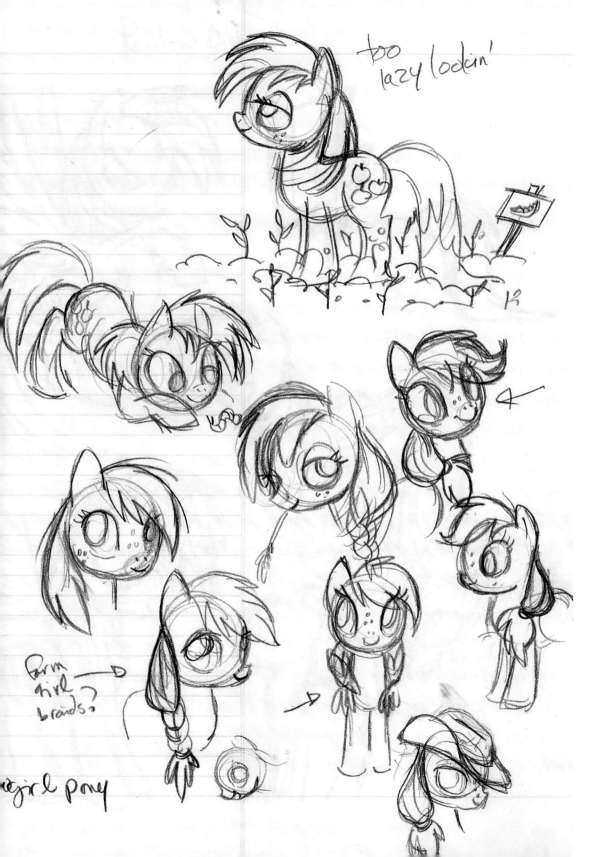

too lazy lookin'

farm girl braids?

girl pony

storytelling, though Disney was the number one inspiration because I was always wanting to draw like that!

When did you know that being an animator was your path/vision? How did you know that this was not just an obsession, but what you really wanted to do?

It wasn't until I was in high school that I realized it was a job you could have. I grew up on the East Coast, in Maryland. I lived in a suburb of Annapolis called Severna Park . . . nowhere near Hollywood, which seemed so far removed and untouchable. Something clicked when I was about thirteen or fourteen. I had always had this love for cartoons and liked to sit around and draw all the time, and that's when it occurred to me that it was a job you could pursue. Though I actually spent a couple of years debating about [it]—do I want to make cartoons or do I want to be a biologist? I was really interested in science and animals . . . but, heh-heh, cartoons won!

Were there particular animators or artists that you looked to or were inspired by that made you think, "Oh, I want to be like that!" or someone in the field that you connected with in some way?

I feel like I'm being really typical and obvious . . . but I wanted to be Glen

Keane! I know that's probably everybody's answer, but he was the most brilliant and shining star of animation in the late '80s and early '90s and that's who I worshipped. You know, it was different when I was in high school because we didn't have the Internet, and books on animation were very hard to find. It's funny, but now I realize that at the time I didn't have access to the information and didn't know names for the things or people whose work I loved.

I don't know if you have ever worked in different materials other than drawing or do now, but have you ever delved into any other kind of media just for fun or for your career?
There are periods where I'm sewing a lot and other times where I step away from it for a long time. I spent a few years designing a doll line, sewing and designing the dolls. They were rag dolls, so they were all fabric embroidery. Sewing is my other art form. The dolls were about eighteen inches tall . . . I wanted them to be huggable, so I made them kind of on the big side. The original designs that I did were entirely handcrafted, with painted and embroidered facial features and details on the cloths. It was actually a [heck] of a lot of fun!! I experimented with different materials to use for hair because regular rag dolls just have yarn for hair. I tried different types of materials and

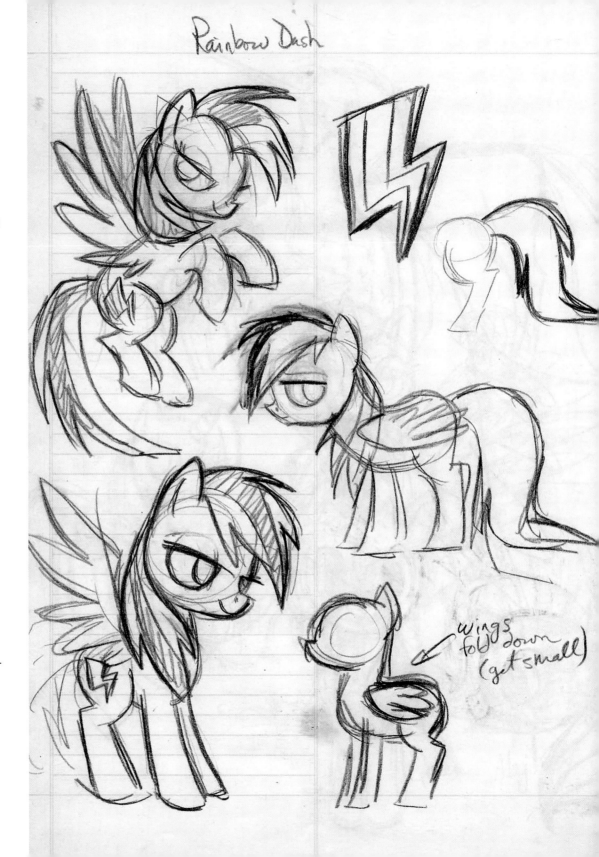

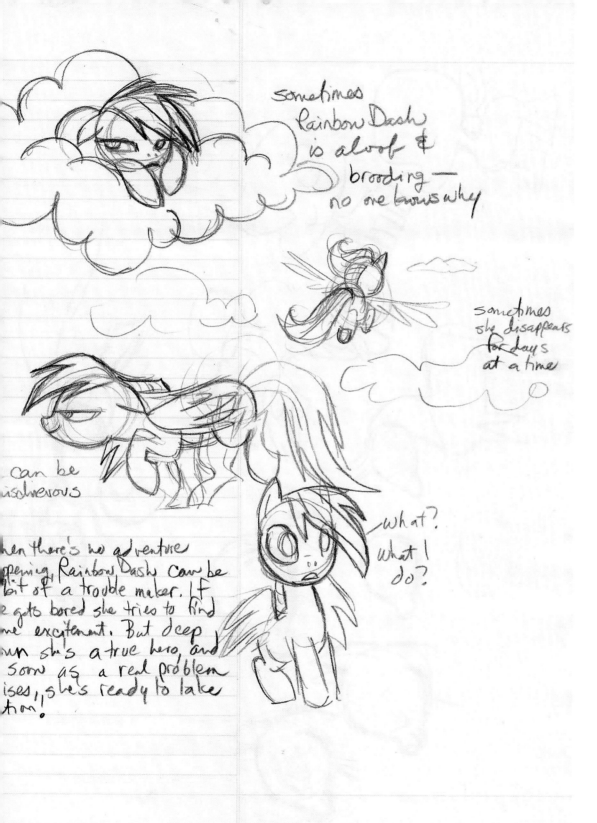

sometimes Rainbow Dash is aloof & brooding — no one knows why

sometimes she disappears for days at a time

can be mischievous

when there's no adventure happening, Rainbow Dash can be a bit of a trouble maker. If she gets bored she tries to find some excitement. But deep down she's a true hero, and soon as a real problem arises, she's ready to take action!

what? what I do?

sewing techniques. I worked on the line for a couple of years, and they did end up at FAO Schwarz for a short time, but they launched in 2008, right when the economy crashed, unfortunately.

I hear you! As an artist, you pitch ideas against the walls, based on things that you love to do or make, and they don't all stick. But it sounds like creatively, just for yourself, it was a cool thing for you to investigate.
You know, what was really kind of magical about it was that I started doing it just for myself. I remember having this weird epiphany at one point when I was trying to decide what material to use for my first doll's hair . . . and it occurred to me that I didn't have to ask anybody! After working in this business, every single thing you do, writing or drawing, you have to show it to a supervisor and executive and you have to hope that they'll like it too in order to move forward. So, you start self-censoring, and sometimes stop thinking about what you'll like and think more about what your boss is going to approve. When I was making the dolls and no one had to approve it except for me, it ended up being this really amazingly beautiful experience to be able to access my own creative desires. I didn't have to ask anyone's permission and I though, "Oh wow, this is how fine artists feel all the time!"

What drives the visual story for you—the character or the world? Do they develop in tandem or does one come first?

For *My Little Pony: Friendship is Magic*, it really was both. Actually, for most of my work I'd say that it's both—but character is number one even though world building is fun and exciting. Giving characters limitations based on the world they live in to work around or cope with just helps with your character-driven storytelling. I love world building and I jump at every opportunity to do that kind of stuff, but for me, the driver has always been the character.

When do you know that a character has just the right look and feel that you intended? How do you know when you've nailed it, and the character you're designing has come to life?

When I'm designing or producing? Because sometimes characters don't come to life until the voice is coming out of them and they're moving around on the screen. But when I'm drawing . . . I know this sounds really weird, and I don't know how to define it exactly, but you're just searching for a feeling or a personal reaction. You saw the original and very early sketches I was doing of *MLP: FIM*. You start out thinking . . . "Well, this is sort of where I want it to be, but I'm not

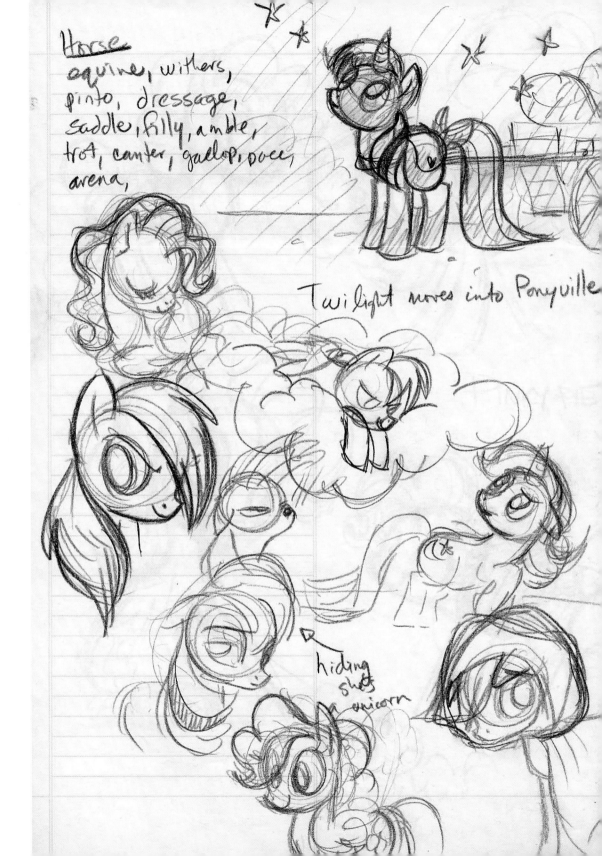

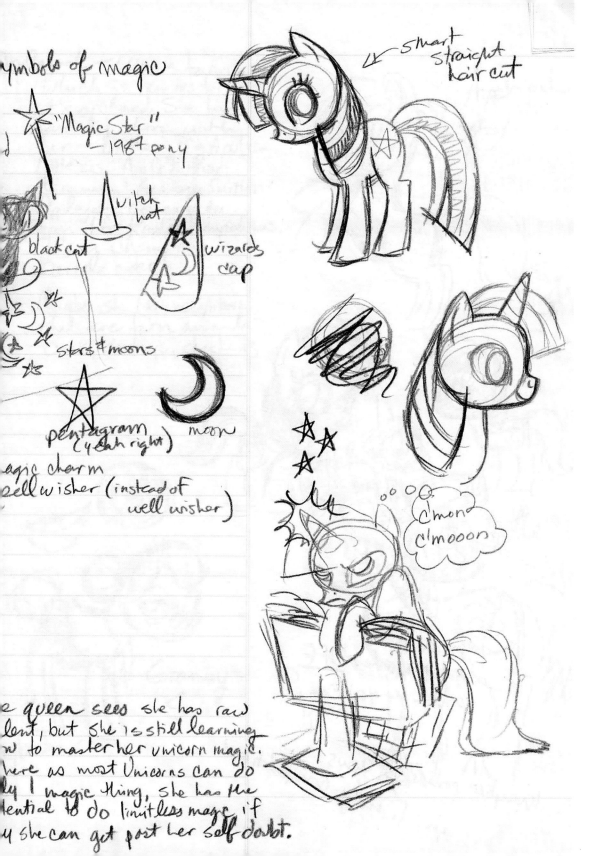

symbols of magic

"Magic Star"
— 1987 pony

witch hat

black cat

wizards cap

stars & moons

pentagram
(yeah right)

moon

agic charm
ell wisher (instead of
well wisher)

← smart straight hair cut

C'mon c'mooon

e queen sees she has raw
lent, but she is still learning
w to master her unicorn magic.
here as most Unicorns can do
ly 1 magic thing, she has the
tential to do limitless magic if
y she can get past her self doubt.

getting that feeling yet," so you keep drawing and you keep trying different proportions and shapes. Sometimes, drawing for me isn't about creating, it's about fixing. You draw something really badly, then you just keep fixing it and fixing it, following your instincts until something clicks. When I was trying to define the style of the ponies, at first I was trying to stay true to the '80s design and they just weren't working! I was trying to give them really straight faces, like the bridges of their noses weren't upturned, but it just didn't feel right. Then I was trying to draw the ponies with giant heads and tiny bodies, but that didn't feel right either. I just kept drawing and drawing and I remember there was one day where I drew just a quick doodle of a face. It wasn't one particular character, but I knew it was what I wanted them to look like. It led me to the kind of features and proportions too. I cut it out and pinned it on my board and it was there for the entire production of *Pony*. The final design really isn't too different from that sketch . . . I just knew it when I drew it—I thought, "That's it!! That's the one," and it's really about recognizing the character based on a personal reaction.

What animation stylistic references or animators did you reference when designing the MLP characters?

Well, I've been drawing ponies since I was eight, and was trying to capture the feeling that they had for me when I was that age. I've been drawing cute horses for so long—I felt like I finally had to just nail it down! If I had to point to anything, it would be the original ponies from the '80s, and an old Disney [character] called Burrito the Flying Donkey. I told the animators to reference that old cartoon as a way to figure out how to animate the Pegasus character, not so much for style but for proportion and movement. I also think that Japanese manga created by Osamu Tezuka was an influence, and I'm thinking specifically about this little unicorn named Unico. It wasn't that I thought about these things when I was designing the ponies, [it's that] those creations and the subconscious influence they had on me as a little kid is what was probably swirling around in my brain while I was trying to draw these things and capture the feel of the ponies.

Do you remember the "I've got it!" moment when the basic concept for the new story and world crystalized? Was there a trigger or was it a slow reveal?

In world building, you start off with little nuggets and neat ideas. For the ponies it was like—I imagined the three different types of ponies—the Unicorns, the Pegasus, and the Earth

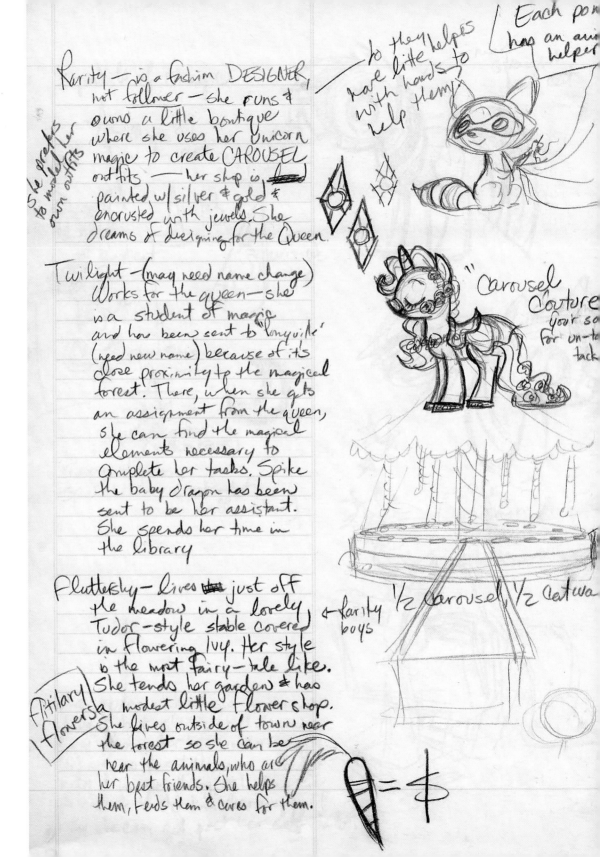

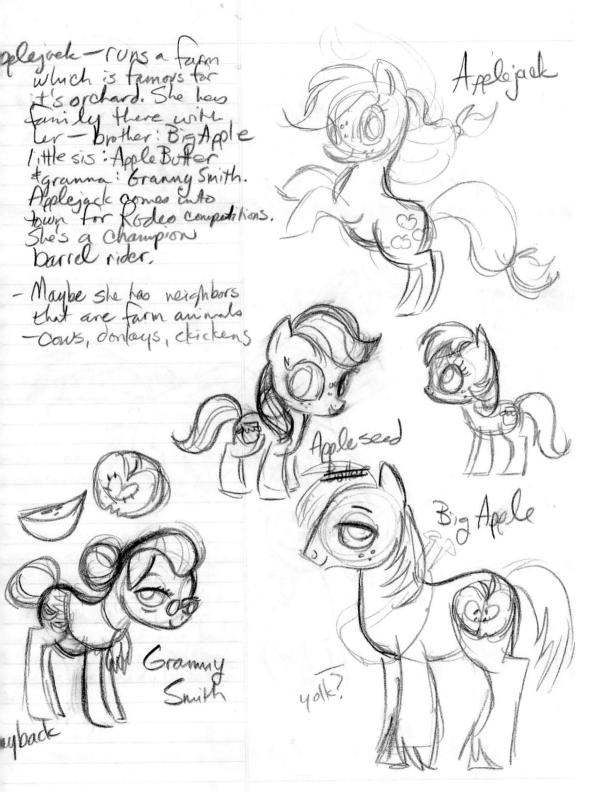

Applejack—runs a farm
which is famous for
it's orchard. She has
family there with
her—brother: Big Apple
little sis: Apple Butter
&granma: Granny Smith.
Applejack comes into
town for Rodeo competitions.
She's a champion
barrel rider.

- Maybe she has neighbors
that are farm animals
—cows, donkeys, chickens

Applejack

Apple seed
Butter

Big Apple

yolk?

Granny
Smith

myback

ponies—as slightly different cultures. I imagined that they were integrated, but maybe once upon a time they were all from different places. This was all stuff I borrowed from my childhood in the way that I played with ponies when I was a little kid. Hasbro made a little cloud shower fountain for ponies and so of course, Pegasus must live in the clouds! They made a castle for the unicorns and I put it up on my dresser, and so unicorns must be from up high in the mountains. They made regular little stables for the Earth ponies, so they must be on the ground, a bit simpler and more traditional, like real horses. The big "AHA!" moment I had is when I called in a friend of mine, Paul Rudish, and asked him to have a jam session with me and we spent about a week just talking and drawing. He turned in a drawing of a Pegasus pony running across the top of some clouds making the rain fall down to the earth below them onto some other ponies. That drawing was a huge inspiration for me. From that came a cascade of ideas of what makes their world different and special, and everything just clicked into place after that: the idea that they are stewards of their own world and they have to make their weather happen, the flowers grow, and the animals thrive.

It's so interesting that one drawing triggered the idea of being active

instead of passive in your world, and that message is carried through the core of the storytelling of *MLP: FIM*. Letting kids know that they can't just sit back in their life, but need to be an active participant, is really powerful.

Yes! This was all inspired by that one sketch that Paul Rudish made.

The villains and mythological beasts play an important role in the world of *Pony* too. Can you share anything about the development or thoughts about their creation?

Everything in *Pony* is influenced by a classical fantasy genre, and that was a huge thing for me as a kid. I remember as a teenager watching *MLP* live on past my childhood and seeing that things became more focused on cupcakes and tea parties and it was getting disconnected from its fantasy roots. Unicorns are part of classic European mythology and Pegasi are from Greek mythology. I felt this was a big permission slip to borrow from these historical sources. When we were coming up with villains and creatures for the world, we would borrow from that mythology. We had a couple of books around for referencing them when we were searching for animals to use. So it was a matter of taking the classical creature, modifying it to fit the story, and designing it to look like it could live in this same world,

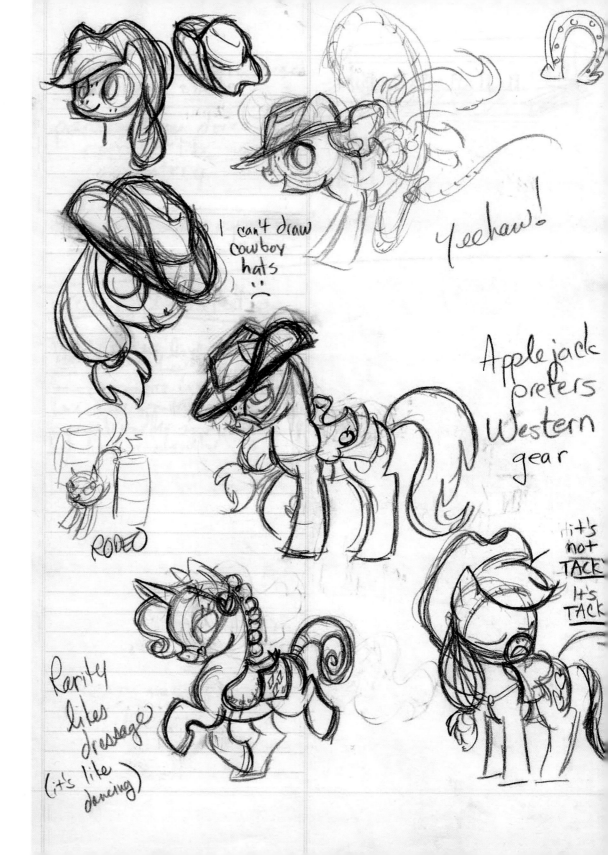

I can't draw cowboy hats :(

yeehaw!

RODEO

Applejack prefers Western gear

it's not TACK it's TACK

Rarity likes dressage (it's like dancing)

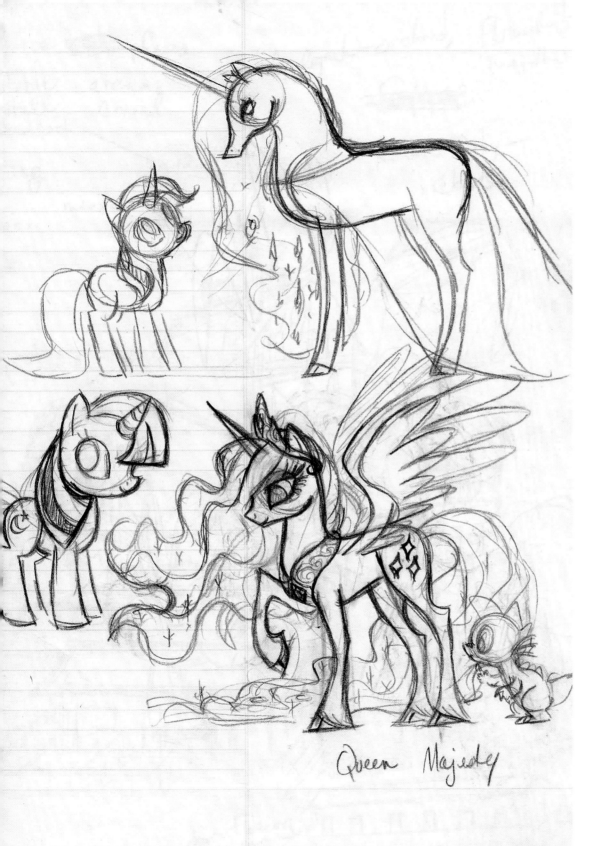

Queen Majesty

stylistically, that the ponies do. They needed to be softened and cuted up to make them fit in the environment of the pony world. In the pilot episode of *MLP*, the ponies have to face a manticore, which is a pretty creepy and scary beast. Before we knew how wide the audience would become for *MLP*, there was a lot of concern that a creature like that would be too scary for kids. So, even though he was supposed to be a scary character, we had to make him really cute and cuddly to alleviate in people's minds worries and fears that it might be too intense for kids. But that turned out not to be an issue, and so the bottom line was to be sure that the creatures really looked like they lived in the same universe as the ponies do.

As a huge *Star Trek* fan, I have to ask about Discord, voiced by John de Lancie! He's my favorite mythical creature in the show, playing the foil for so many stories.
He was really fun because I just made him up! I was thinking, what's the opposite of harmony? That would be discord. And what does "discord" mean? It means chaos, it means . . . a mess and things that don't make sense! What I thought was really great was, when you look at Greek mythology, most of the monsters were a bunch of different creatures chopped up and sewed back together.

I thought, "Let's make a new type of animal by following the rules of what's been established in terms of mythology." So that's what I did for Discord, pulling from a bunch of different creatures to create him. He was featured in the first episode of the second season, and that was one of the last stories that I was involved in. For season one and this episode, everything came across my desk—I worked on storyboards, edited scripts, and made a lot of notes on the script.

It sounds like as an artist, you're comfortable wearing a lot of creative hats depending on what's needed.
I'd say that's mostly true, although I'm not comfortable creating backgrounds or doing color. I would tend to give my input on that if it affected the story in some way. In my career before I directed or created shows, I was an animator for a really long time, then I was a storyboard artist for a while and also a scriptwriter for quite some time. I think if you look around at the people who direct, they've had several different types of jobs in their career that help them. I think that I was lucky because I was able to conceive the story, and write, and could also storyboard and design characters. . . . I think it really helped with *Pony* to be able to wear all those hats. But backgrounds are definitely not in my wheelhouse! I was working really closely with Dave

SHAMAN

folk-lorist

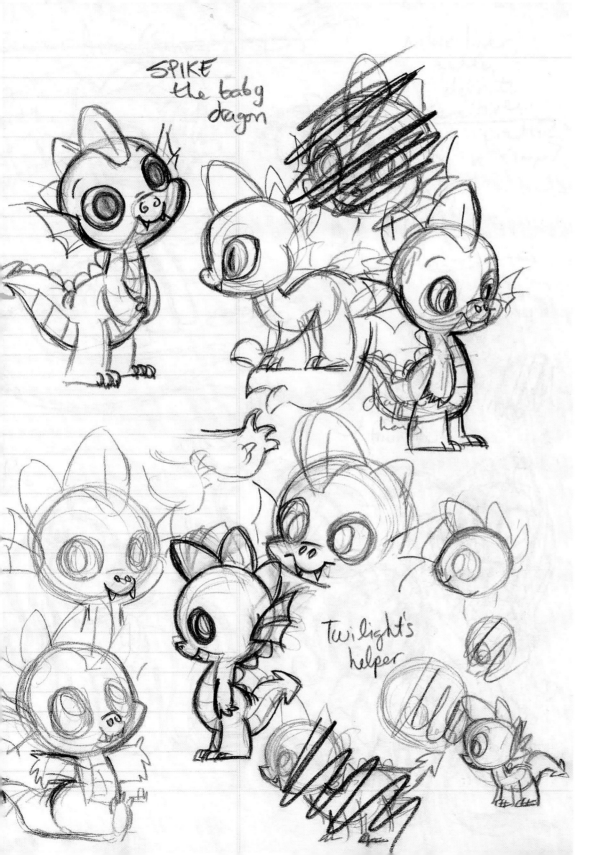

SPIKE
the baby
dragon

Twilight's
helper

Dunnet, describing what I was hoping for and sending him photo references. Like for Ponyville, I wanted it to have a fairy-tale kind of feel, so I was sending him German cottages, and I wanted Canterlot to have a European feel, so I sent lots of pictures of cathedrals and castles. I remember that he did a bunch of drawings of Canterlot, and the first one was just amazing, then the drawings started to go more in a cartoony way. I thought his first instinct was the best, so he went back to that and sent a drawing that made my head explode because it was just perfect! What's incredible about Dave is that he's a fantastic artist, but he's also amazing at conceptualizing worlds and incorporating different ideas that all come together in a location. It's genius! For me, it was all about making sure each episode was as good as it could possibly be.

Even though these ponies are like family to me now, I've watched them evolve over the years from the simplicity of random names such as Gingersnap or Minty, to slightly less random names with brief profiles such as "Minty—who loves to collect socks," to these more complex characters that have real personalities. Today the characters are truly more relatable, not all sugar and spice and everything nice. These characters have real three-dimensional traits just as real people do, complete with quirks, faults, and tempers.

—MATT MATTUS, HASBRO

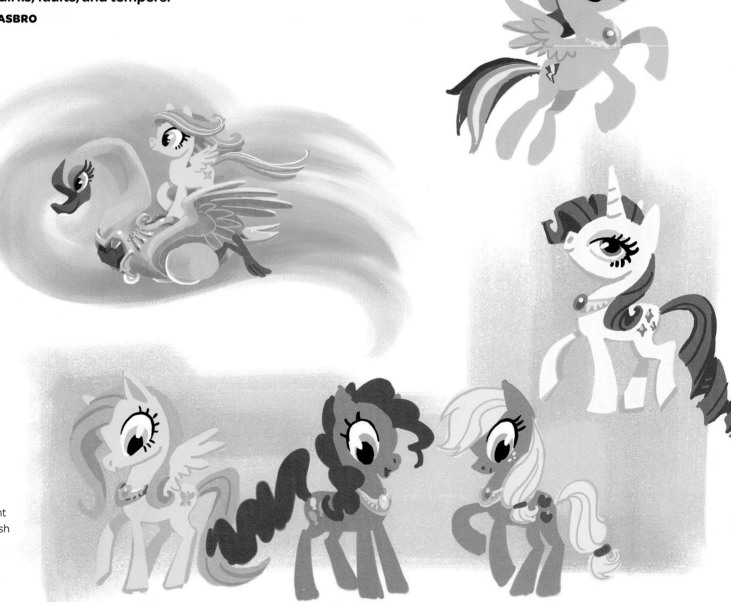

The early development sketches by Paul Rudish reflect a new way of thinking about the ponies and their roles in the world.

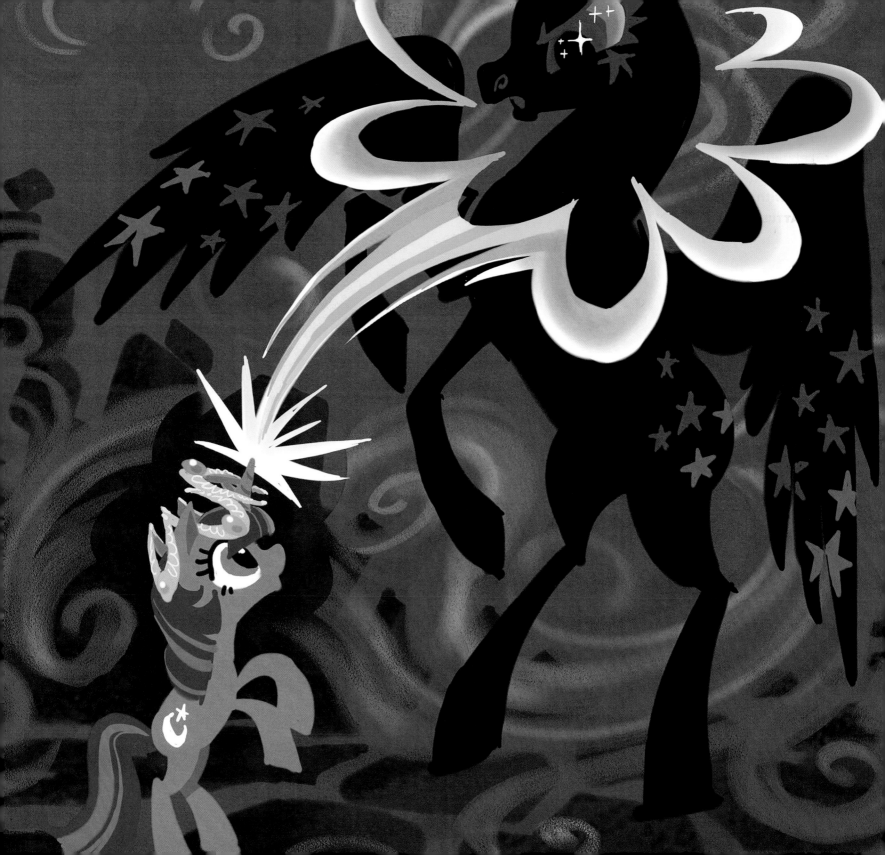

HOW TO DRAW A PONY

In creating ponies, there are some basic ground rules for the standard pony design and movement.

It involves paying attention to shape and proportion, as the body is basically a bean shape, the head is a ball, and the legs are curved triangles. A pony is typically three heads tall and can be segmented into three parts: The head is the largest and longest element, the body is about half the height of the head, and the legs are slightly shorter than the height of the head. From a side view, the neck is approximately half the width of the head, and the bean-shaped body is the same width as the head. A key element to the design of a pony is the placement, size, and shape of the eye. Most ponies' eyes vary in their details, but the basic placement and shape remain consistent.

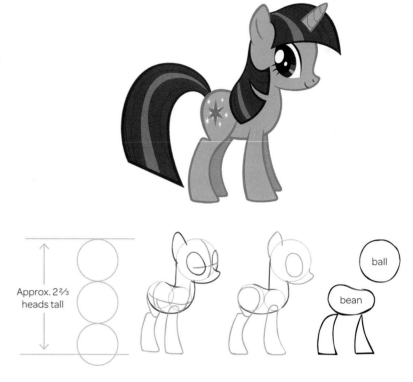

Approx. 2⅔ heads tall

ball

bean

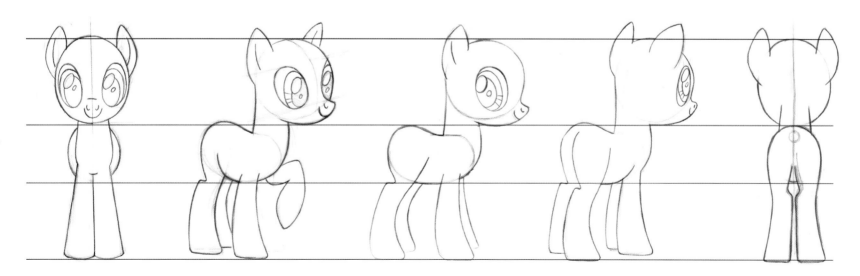

Almost all the female ponies have the same body structure. The only difference between them is the hair, eyes, color, and Cutie Mark.

36

VARIATION ON FORM

We use pretty much the same body shape for all the ponies: The males were designed for Season 1, and they obviously have a little more of a rounded nose, [wherees] the females have more of a scooped, styled face with a button nose. Males tend to have shorter hair. The female shapes tend to have more roundness, and the males have beards sometimes.

—REBECCA DART, DHX MEDIA

As the seasons have gone on, we've had some different body types for each sex as well—we have a short, squat male and a tall, skinny one—getting repurposed in funny ways too. . . . For a new character, it all seems to come together—with the combination of the design, voice acting, and boarding—in the final animation. This helps to define a new character. They don't really feel complete or real until that episode is done.

—JIM MILLER, DHX MEDIA

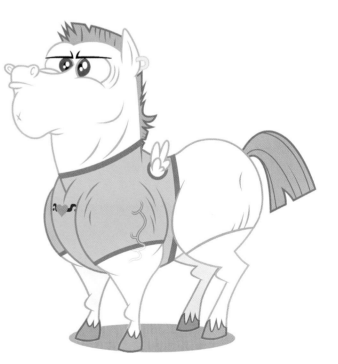

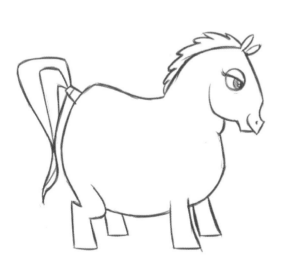

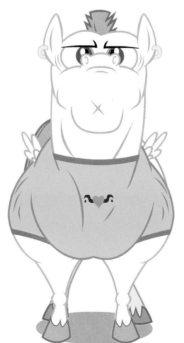

Body types are designed to reflect a variety of characteristics, including age and personality. Pony color, hair designs, costumes, and other added props help to flesh out a pony's personality.

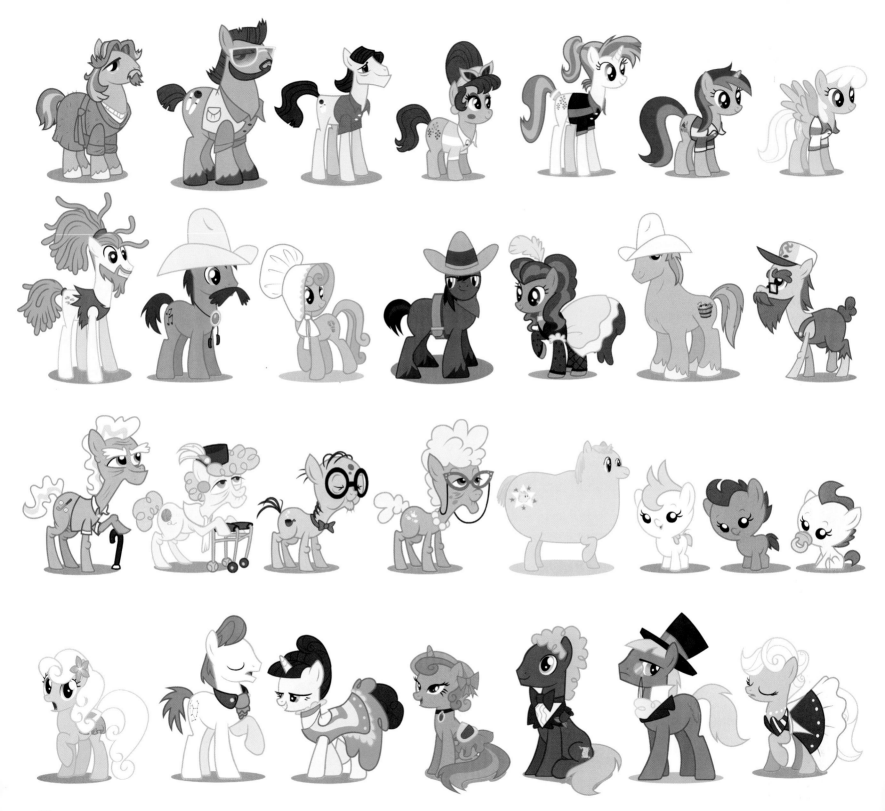

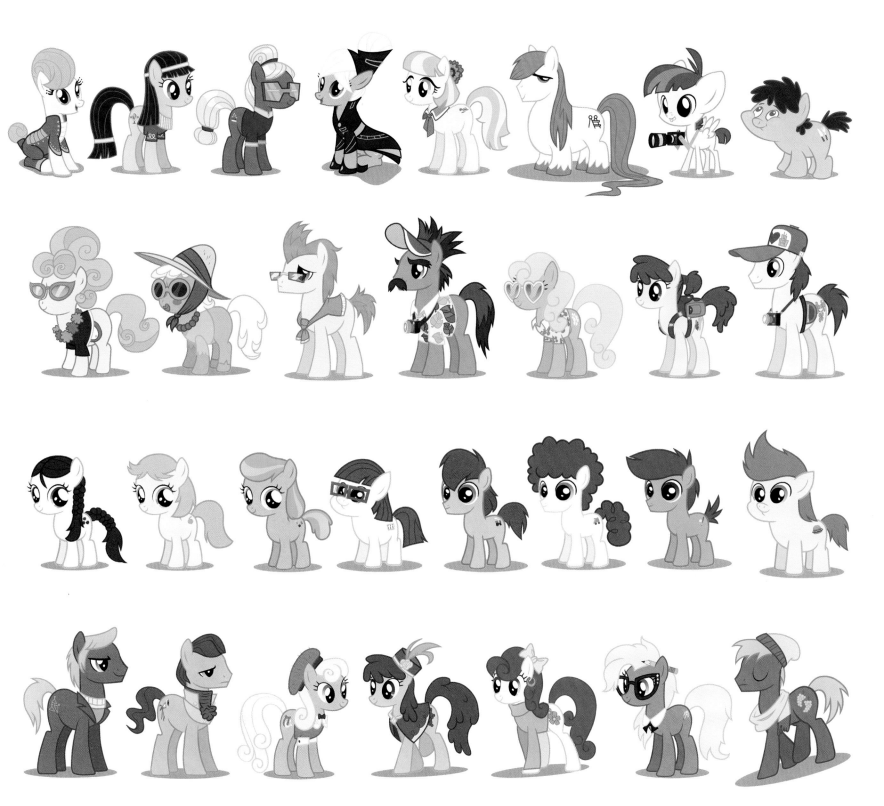

DRESSING PONIES

Fashion is just putting clothes on a frame, and we approach the ponies almost like humans on all fours. They don't have to have bodices like humans—because they don't need that. There has been a lot of back and forth about what to do with the tail: Does the tail go under the dress, or through the costume? If it's a simple dress, we tend to put the tail on the outside, because otherwise it looks like they have a huge bum! With a ball gown, you can put the tail underneath. That changes depending on what's needed.

—REBECCA DART, DHX MEDIA

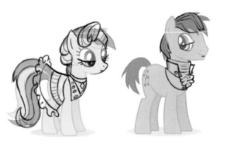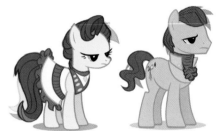

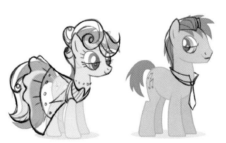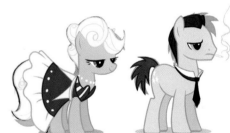

Costume design, originally meant for humans, must be modified to fit the pony form.

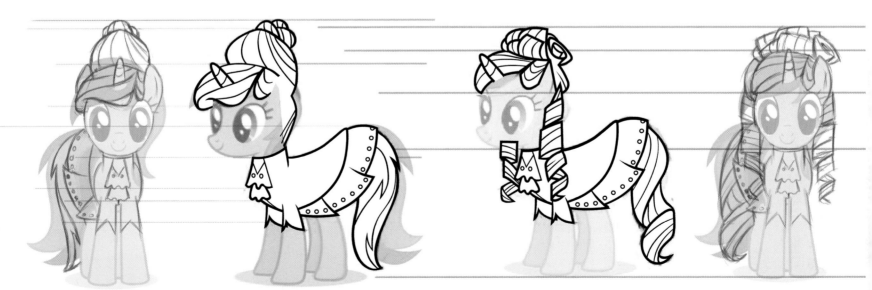

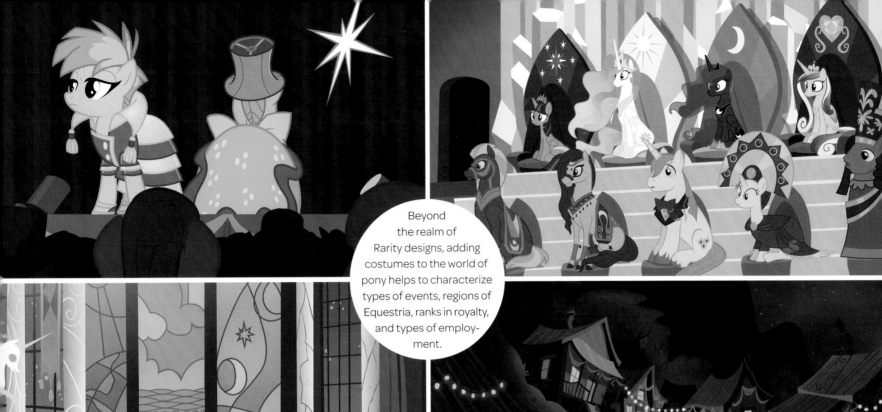

Beyond the realm of Rarity designs, adding costumes to the world of pony helps to characterize types of events, regions of Equestria, ranks in royalty, and types of employment.

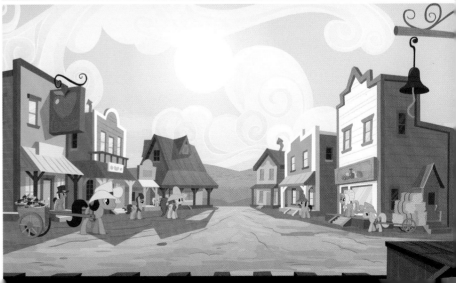

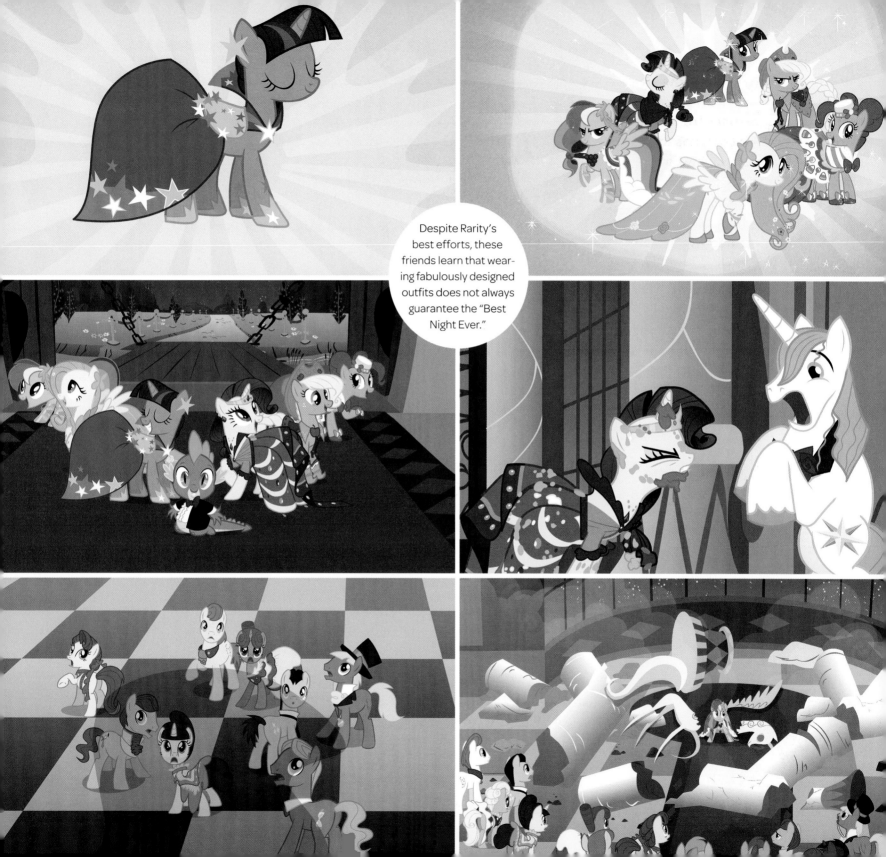

Despite Rarity's best efforts, these friends learn that wearing fabulously designed outfits does not always guarantee the "Best Night Ever."

There is a fine line between what's appealing and what's ugly, and we've had to design ugly stuff before and after the ugly dresses from "Suited for Success." A lot of it has to do with contrasting color, adding patches, and asymmetry.

—JIM MILLER, DHX MEDIA

It's a lot easier to design beautiful than ugly!

—REBECCA DART, DHX MEDIA

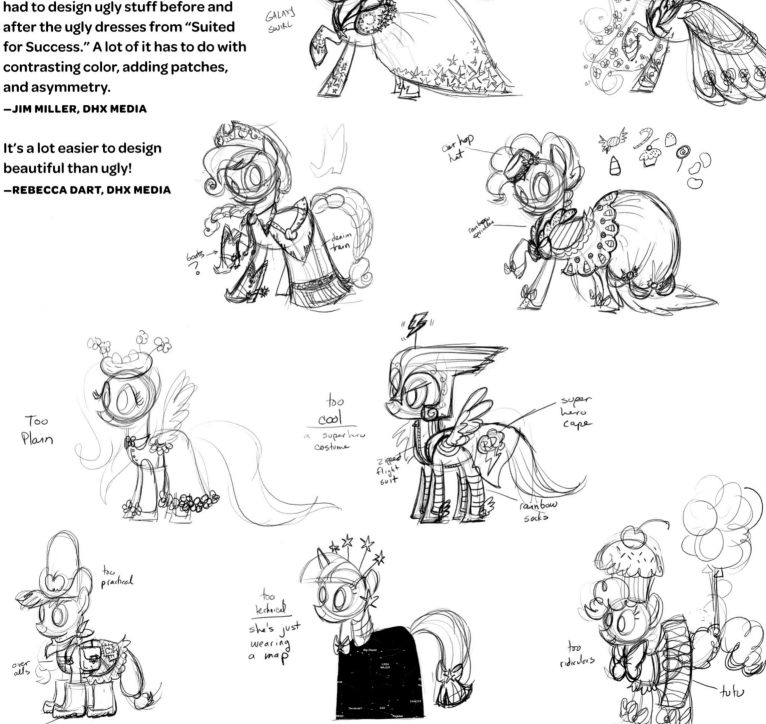

GALAXY SWIRL

boots?

denim train

car hop hat

rainbow sprinkles

Too Plain

too cool
a superhero costume

super hero cape

zipped flight suit

rainbow socks

too practical

over alls

galoshes

too technical
she's just wearing a map

too ridiculous

tutu

2 everypony

THE MANE SIX

Truthfully, each character has enough potential for their own series.
—JIM MILLER, DHX MEDIA

The creative team considers how the personality of each character translates into facial expressions, body language, props, and home environment. The Mane Six—Twilight Sparkle, Rainbow Dash, Fluttershy, Applejack, Rarity, and Pinkie Pie—each have expressions and style characteristics that are unique to that character, as well as general expressions that they all share. According to the DHX Media team, "There are certainly characters that would make different expressions, like you might do something with Pinkie Pie that you would never do with Applejack or Twilight or Rarity. So we don't have something that's specific for just one character, but we will avoid certain expressions if it goes outside their personality."

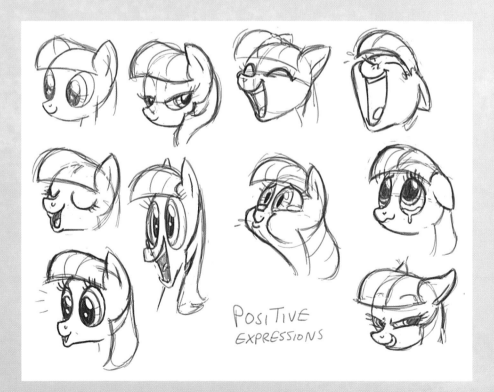

POSITIVE EXPRESSIONS

TWILIGHT SPARKLE

Twilight's book smart and kind of a neurotic perfectionist, a bit proper—she wants everything just so. She's got a touch of OCD. Everything has to be perfectly straight—if you went to her house, all the books would be perfectly aligned, everything is in its place. We've done jokes like having Applejack move a pencil, and she's like, "Hey, that pencil is out of place!"

—JAYSON THIESSEN, DHX MEDIA

Twilight Sparkle's coloration suggests both royalty and mystical awareness. Her original Cutie Mark reflected that in its celestial design, but it was modified to express that she is a vibrant and special star in the universe of pony.

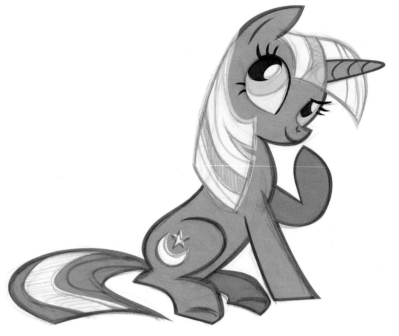

Twilight Sparkle was originally conceived with a different Cutie Mark and hair color.

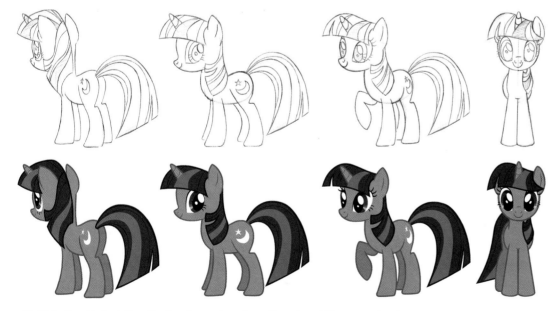

Twilight Sparkle's pet, Owlowiscious

Twilight Sparkle is defined by hard, angular edges: From her stiff, razor-edged bangs to her perky tail, she personifies a tidy pony in control.

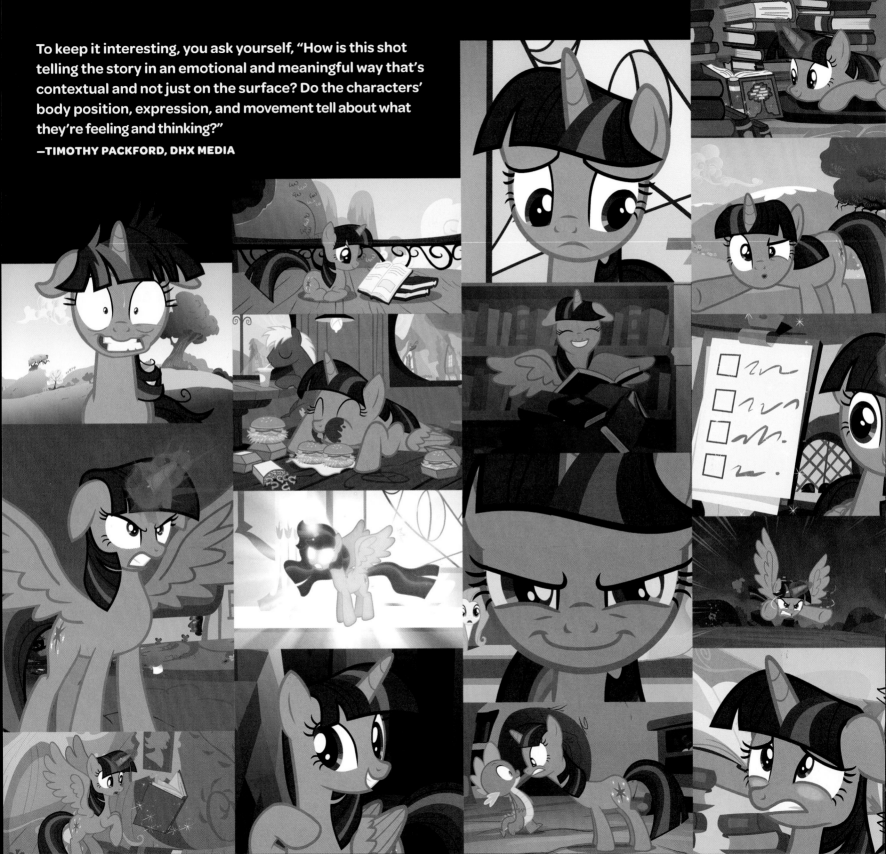

To keep it interesting, you ask yourself, "How is this shot telling the story in an emotional and meaningful way that's contextual and not just on the surface? Do the characters' body position, expression, and movement tell about what they're feeling and thinking?"

—TIMOTHY PACKFORD, DHX MEDIA

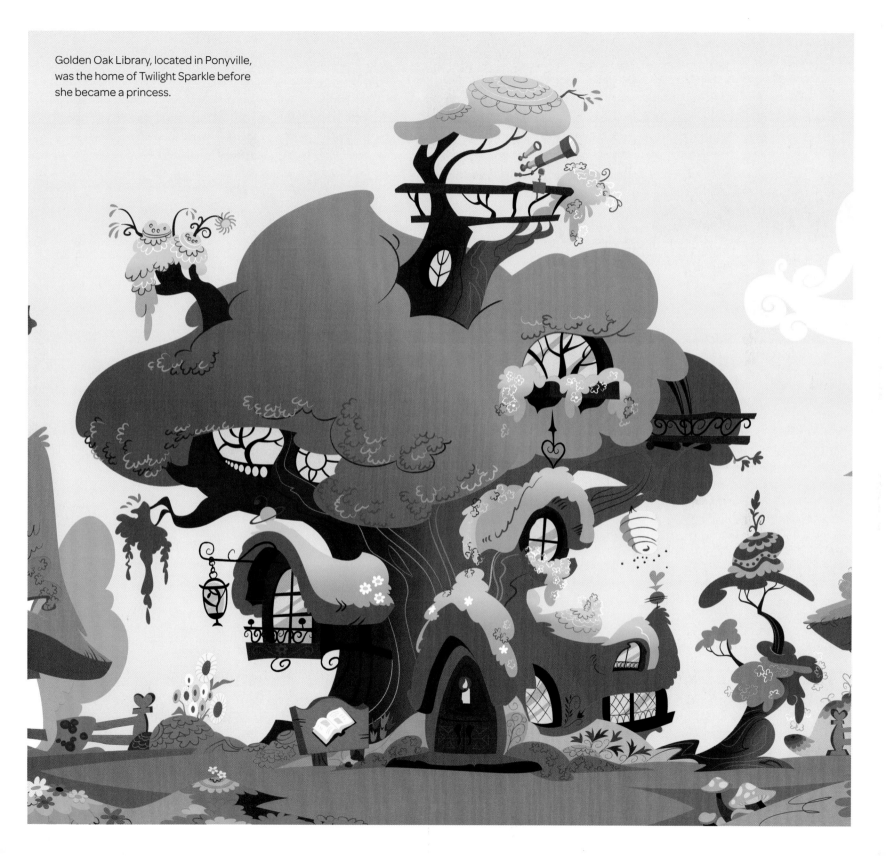

Golden Oak Library, located in Ponyville, was the home of Twilight Sparkle before she became a princess.

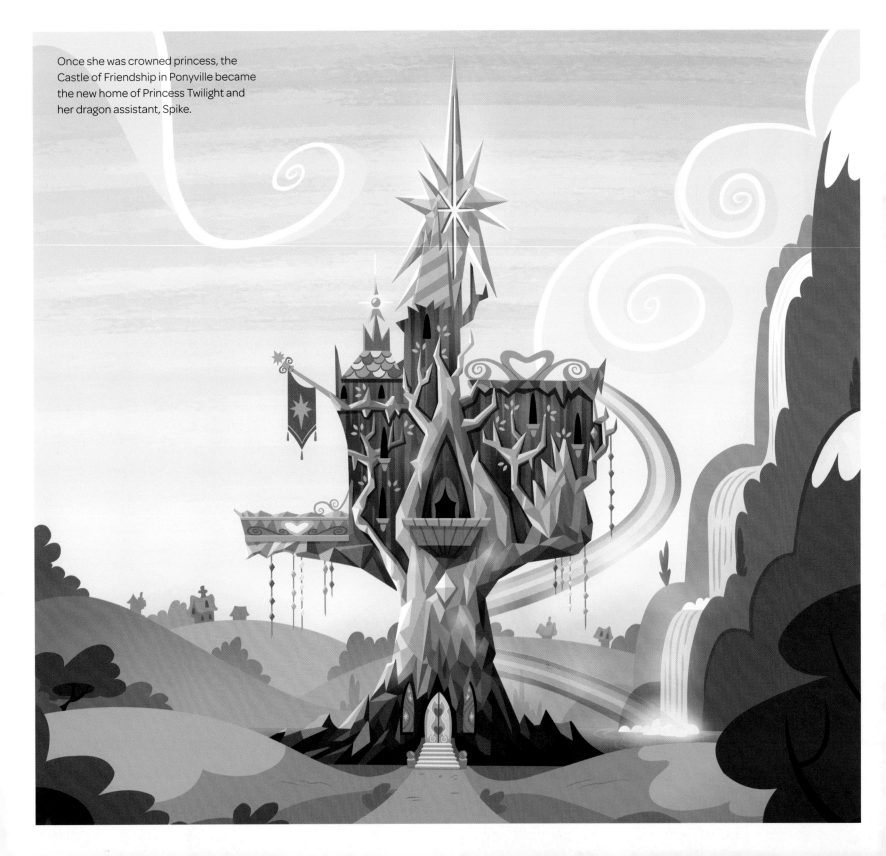

Once she was crowned princess, the Castle of Friendship in Ponyville became the new home of Princess Twilight and her dragon assistant, Spike.

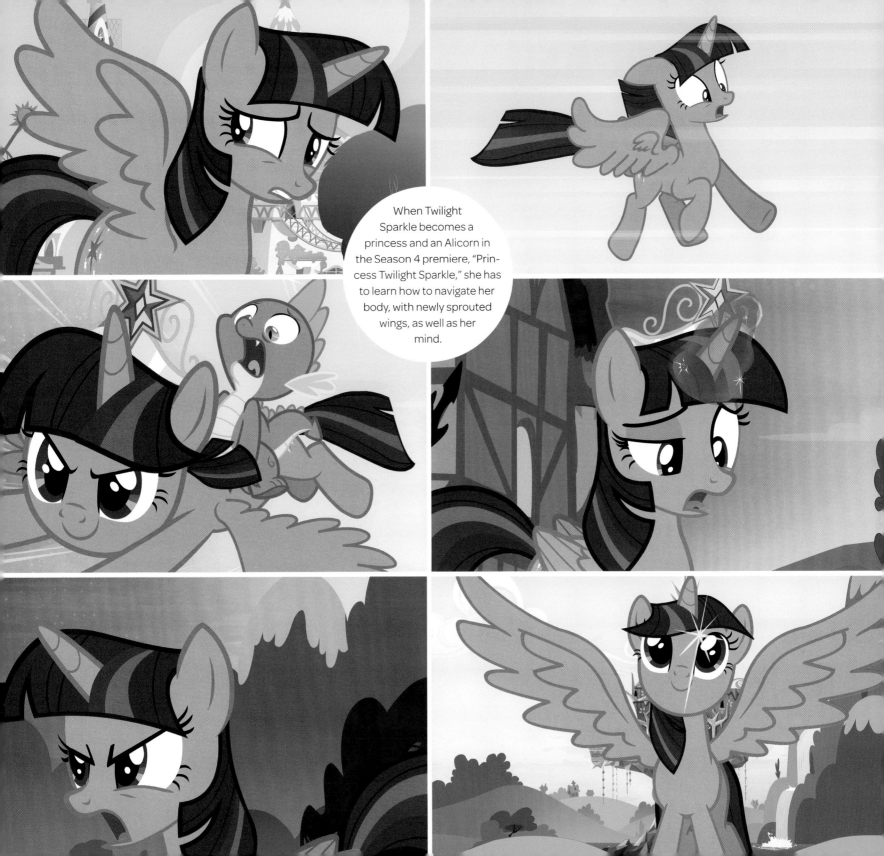

When Twilight Sparkle becomes a princess and an Alicorn in the Season 4 premiere, "Princess Twilight Sparkle," she has to learn how to navigate her body, with newly sprouted wings, as well as her mind.

RAINBOW DASH

Rainbow Dash is an impetuous Pegasus pony who doesn't think things through in the same way as Twilight Sparkle. She's more of an "act first and ask questions later" type. She's confident most of the time, acting without questioning herself. You don't see much of Rainbow Dash's house, because she doesn't stay still for very long. . . . I think that it's a testament to the clearly defined characters that Lauren established that helps inform all of this stuff moving forward. Because they are so uniquely defined, those choices become a lot more obvious.

—JIM MILLER, DHX MEDIA

Rainbow Dash's rainbow-colored hair and tail represent her ability to fly fast enough to cause a sonic rainboom.

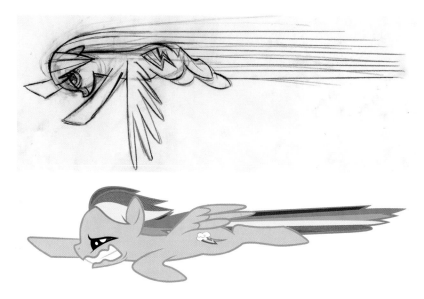

(above) Lauren Faust's original characterization of Rainbow Dash in flight shows motion and energy in her line work that suggest speed. The final color version by DHX Media captures the energy of the pencil drawing.

(left) Rainbow Dash's pet, Tank

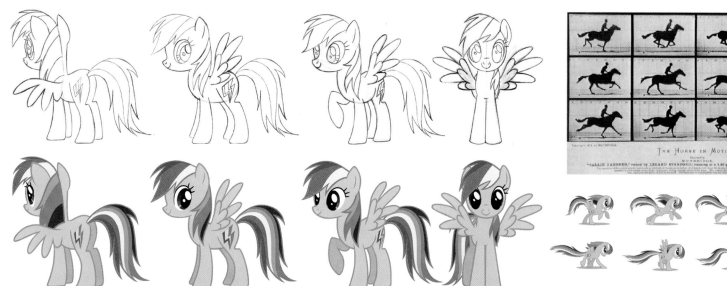

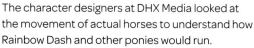

The pointed shapes and vibrant rainbow color of Rainbow Dash's mane and tail suggest sharpness, speed, and energy and are meant to contrast with her sky-blue body.

The character designers at DHX Media looked at the movement of actual horses to understand how Rainbow Dash and other ponies would run.

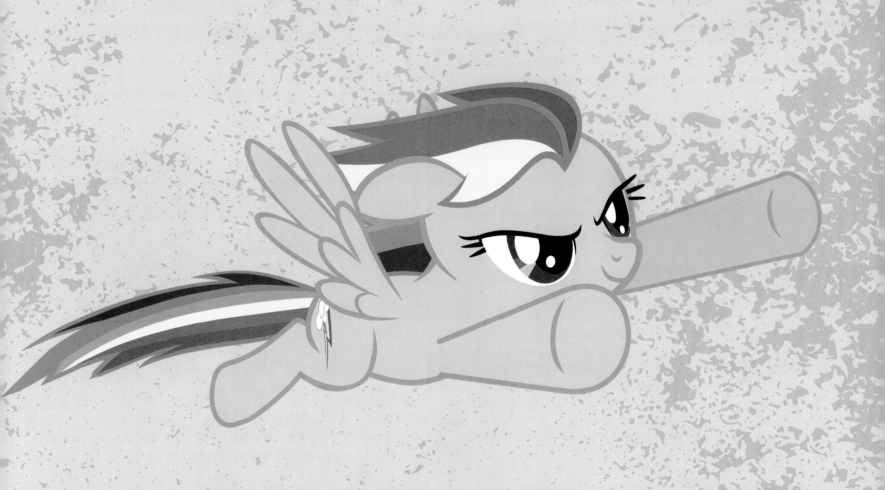

Rainbow Dash's expressions are all about body movement and gesture. Although her face clearly demonstrates her state of mind, her body is in constant expressive motion.

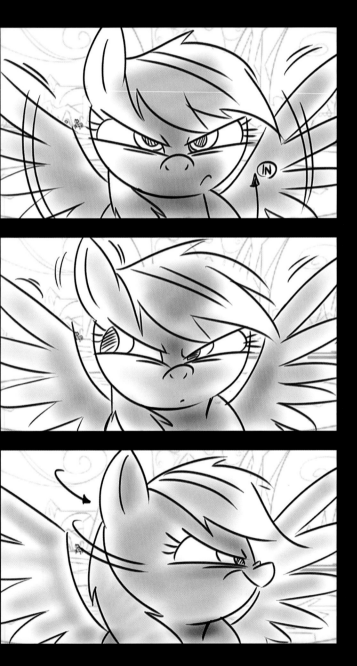

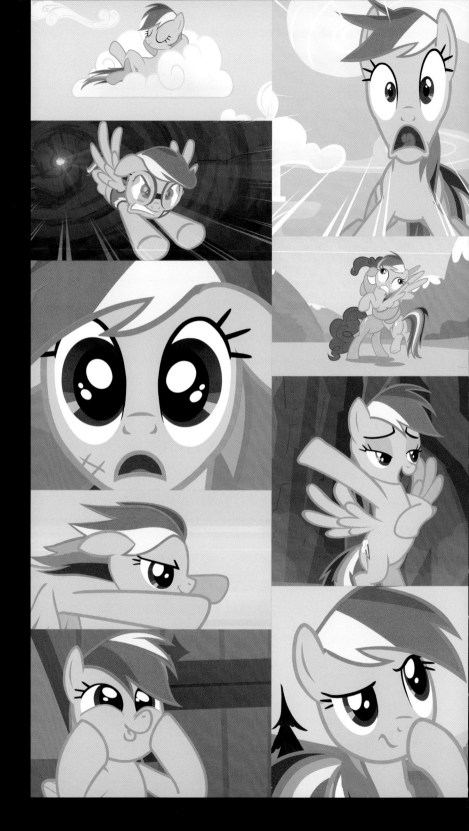

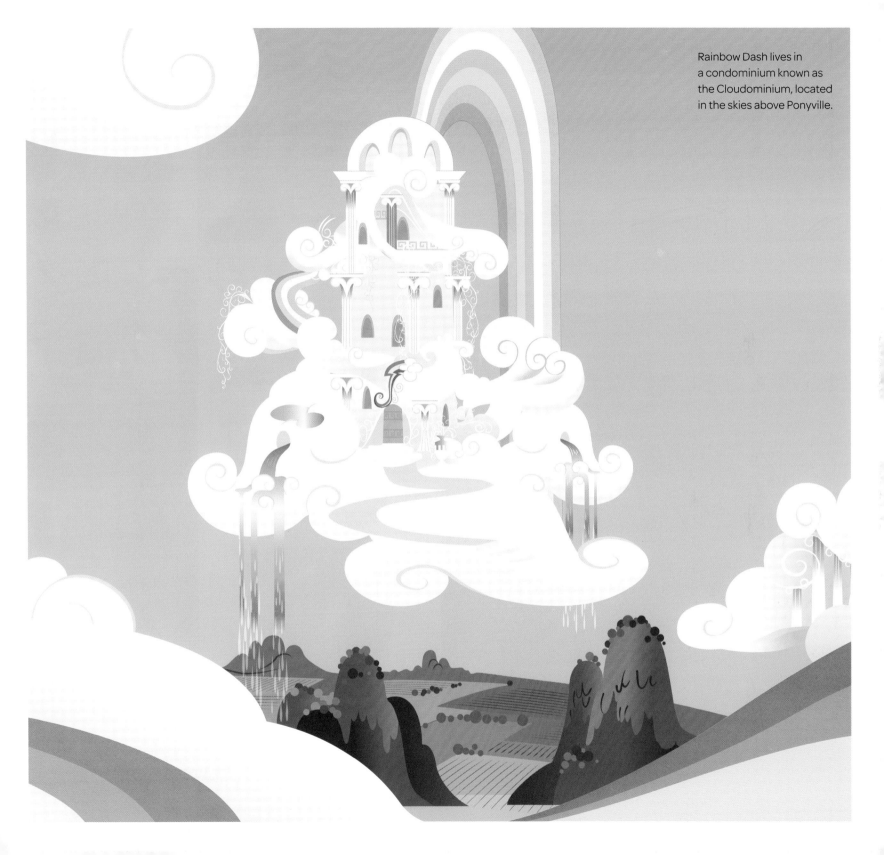

Rainbow Dash lives in a condominium known as the Cloudominium, located in the skies above Ponyville.

FLUTTERSHY

Fluttershy's character is defined by her shy sweetness; soft, whispery voice; and tender, nurturing nature. Her character sketches are all about fluidity, curve, and organic movement.

Fluttershy's Cutie Mark represents her affinity for animals, and her hair suggests a kind of bouncy, gentle, optimistic energy.

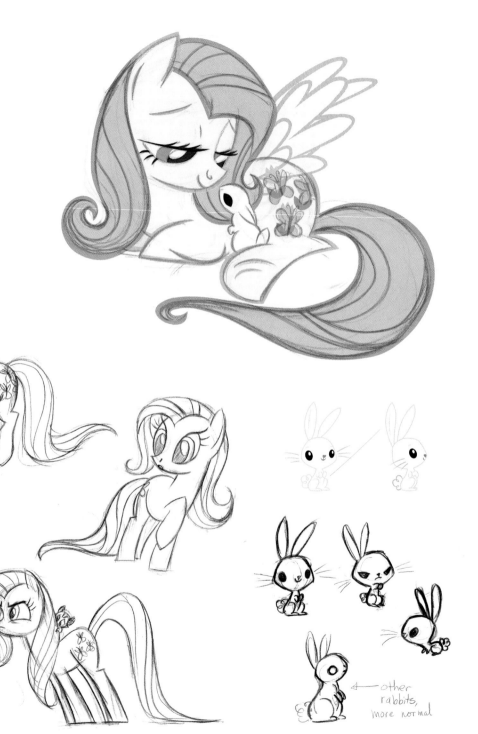

other rabbits, more normal

Fluttershy's pet, Angel

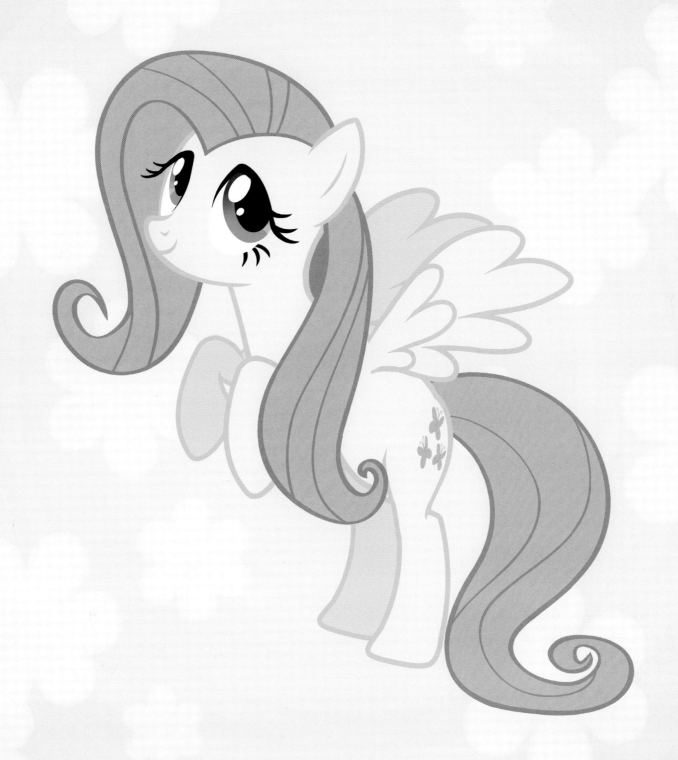

Fluttershy's expressiveness is focused primarily in her eyes, because her most potent weapon is "the Stare": Any pony or other creature under the power of the Fluttershy Stare is powerless and moved to meekness.

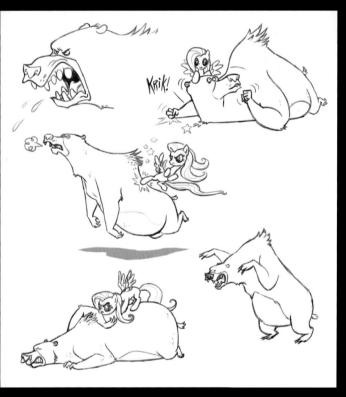

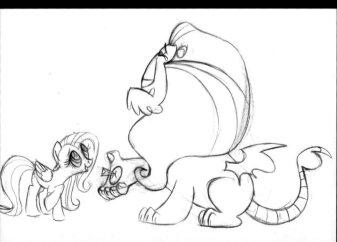

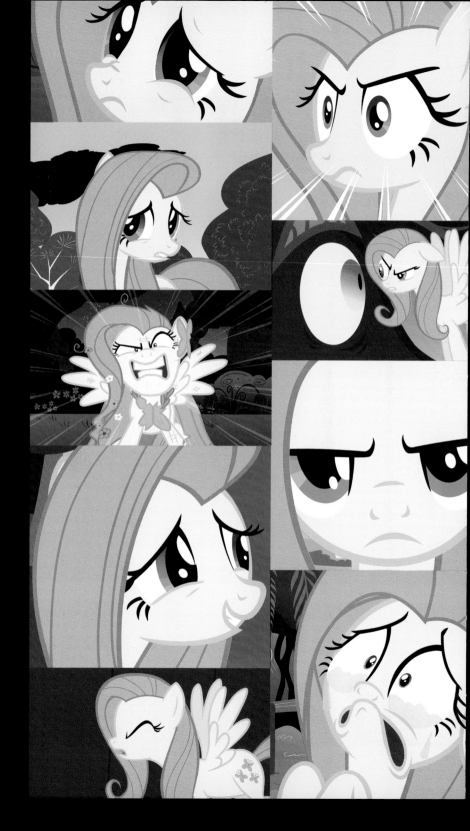

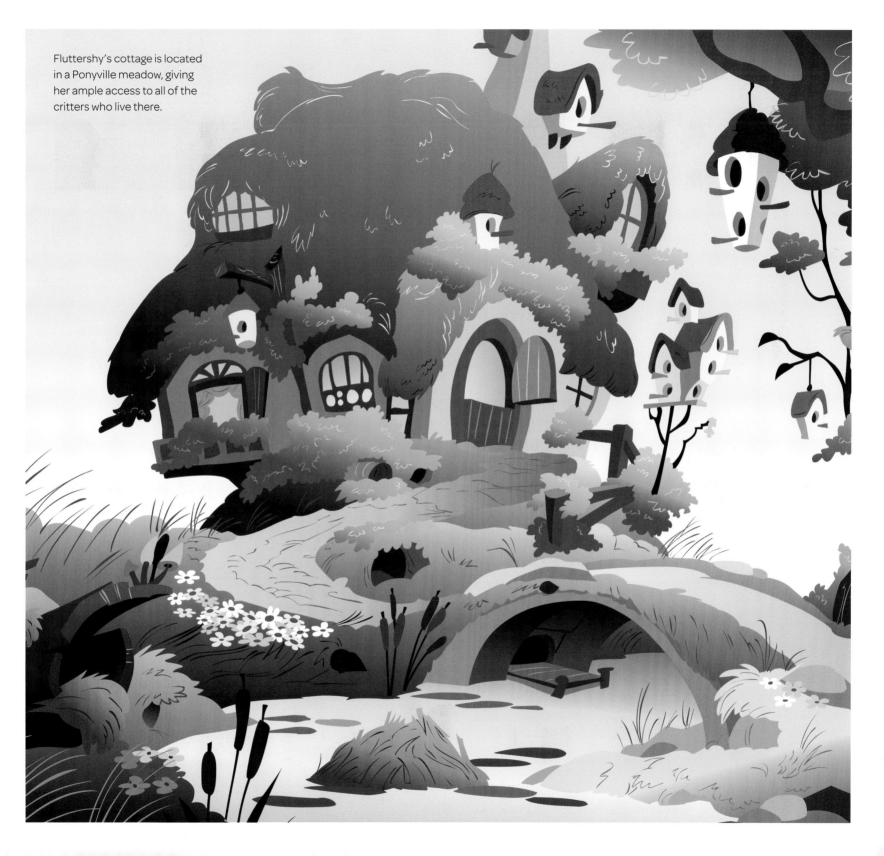

Fluttershy's cottage is located in a Ponyville meadow, giving her ample access to all of the critters who live there.

APPLEJACK

Applejack likes the mud, she's easy to please, and she doesn't take things too hard. She doesn't care about getting dirty—and doesn't care about fancy things.
—JAYSON THIESSEN, DHX MEDIA

She's about efficiency and getting things done. She tries to combat a problem head-on in the simplest, most direct way.
—JIM MILLER, DHX MEDIA

Applejack's down-home spirit is characterized by her lack of adornment and unflinching work ethic. Her Cutie Mark not only represents her name, but also is a symbol of the down-home simplicity found in a classic and common fruit.

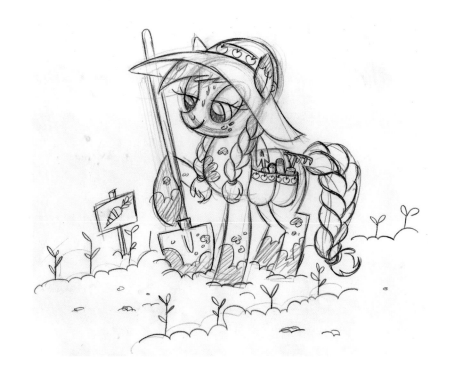

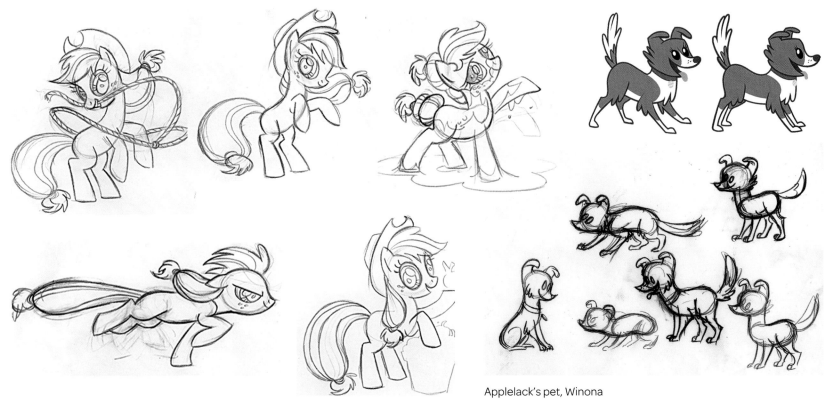

Applelack's pet, Winona

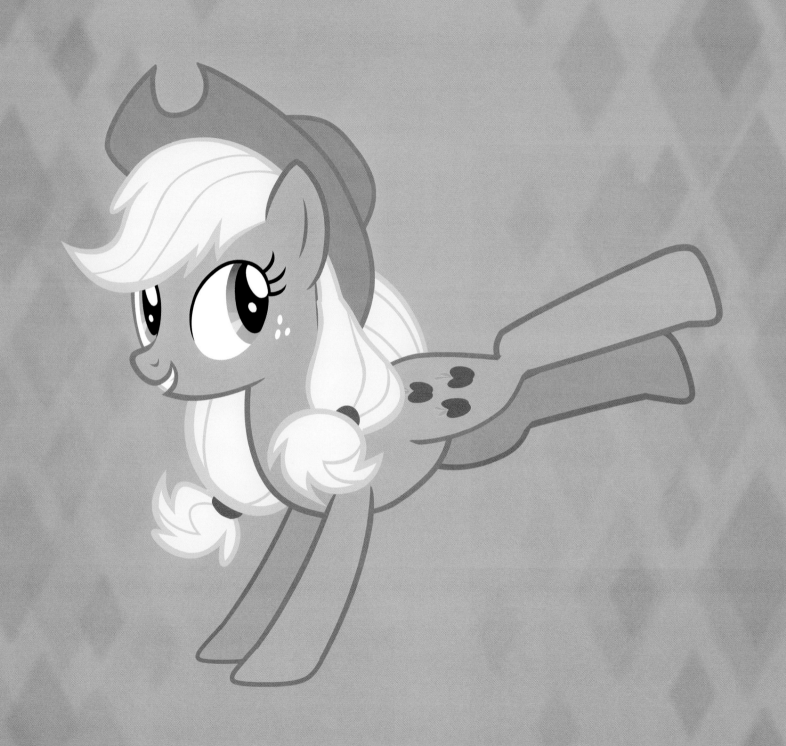

Applejack's expressions are not as dramatically exaggerated as those of some of the other Mane Six ponies, but that's in keeping with her straight-forward, no-frills, true-blue personality.

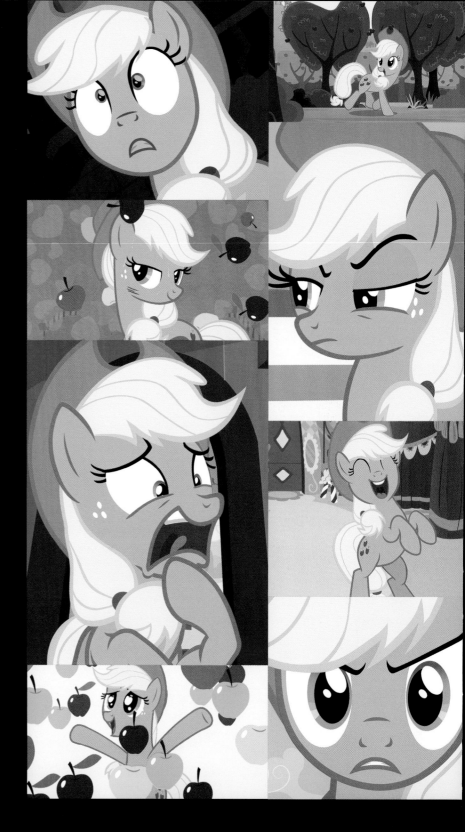

Sweet Apple Acres, located in Ponyville, is the home of Applejack; her grandmother, Granny Smith; her brother, Big Mac; and her little sister, Apple Bloom.

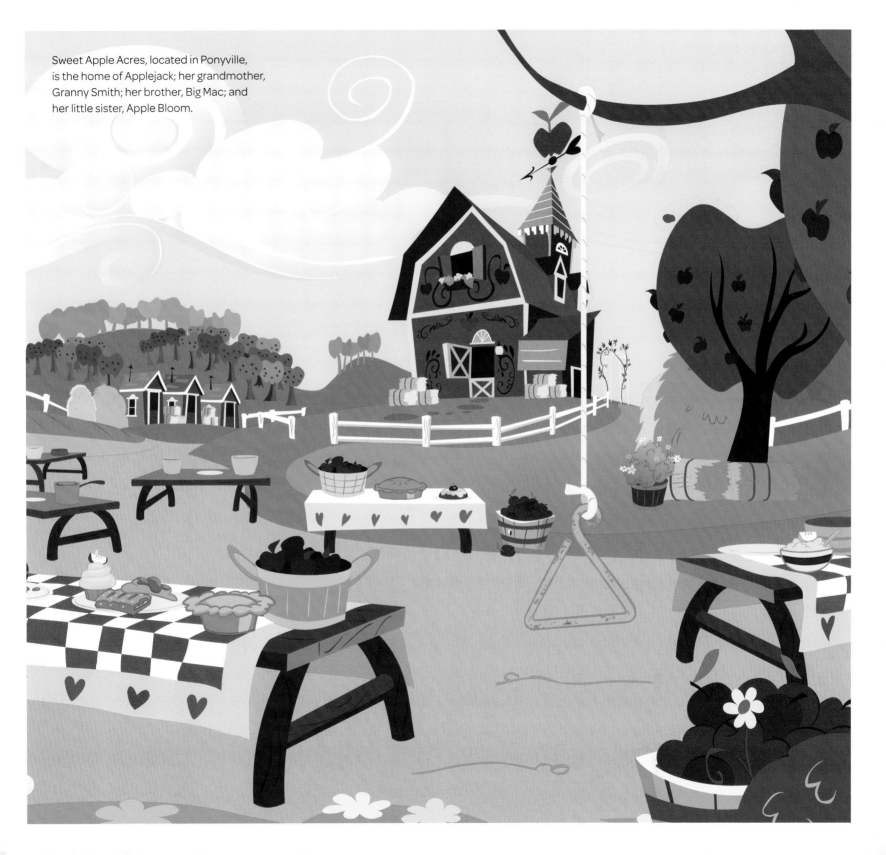

RARITY

Unlike Applejack, Rarity—a Unicorn pony—is all about fancy. The main floor of the boutique is about flourish and embellishment. Her whole world is about adornment and bling!

— JIM MILLER, DHX MEDIA

Adornment, refinement, and all things related to beauty define Rarity's world.

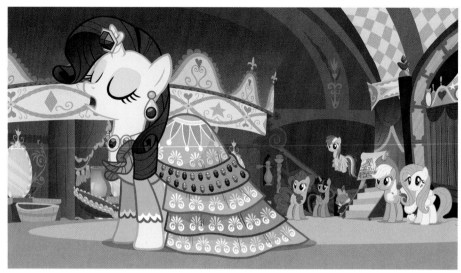

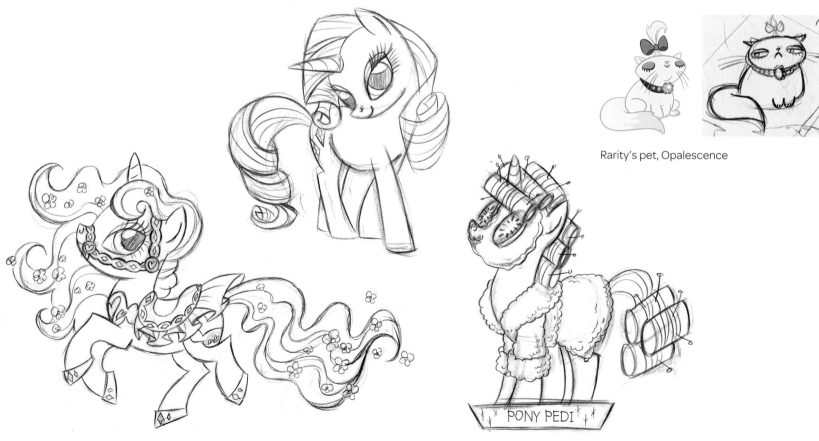

Rarity's pet, Opalescence

PONY PEDI

66

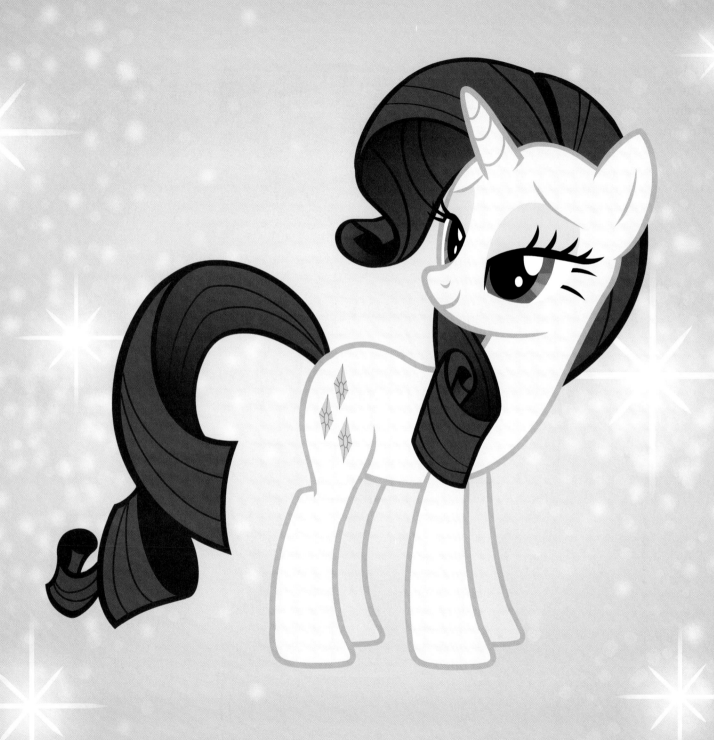

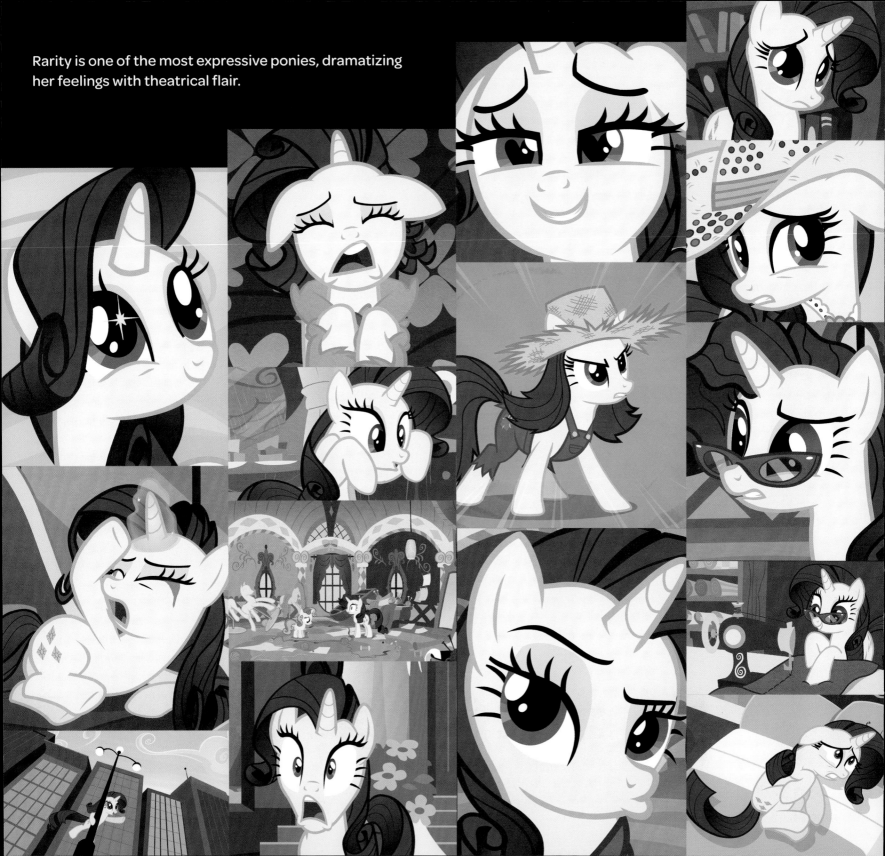

Rarity is one of the most expressive ponies, dramatizing her feelings with theatrical flair.

Rarity's home and workplace, the Carousel Boutique, is located in Ponyville.

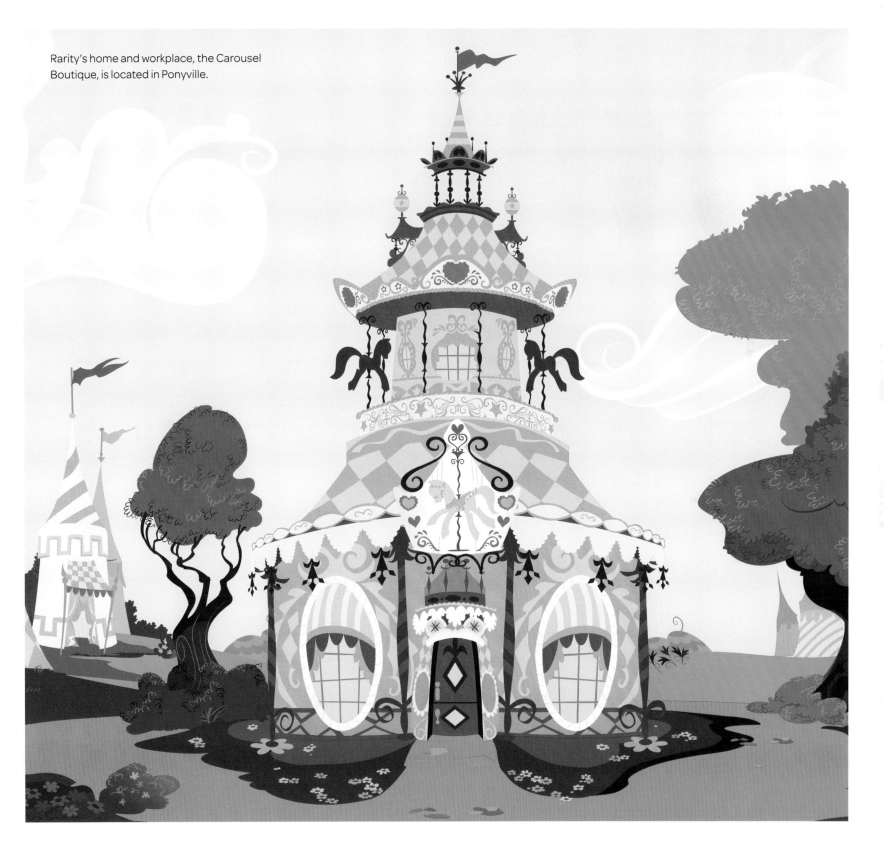

PINKIE PIE

Pinkie Pie is basically . . . a frenetic sugar rush!
—JAYSON THIESSEN, DHX MEDIA

Pinkie Pie is all about breaking with convention. She's sweet, happy, and outrageous, and she talks at the speed of lightning. Like Fluttershy, she's designed with curves and round shapes, but overall she looks more like a bubble, balloon, or cloud, reflecting her cheerful, buoyant state of mind.

Now an Earth pony, but originally conceived as a Pegasus pony, Pinkie has seen changes to her wings, coloration, and even name spelling—from Pinky to Pinkie.

Pinkie Pie's pet, Gummy

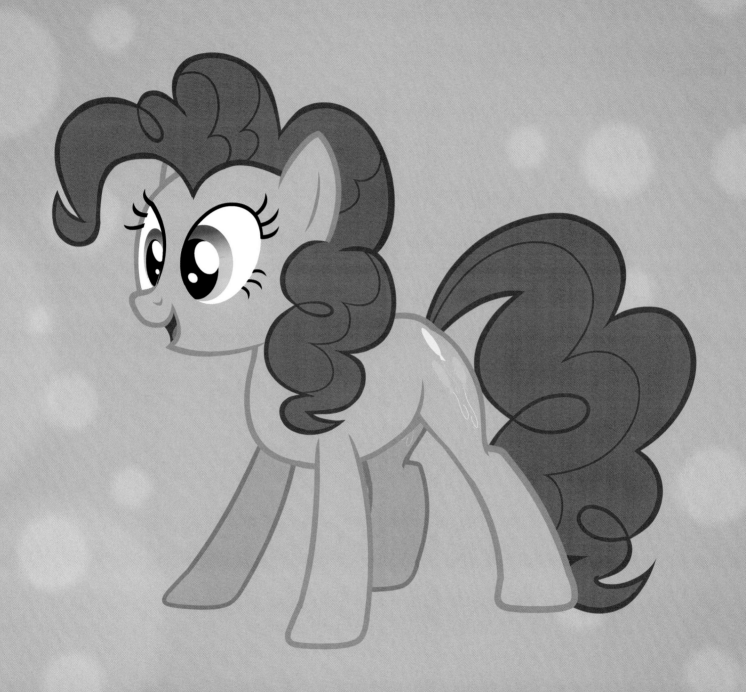

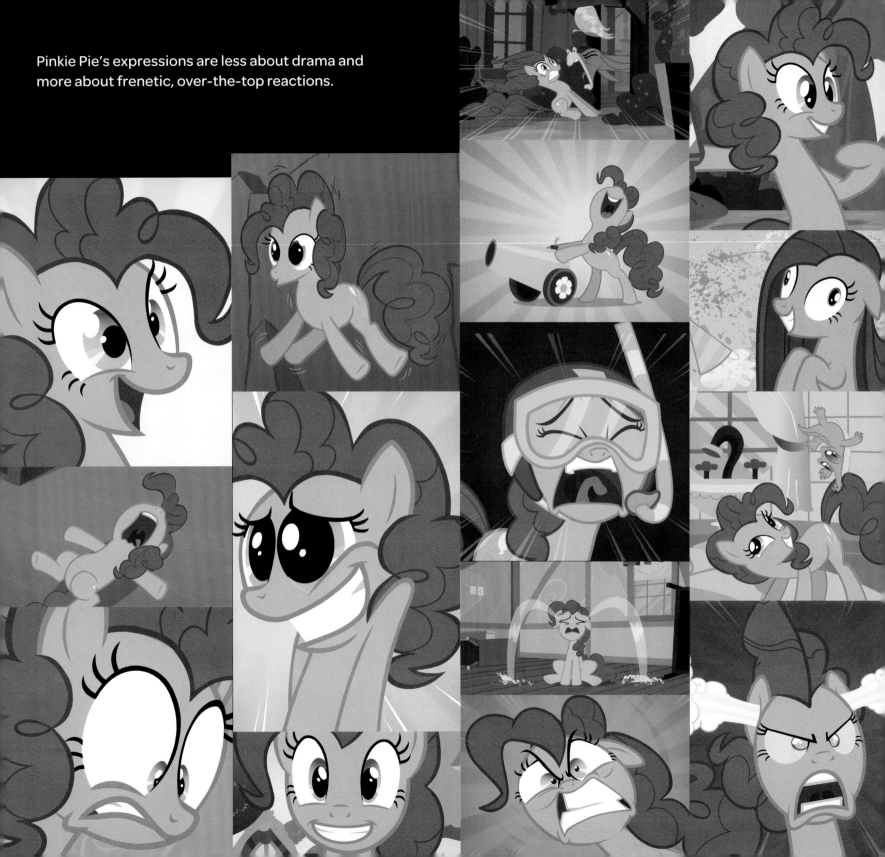

Pinkie Pie's expressions are less about drama and more about frenetic, over-the-top reactions.

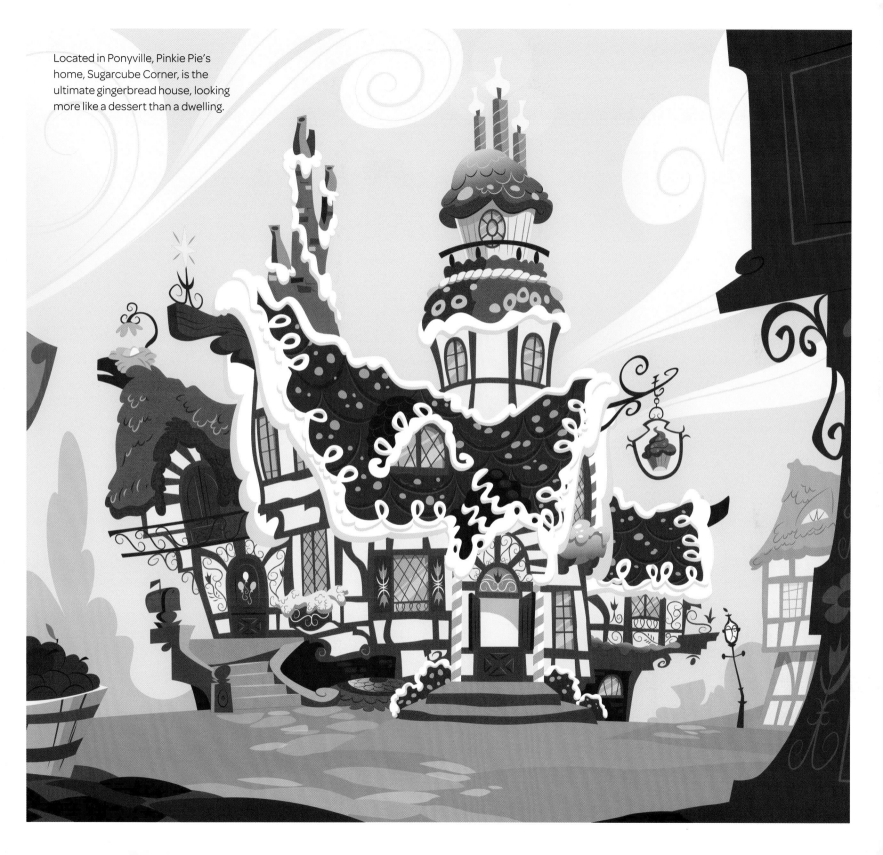

Located in Ponyville, Pinkie Pie's home, Sugarcube Corner, is the ultimate gingerbread house, looking more like a dessert than a dwelling.

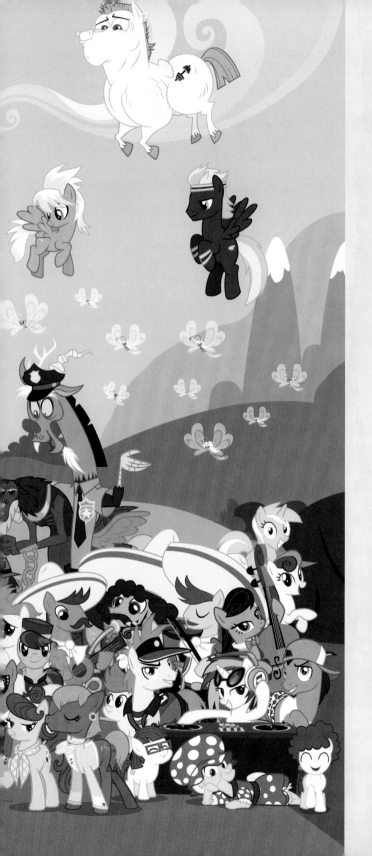

EXTENDED FAMILY

Friendship Is Magic has an enormous cast of background ponies living throughout Equestria. The current count reaches more than two hundred characters who have speaking roles, and this count grows daily as new episodes are written. Although the following characters are rarely front and center—hence the designation "background pony"—they play important supporting roles in the story line and the humor of the show.

The development of this extended cast of characters helps to suggest that the land of Equestria is vast and varied in its pony population. Fans frequently become enamored with a particular background pony, who then often ends up getting more airtime in future episodes because of fan interest.

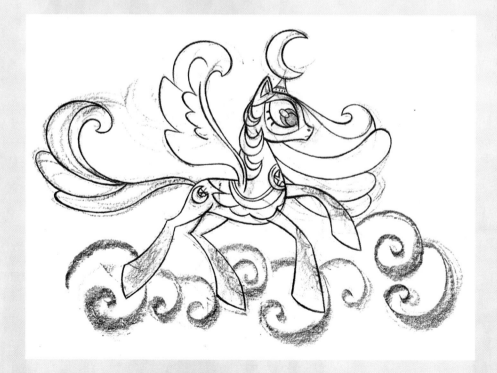

SPIKE

Spike is the ever-faithful dragon assistant to Twilight Sparkle. He lives in the Golden Oak Library with her until they both move into the Castle of Friendship. He's rarely far from her side since they moved from Canterlot to Ponyville together. Although he represents a childlike figure, with his large, round head and small body, he often assists in helping Twilight learn a lesson or accomplish a goal.

Spike's role is to act as a foil in personality, size, and shape to his pony friends. His design reflects his difference from the ponies and provides plenty of opportunity for exploring this contrast in story lines.

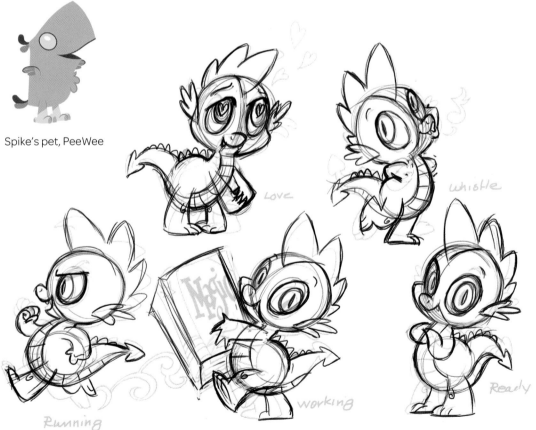

Spike's pet, PeeWee

Love

Whistle

Running

working

Ready

Spike has two loves: Rarity and gems!

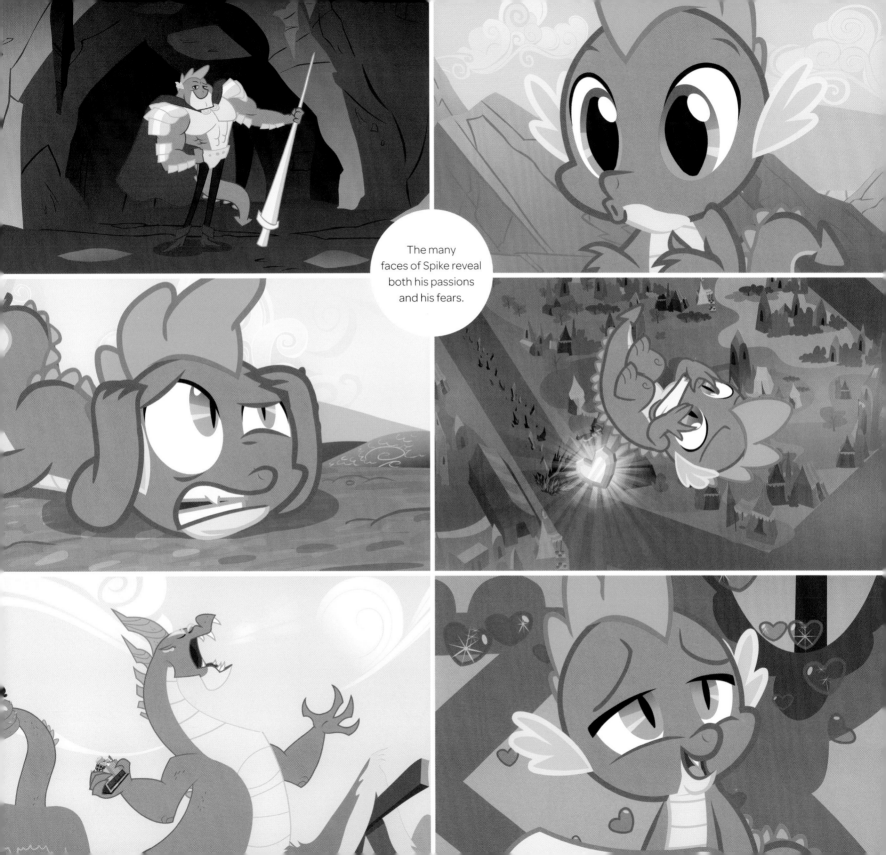

The many faces of Spike reveal both his passions and his fears.

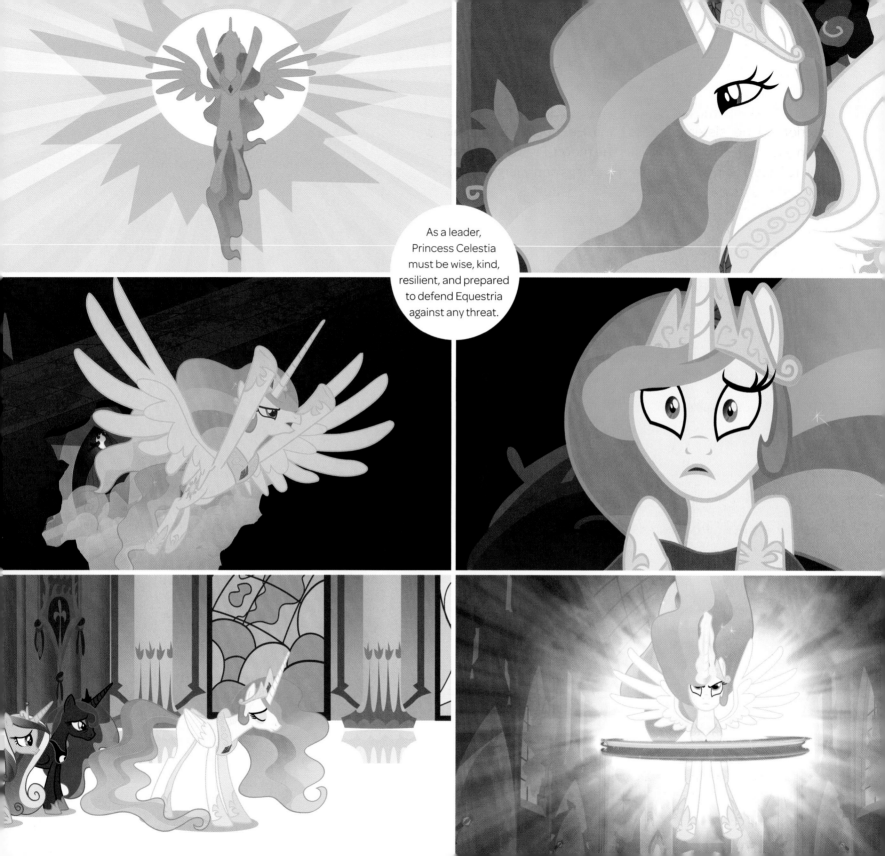

As a leader, Princess Celestia must be wise, kind, resilient, and prepared to defend Equestria against any threat.

PRINCESS CELESTIA

Princess Celestia is the co-ruler of all of Equestria and resides in Canterlot with her sister, Princess Luna. Her duties include raising the sun each day, while Luna raises the moon. Princess Celestia's design reflects her maturity, with longer legs and a larger body type than the standard pony. As an Alicorn capable of both magic and flight, she appears more horse-like and her color palette suggests magic and the color of a celestial body. Princess Celestia has a regal bearing, both as Twilight Sparkle's revered mentor and as an ambassador to ponies of other regions.

Princess Celestia's pet, Philomena

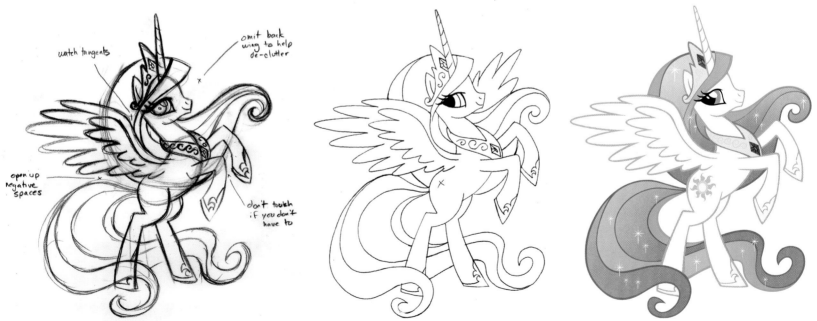

watch tangents

omit back wing to help de-clutter

open up negative spaces

don't touch if you don't have to

The character development process starts with a sketch (shown here with review notes), moves to a clean vector line, and finally becomes a color image rendered in Flash.

PRINCESS LUNA

Princess Celestia's younger sister, Princess Luna, had to overcome some anger issues before she could resume her royal duties. Her alter ego, Nightmare Moon, arose out of her angry heart as a youth, and nearly defeated her older sister, Celestia. Celestia was left with no choice but to banish her to the moon for a thousand or so years. But the Elements of Harmony, an unstoppable force for good, reunited the sisters in protecting Equestria again. Her most interesting job to date, beyond raising the moon, is helping ponies solve their problems through their dreams.

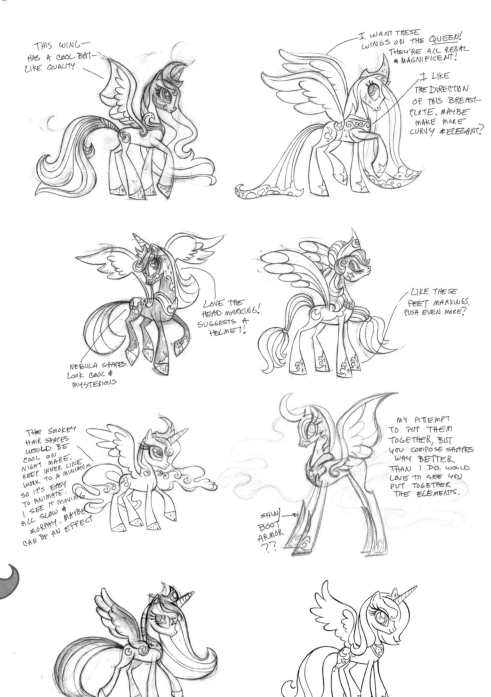

Princess Luna's design went through multiple iterations before landing on the final choice. Her wing and hair designs relate to her sister, Princess Celestia.

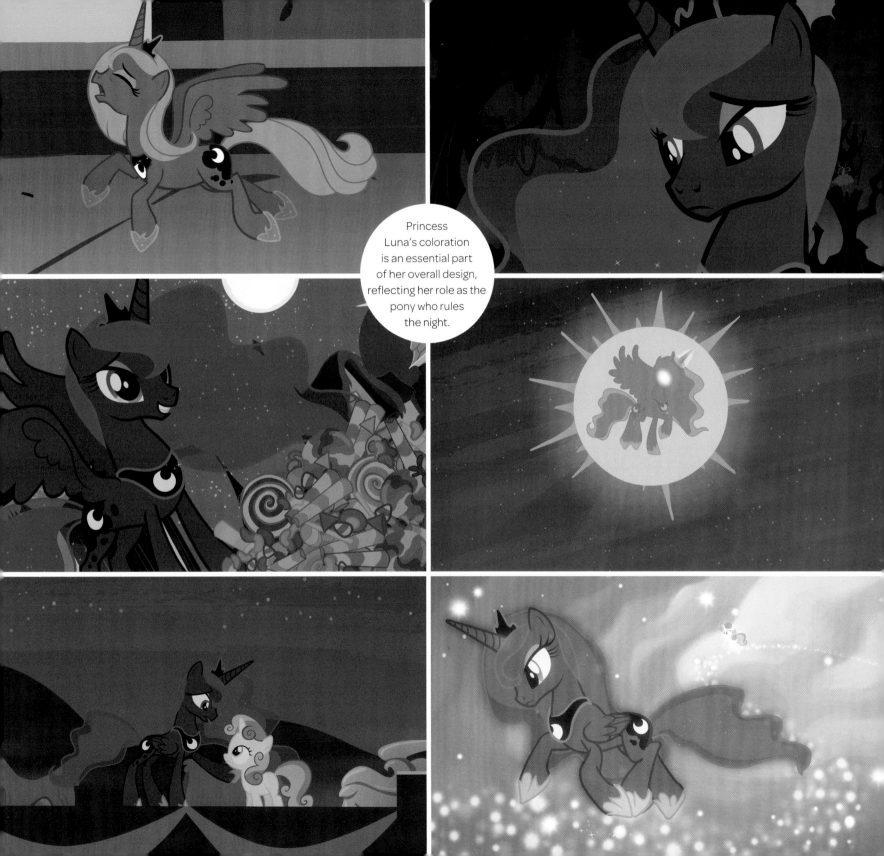

Princess Luna's coloration is an essential part of her overall design, reflecting her role as the pony who rules the night.

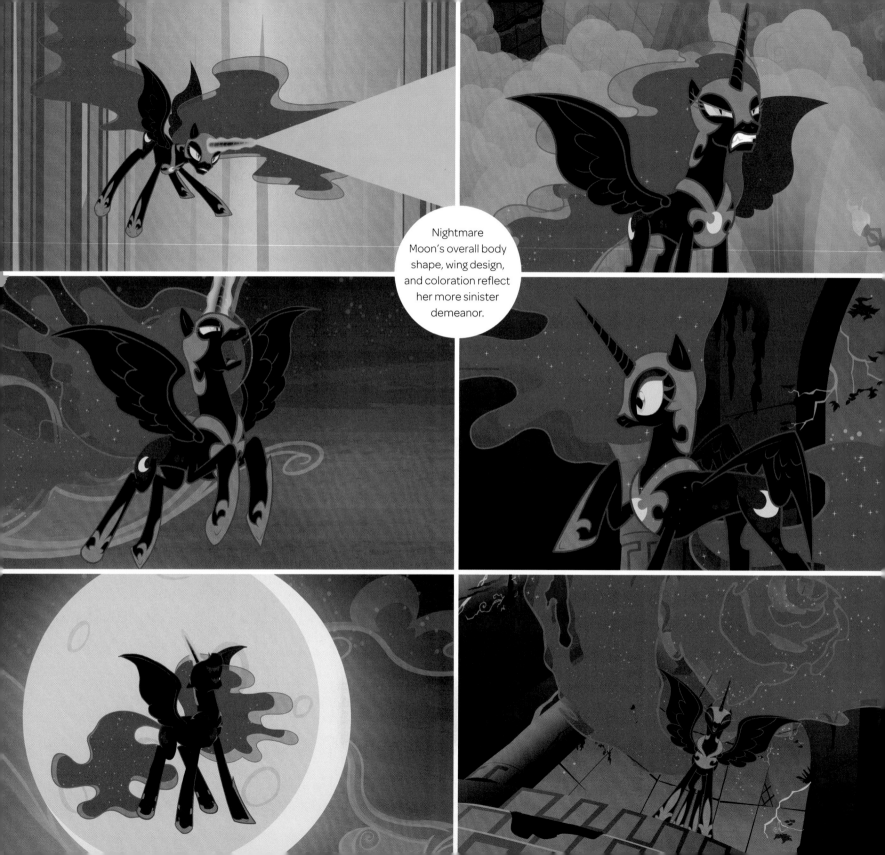

Nightmare Moon's overall body shape, wing design, and coloration reflect her more sinister demeanor.

NIGHTMARE MOON

Princess Luna famously rebelled against her sister and transformed into Nightmare Moon. Intent on plunging Equestria into perpetual nighttime, Nightmare Moon was reformed by the Elements of Harmony but not before she was banished to the moon by her own sister. Princess Luna has since worked through her feelings of resentment and now the sisters are reunited in leading Equestria.

Every year on Nightmare Night, ponies across Equestria revel in the fun of scaring each other with threats of Nightmare Moon's return.

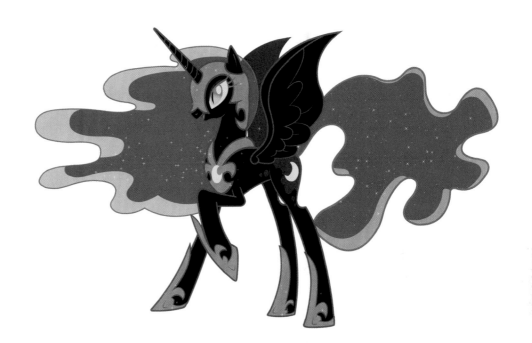

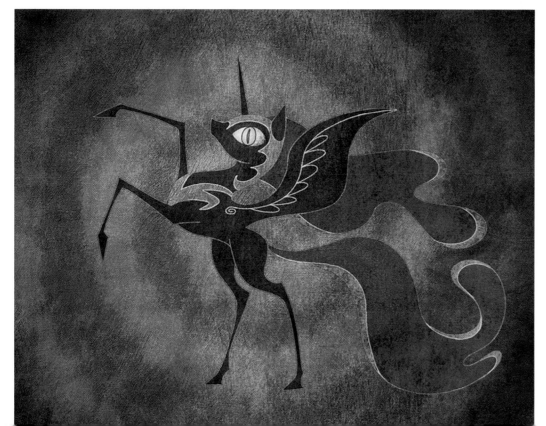

The opening episode of *My Little Pony: Friendship Is Magic* features a book of fairy tale–style drawings explaining an ancient prophecy that Twilight Sparkle found in the Golden Oak Library.

3
FOILS & FOES

DISCORD

Despite the powerful Alicorns protecting Equestria, Discord has managed to upend life there more than once. But Discord was not intended to have a recurring role in the series. He was meant to be a way to create visual chaos by depicting a space that doesn't make sense.

He's the one character where we can break all of the rules of the show. He can have a reference to something that's a bit more modern day or contemporary. He has hands—which is a big thing. In Seasons 4 and 5, I ended up with a couple of Discord episodes, and he then became a kind of character where you could just throw him in a different costume and have him do something extra silly—it seems to work really well for him.

—JIM MILLER, DHX MEDIA

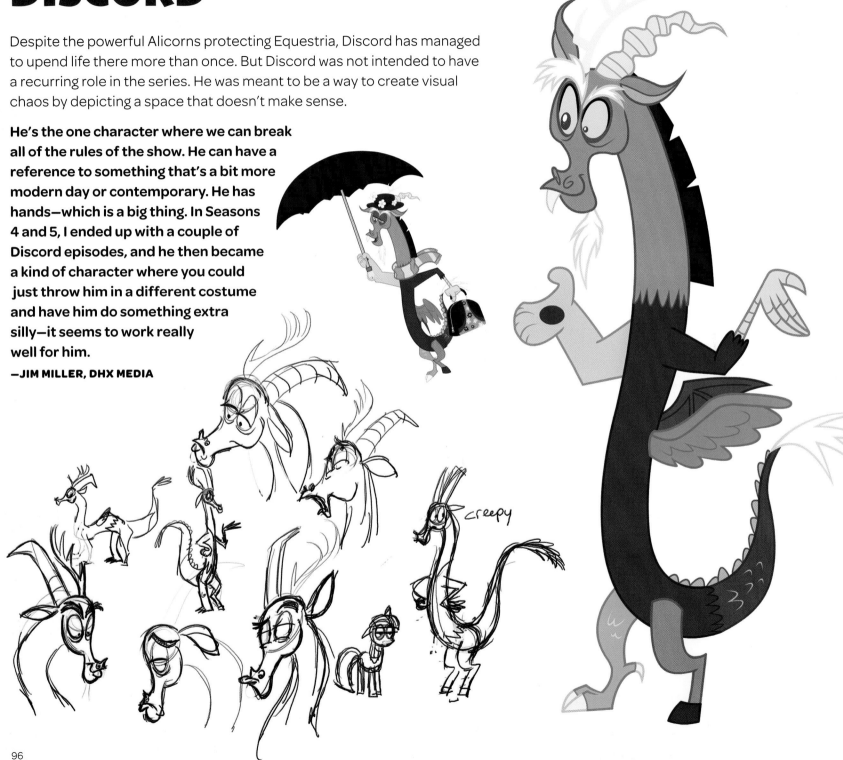

creepy

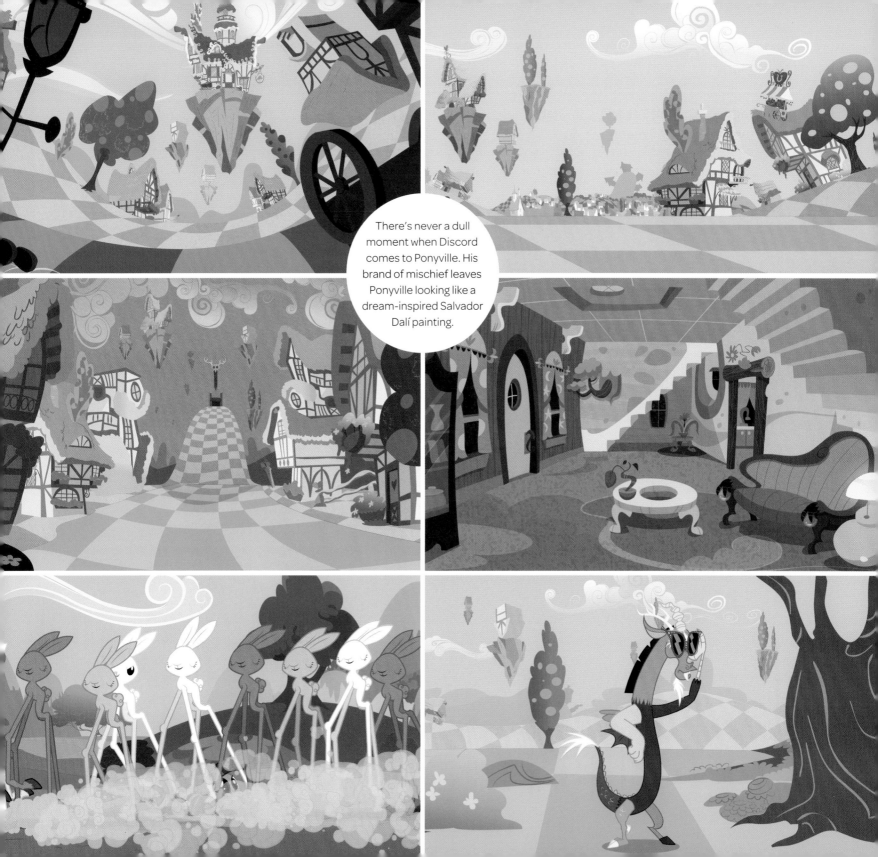

There's never a dull moment when Discord comes to Ponyville. His brand of mischief leaves Ponyville looking like a dream-inspired Salvador Dalí painting.

What I like is that he started out as a villain and now he's not a villain, but he never really changed. It's really just whether or not he's trying to hurt the ponies or take over their world. He's still the chaos character that we were introduced to; it's just that now he's not doing it for evil purposes. He's essentially the genie from *Aladdin* in a way, or Loki—really, any sort of trickster. He can be either negative or positive, but it doesn't change his trickster nature.

—JAYSON THIESSEN, DHX MEDIA

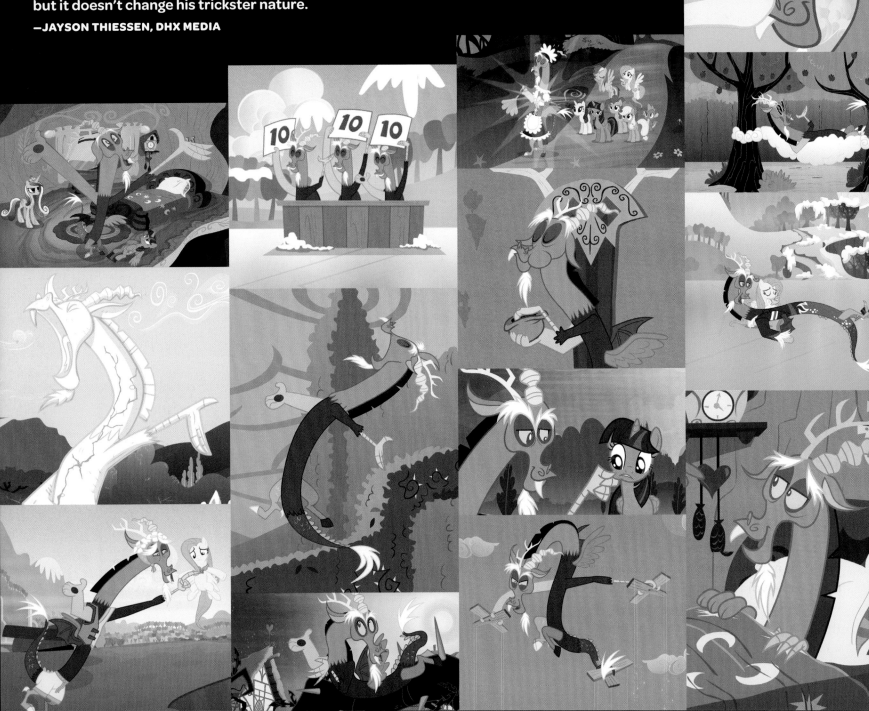

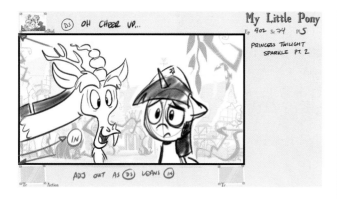

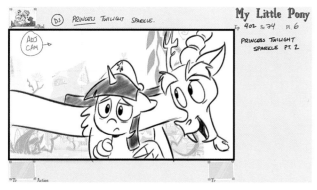

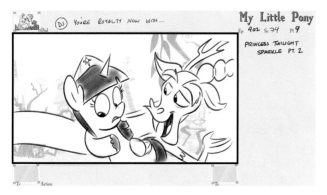

John de Lancie, voice of Discord, records his lines over the phone, but his first episode recording was taped. We could see him; he couldn't see us. He was acting as wild as he could, as if he was on camera! Generally, we go by how the voices sound and what's intended. It's all about what the story needs and what the sound is telling us about the character.

—JAYSON THIESSEN, DHX MEDIA

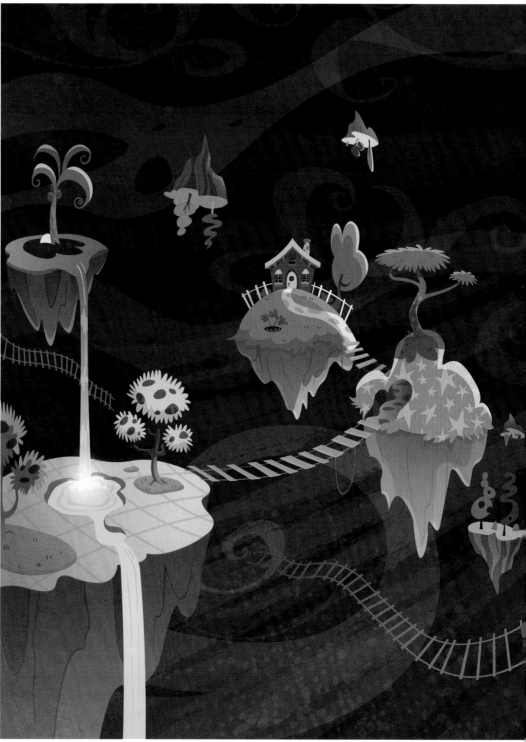

Discord's lovely neighborhood in Chaosville

QUEEN CHRYSALIS

When I designed Queen Chrysalis for "A Canterlot Wedding" in Season 2, initially she was drawn as being wet and hunched over, and it made her look weak and a bit Gollumesque. I also wanted to make her look rotten, like she crawled out from under a log, because she's buglike—that's why she's all moth-eaten and full of holes. . . . I saw a note from Hasbro that said she wasn't scary enough, so I had to do a special pose of her rearing up to prove that she could be a super villain. Just putting her upright made her more commanding.

—REBECCA DART, DHX MEDIA

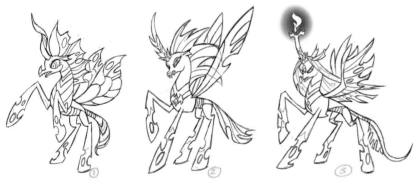

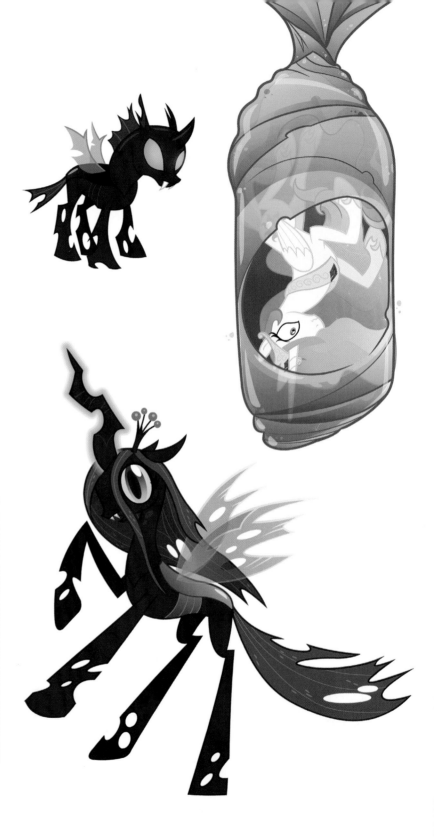

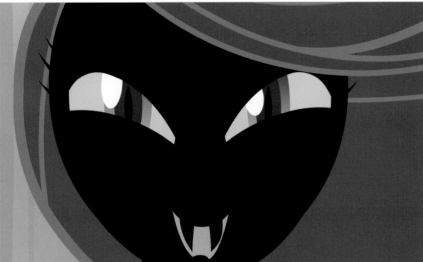

Queen Chrysalis's obvious decay is in stark contrast to Princess Celestia's and Princess Cadance's vigor.

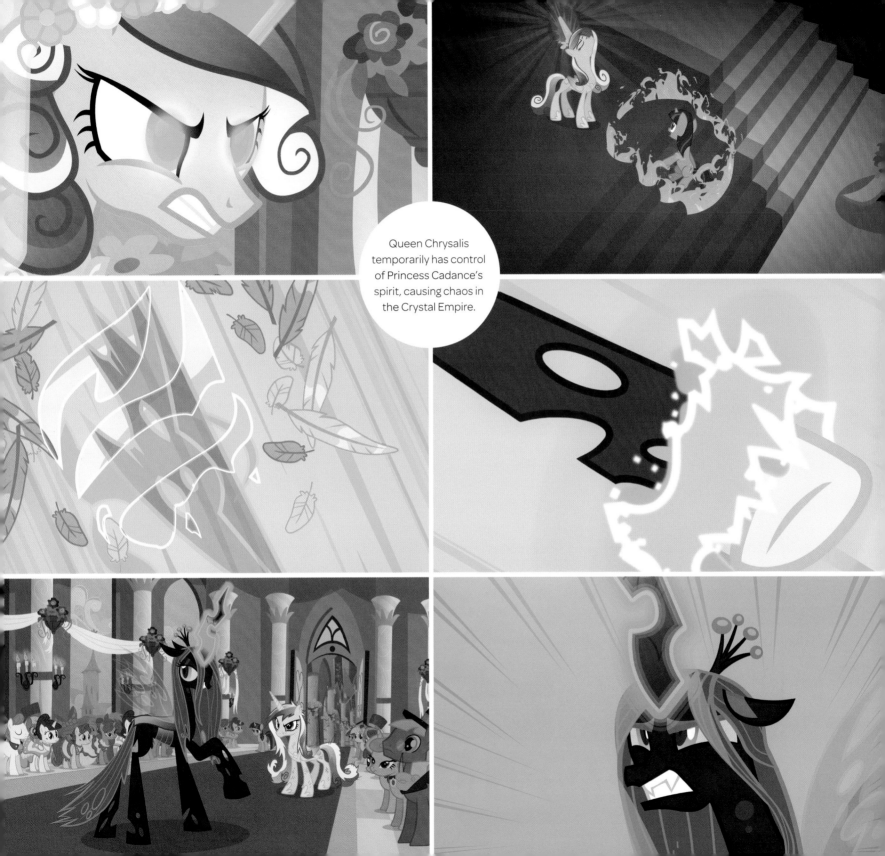

Queen Chrysalis temporarily has control of Princess Cadance's spirit, causing chaos in the Crystal Empire.

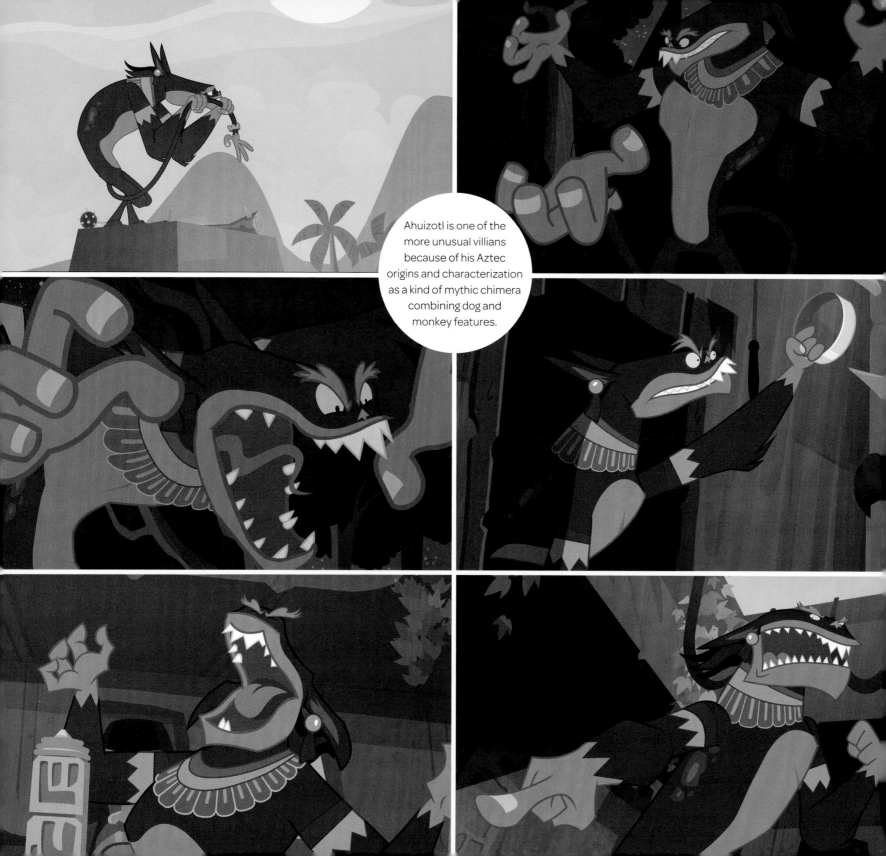

Ahuizotl is one of the more unusual villians because of his Aztec origins and characterization as a kind of mythic chimera combining dog and monkey features.

AHUIZOTL

Ahuizotl's design was based on the legendary creature in Aztec myth. His head shape is based on an ancient sculpture. I put his eyes where the nostrils normally are—I just wanted to mix it up. The hand on the tail is from the original mythology.

—REBECCA DART, DHX MEDIA

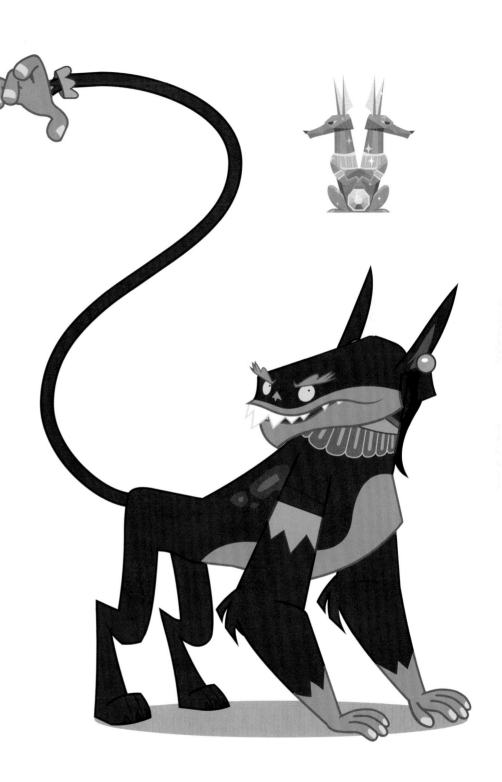

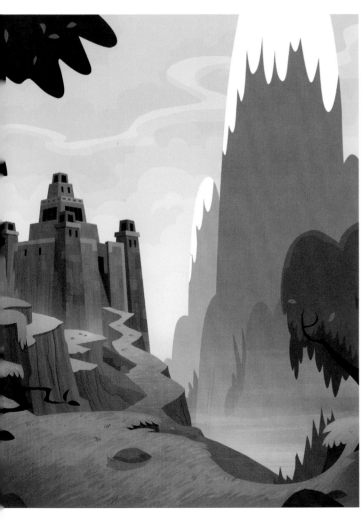

Ahuizotl's temple is known as the Fortress of Talacon.

KING SOMBRA

King Sombra's design depicts his incarnation as both a solid creature and a flowing mass of smoky darkness. His lack of color suggests his evil demeanor, punctuated by his blood-red eyes and royal cape. As a pony, he has a body structure that is bulkier and more elongated, alluding to his status as a once-powerful ruler of the Crystal Empire.

From the Season 3 premiere: King Sombra's shorn Unicorn horn falls to the ground, transforming into black crystal that darkens the sky and threatens to take over the Crystal Empire. He's ultimately thwarted by Alicorn magic.

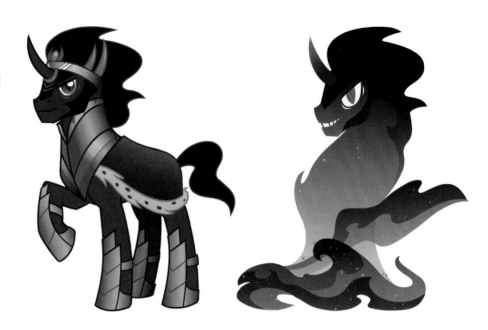

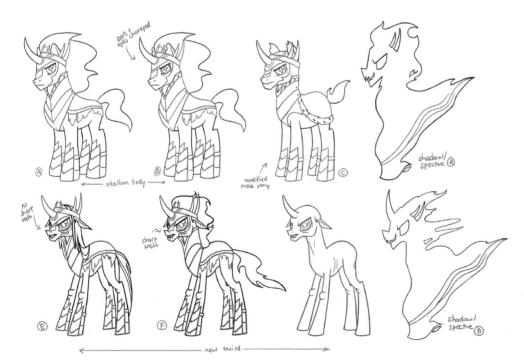

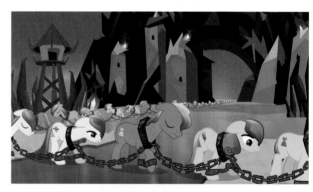

The middle stage of King Sombra's body form as he changes from one state to another bears some resemblance to Queen Chrysalis in the facial design, emaciated body, and spindly legs.

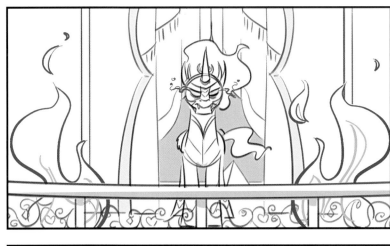

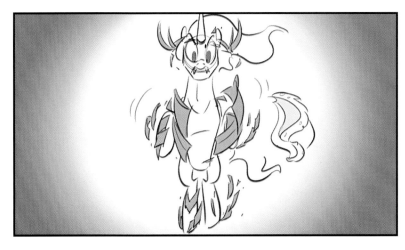

King Sombra seized the Crystal Empire, enslaving the Crystal ponies. He was overthrown, turned into shadow, and banished to the arctic north by the combined forces of Princesses Celestia and Luna.

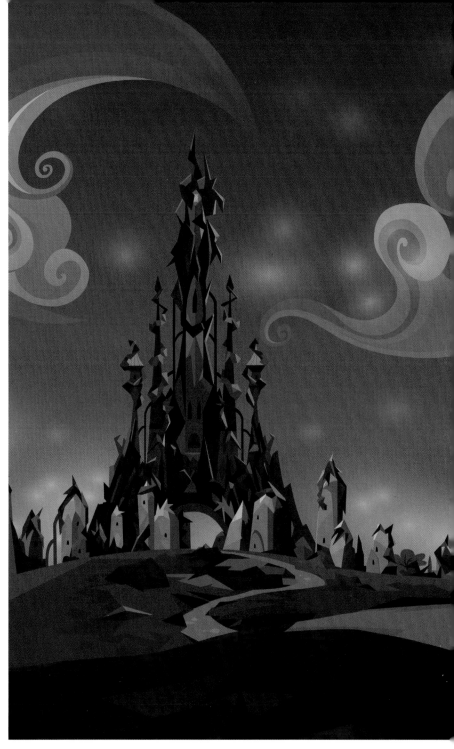

King Sombra's castle reflects his sinister appearance in its sharply pointed spires and dark, brooding palette. The color of the sky indicates a kind of smoglike haze that seems to emanate from King Sombra's dark soul.

LORD TIREK

Tirek's character is based on a centaur, whose head, arms, and chest are those of a human, and the rest of its body, including four legs, hindquarters, and a tail, is like that of a horse. Because there are no humans in *My Little Pony: Friendship Is Magic*, his head Is more bull-like, with a goat's shaggy whiskers.

The nemesis in Season 4's "Princess Twilight Sparkle" episodes is Tirek. How scary can you get? I go as scary as I can, then we take a look and say, okay, maybe that's too scary. I have a ten-year-old daughter and really bounce a lot of this stuff off of her. She'll say, "That's too scary" or "That's not scary enough," or "That's funny" or "That's not funny." Basically, I push the limits as far as I can. Then the directors look at it, and we all decide if it's too much or too little and go from there.

—PHIL CAESAR, DHX MEDIA

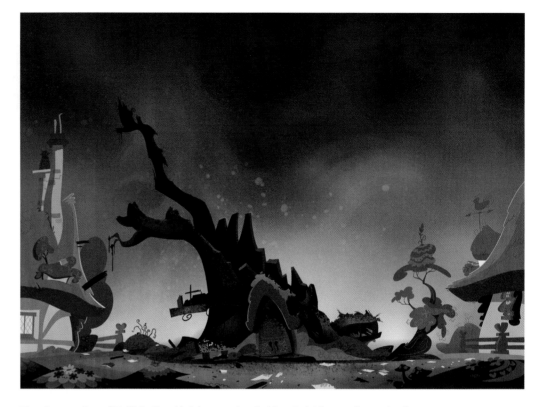

The destruction of Twilight Sparkle's home, the Golden Oak Library, dramatically demonstrates Tirek's destructive powers.

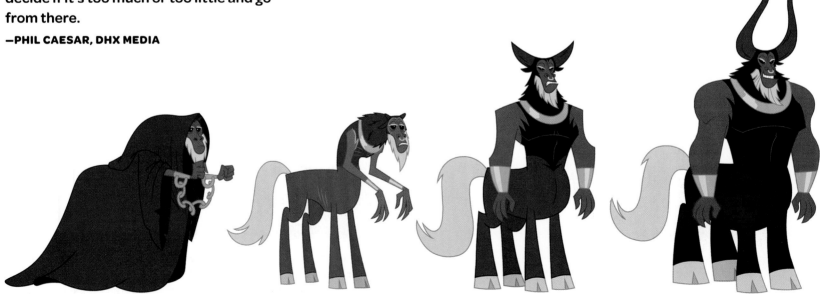

The artists at DHX take a first pass at color for character designs and then send to Hasbro Studios for review. Initially, Tirek's body was almost entirely red, but we felt it made him feel too scary, which is saying a lot because his design is already pretty intimidating! We suggested coloring his upper body black, which helped tone down the intensity and had the added benefit of drawing your eye to the most expressive parts of his body: the face and arms.

—BRIAN LENARD, HASBRO STUDIOS

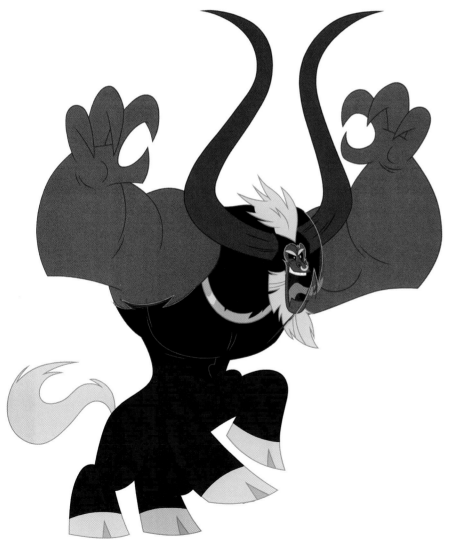

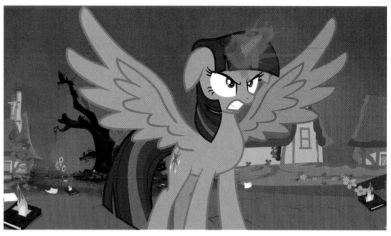

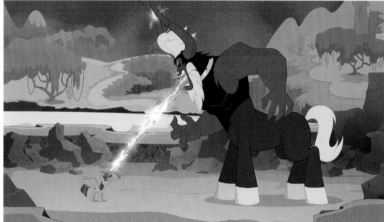

The battle between Tirek and Princess Twilight initially seems unbalanced based on size and physical strength. But Princess Twilight Sparkle has more magical power than either she or Tirek realizes until the end of the episode.

STARLIGHT GLIMMER

Starlight Glimmer is the antagonist for the Season 5 opener, and she plays a very important role going forward. She is convinced that Cutie Marks cause disharmony and that everyone having different degrees of ability makes ponies unable to be proper friends. She believes it's important that no one be more special than anyone else; she's all about everyone being equal. She has a talent for magic as well and is a proto-Twilight character. Her colors parallel Twilight Sparkle's for that reason.

—JIM MILLER, DHX MEDIA

From the Season 5 premiere: Starlight Glimmer is a perfectly pleasant-looking unicorn living in a perfectly ordinary little town. But this pony's idea of a perfectly equal society spells big trouble for the Mane Six.

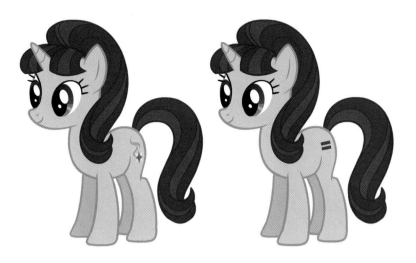

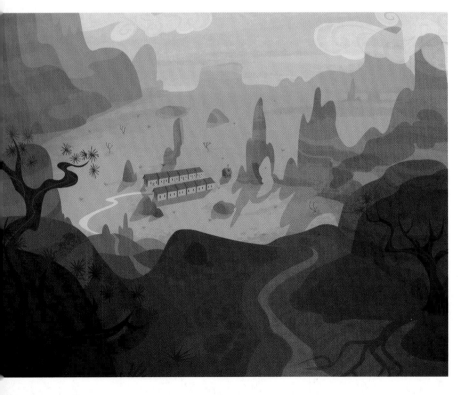

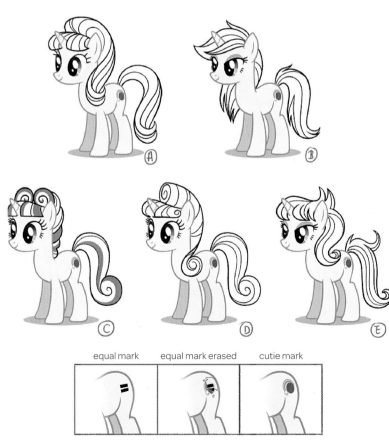

equal mark equal mark erased cutie mark

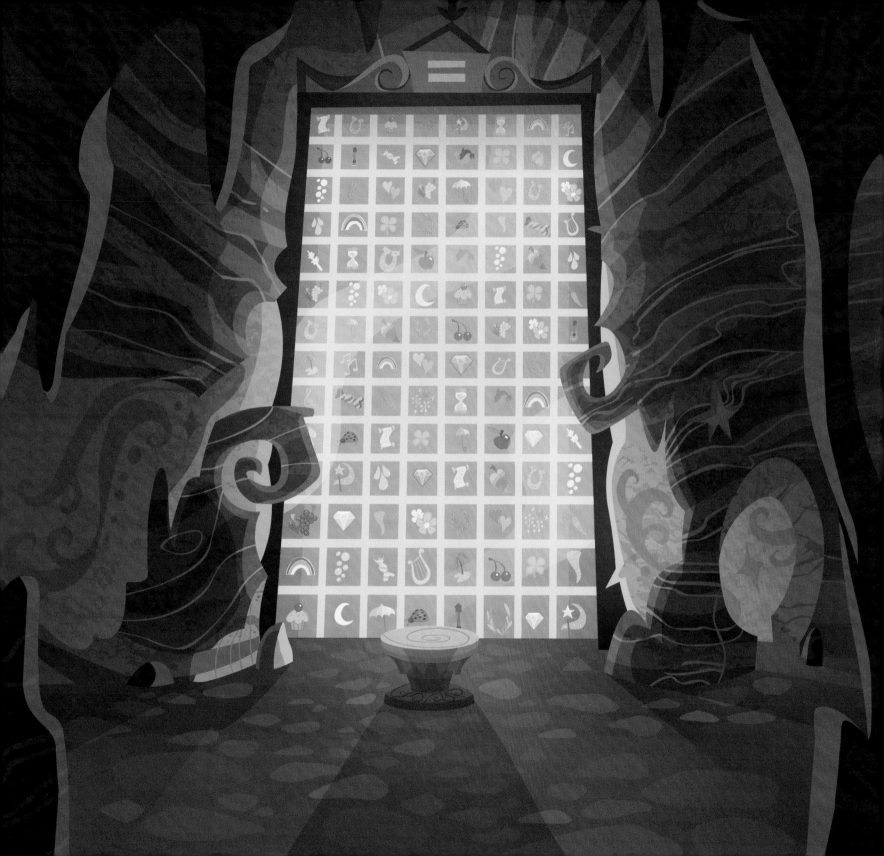

4

CREATURES & MYTHICAL BEASTS

CERBERUS AND ORTHROS

Designing characters that are based on preexisting models gives a springboard to jump off from creatively, but it doesn't solve the question of how a creature will move when it's animated. It's a particular concern when it involves a beast with more than one head, like Cerberus and Orthros.

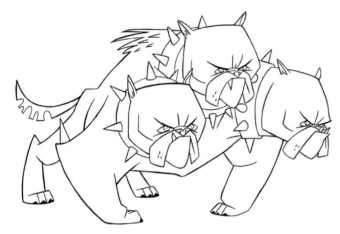

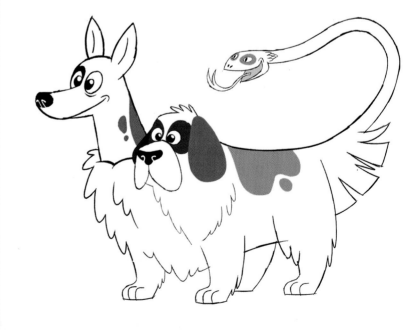

CHIMERA

The overall design of a creature like the Chimera creates the need for balancing the silhouette, or overall shape, of the character. The chimera's tail keeps this creature's design from feeling too top-heavy, where the shapes are largest and the focus is primarily on the faces.

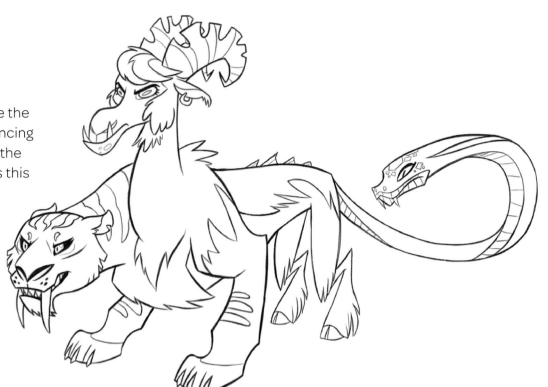

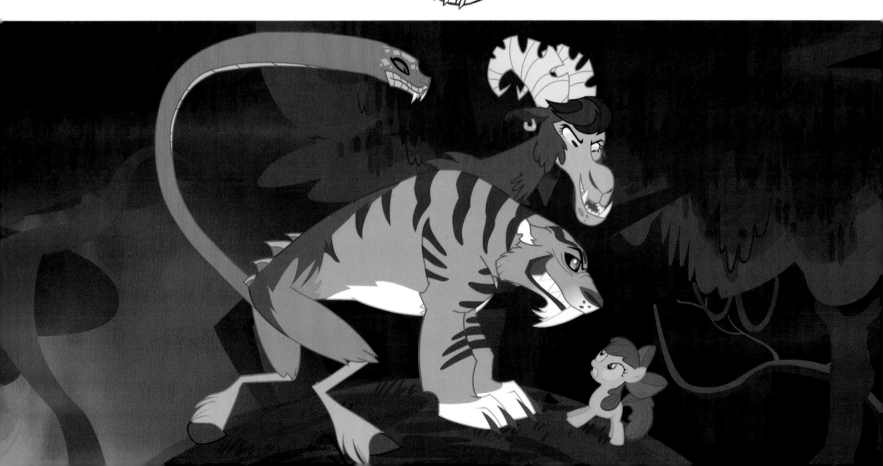

MINOTAUR AND URSA MAJOR

Designing a character with an upside-down triangle for its torso typically indicates power and strength. The motivational Minotaur, Iron Will, is purposely built top-heavy to suggest that he might be more brawn than brains.

With creature design, a lot of it is influenced by mythology—so these things already have kind of an iconic look, and Rebecca and her team take those ideas and build on them to make them fit the world.

—JIM MILLER, DHX MEDIA

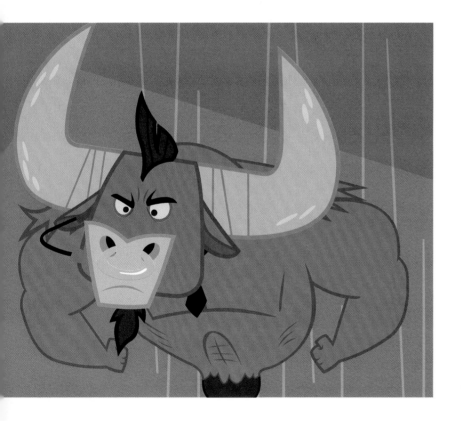

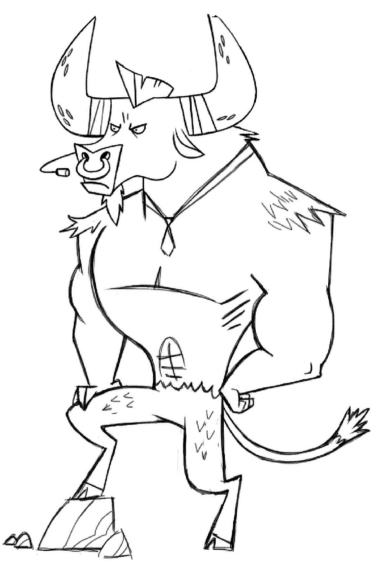

The Ursa Major is one of the largest creatures in Equestria. Her color, body gestures, and facial expressions take much of the menace away from the ferociousness of her sharp claws and teeth.

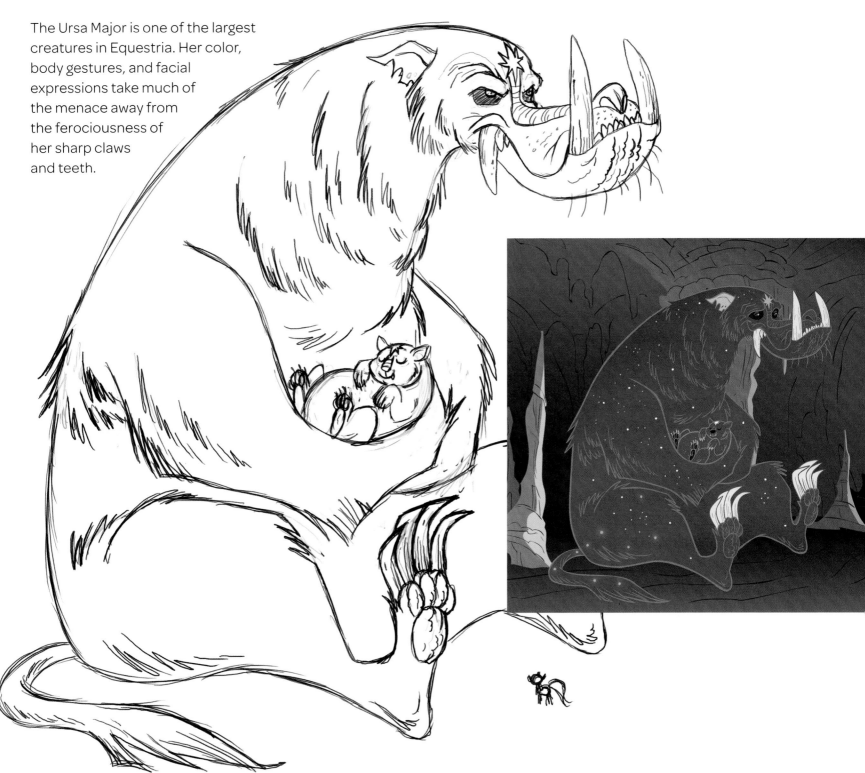

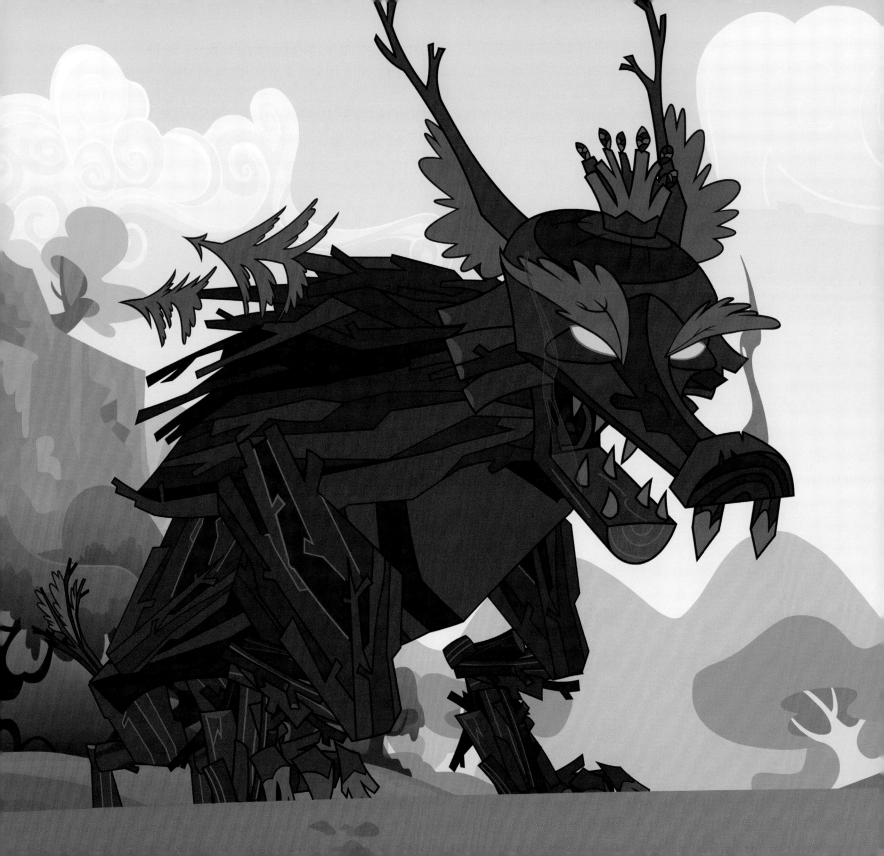

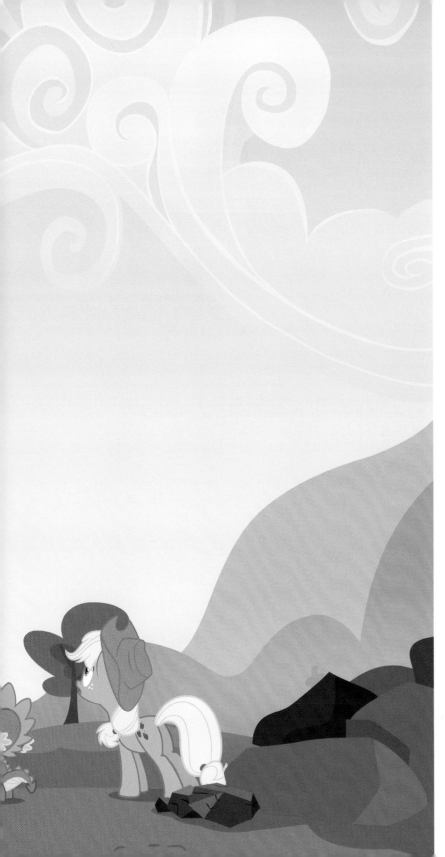

TIMBERWOLF

The Timberwolf is essentially a dog made of wood. What makes the translation more menacing is the sharp geometry of the shapes, as well as the overall size of the creature in relationship to a pony.

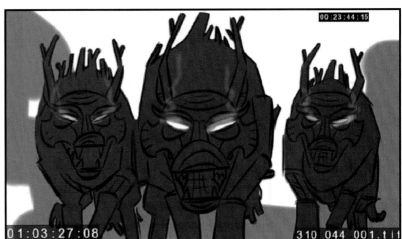

The Timberwolves' appearance is made more menacing by their size and machinelike structure.

SEA SERPENT

While the Sea Serpent presents an obstacle to the ponies' quest, his expressive face and whimsical hair design reflect the unexpected humor he lends to the story. In 2013, his character was released in a figurine set by Hasbro, in which he bears the name Steven Magnet.

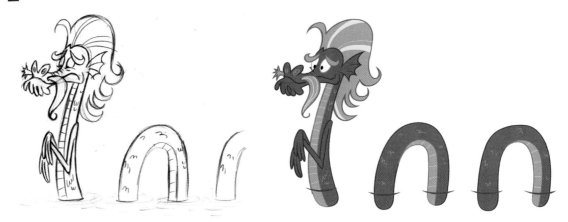

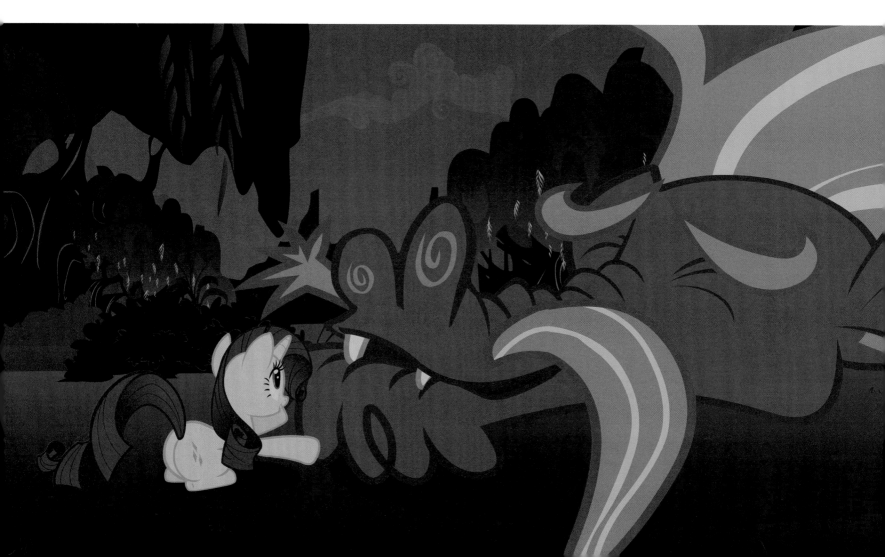

CRAGADILE

The Cragadile is the most realistic of these creatures, and its appearance is more likely to be menacing than those of its aquatic counterparts.

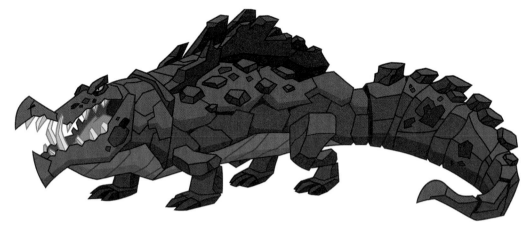

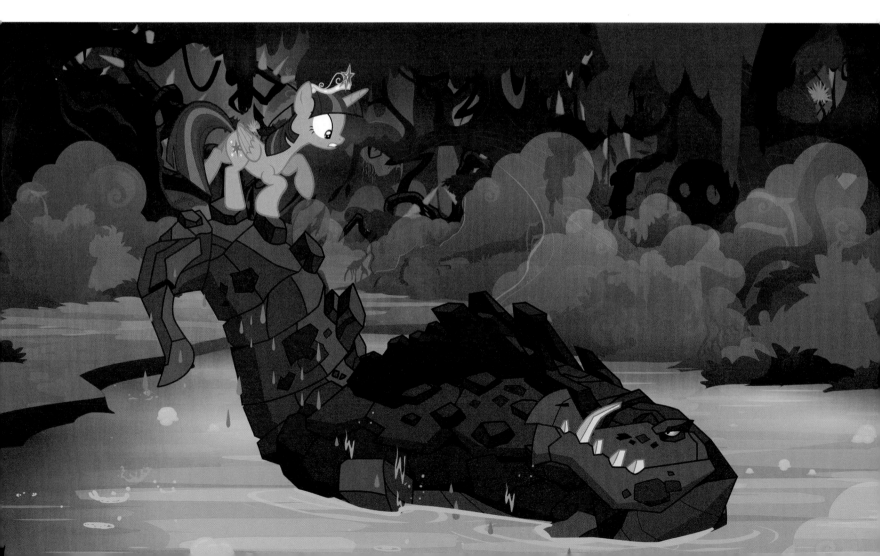

HYDRA

Because the Hydra is vibrantly colored and drawn with more cartoon-like features and curving shapes, it appears far less frightening than its aquatic neighbors.

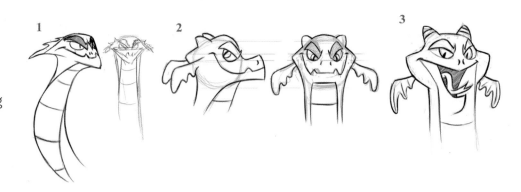

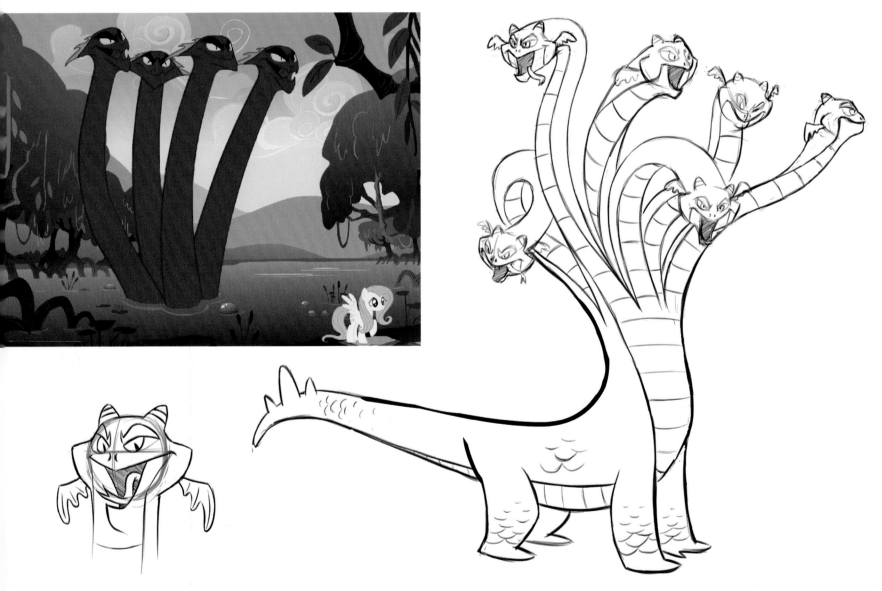

QUARRAY EEL
AND TATZLWURM

Although the Quarray Eel is drawn with sharp teeth and a large jaw, its vibrant colors lessen the fear factor.

The Tatzlwurm's design changed in the early stages of development from a creature that looked too much like a sea serpent to something resembling a worm.

How scary a creature is can be changed by color. Something that is drawn very scary, when colored lighter or more vibrantly, can be less frightening. If you take a horrible monster and make him pink, it seems less scary.

—REBECCA DART, DHX MEDIA

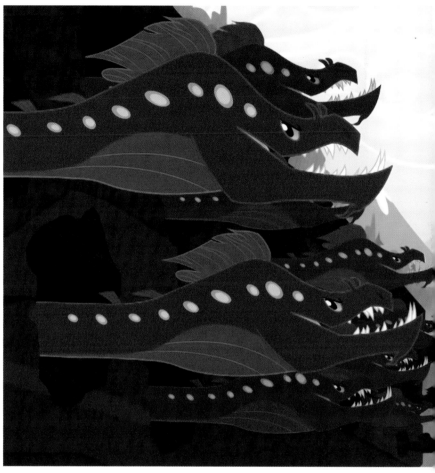

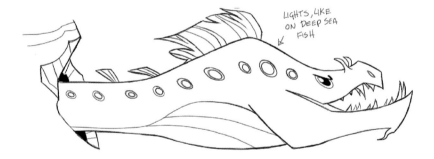

LIGHTS, LIKE ON DEEP SEA FISH

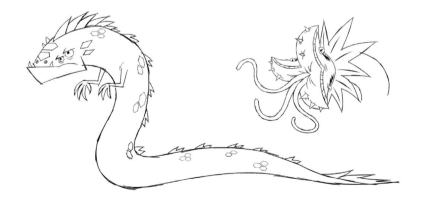

COCKATRICE

The Cockatrice is a combination of a dragon and a rooster. When a creature is made of two types of animal characters, blending the different characteristics of each animal to make it a more believable invention is generally the rule in character design.

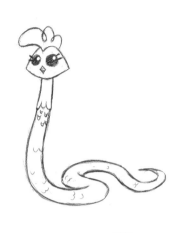
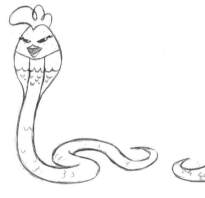
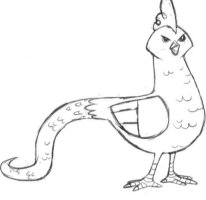

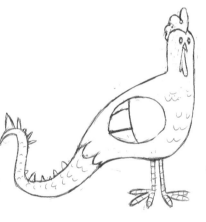
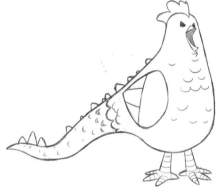
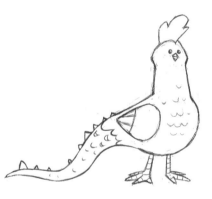
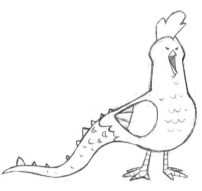

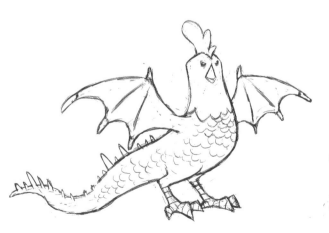
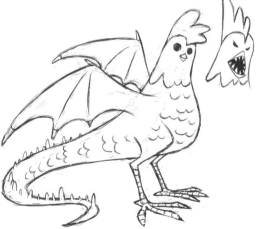
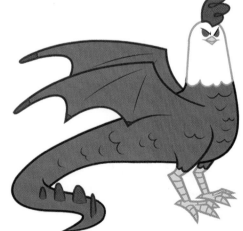

PARASPRITE AND BUGBEAR

Designing a character with wings that need to be animated means paying close attention to the potential movement of the wings as the character flies. The Parasprites display wings that could believably carry them when they fly. Bugbear looks less frightening because of its ineffective-looking, extremely tiny wings.

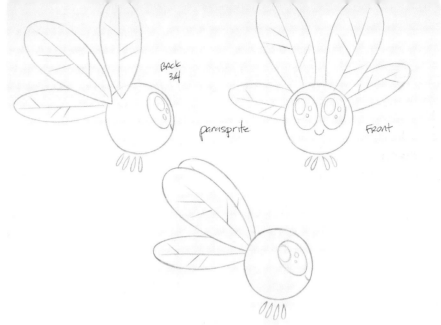

BACK 3/4

parasprite

Front

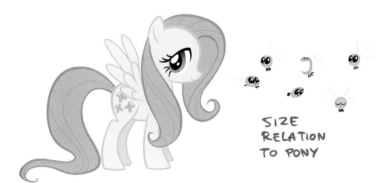

SIZE RELATION TO PONY

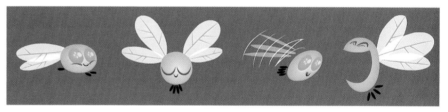

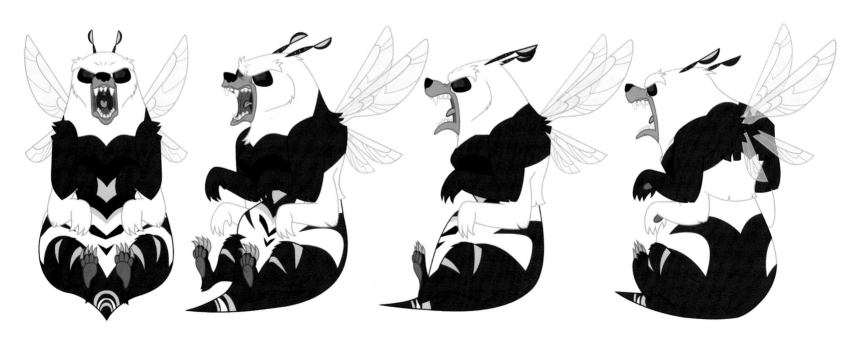

MANTICORE AND DRAGON

The Manticore was explored by Lynne Naylor in a variety of iterations, with the final result meant to show a silly yet fierce demeanor. His sharp, pointed wings are countered by his round mane and curved anatomy. The dragons of *My Little Pony* are based on traditional dragon designs, but have a twist toward the show's humor, with exaggerated noses and large heads resting on exceptionally skinny necks. Lauren Faust's original dragon design is more suggestive of an elegant, even beautiful creature resembling the pony characters.

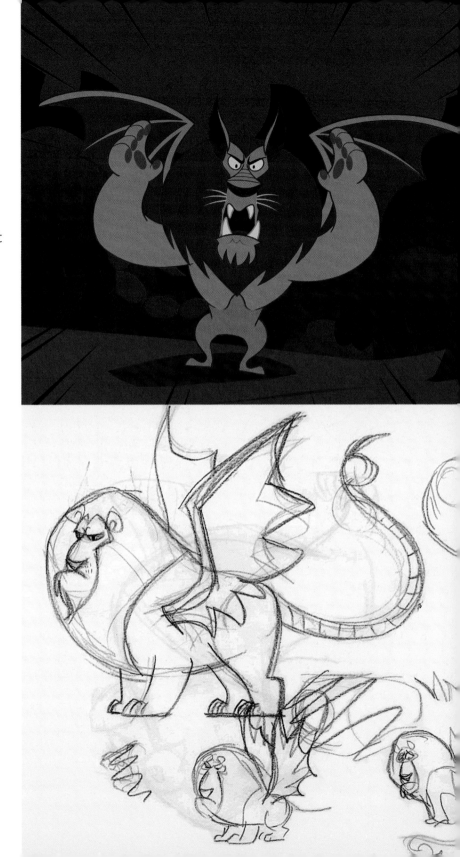

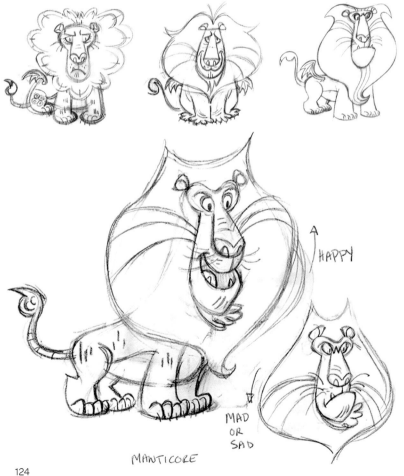

HAPPY

MAD
OR
SAD

MANTICORE

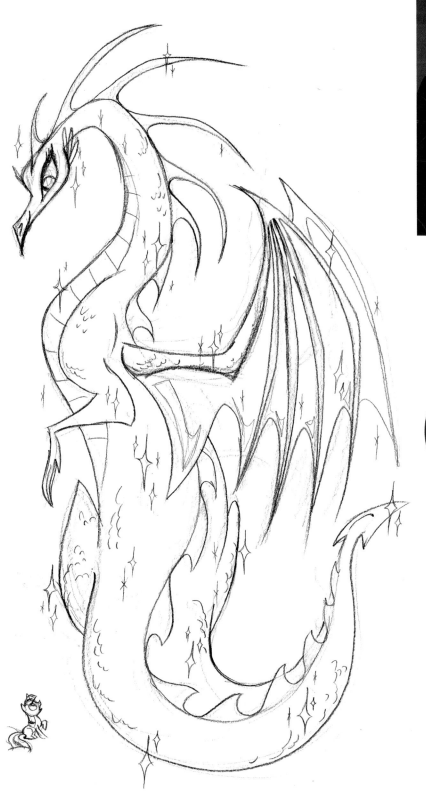

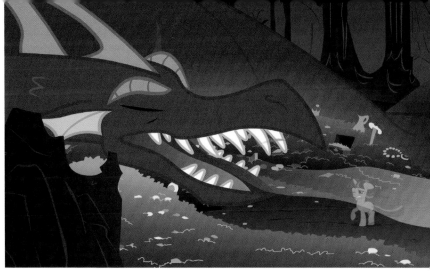

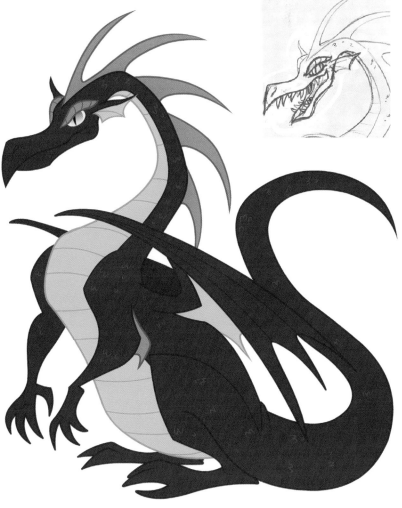

ARIMASPI THE CYCLOPS AND THE GRIFFONS OF GRIFFONSTONE

In the Season 5 script "The Lost Treasure of Griffonstone," there's a Cyclops that's described, and in mythology it's a human character. We can't draw human characters, so we had to try to come up with a character that was a Cyclops that also worked within the pony world. Since it takes place in the mountains, I sort of made the character half mountain gorilla and half mountain goat.

—REBECCA DART, DHX MEDIA

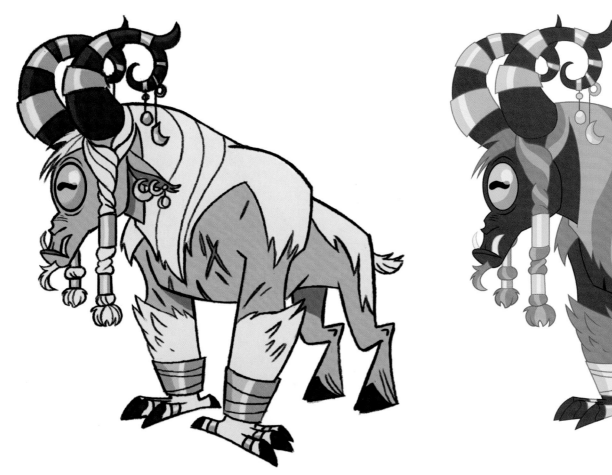
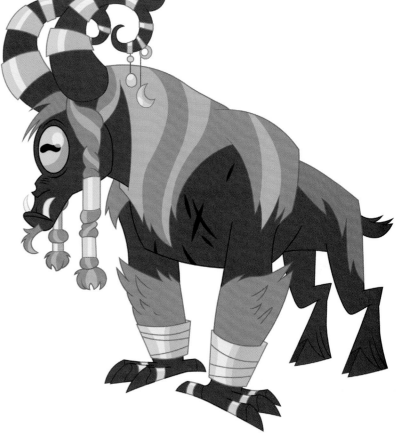

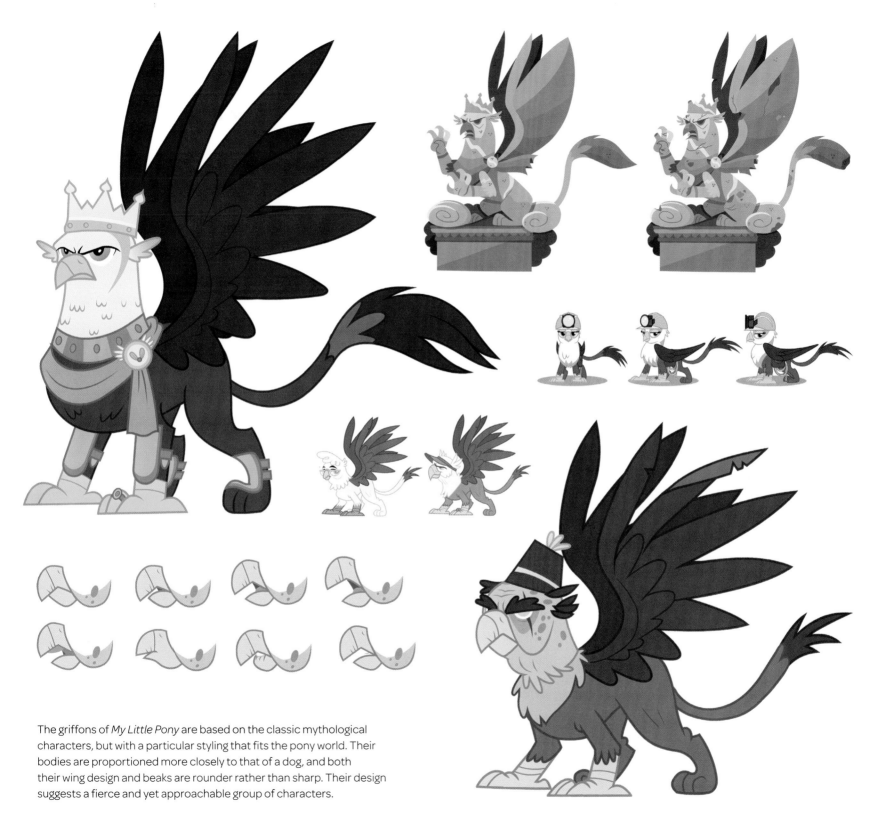

The griffons of *My Little Pony* are based on the classic mythological characters, but with a particular styling that fits the pony world. Their bodies are proportioned more closely to that of a dog, and both their wing design and beaks are rounder rather than sharp. Their design suggests a fierce and yet approachable group of characters.

An illustrated history of Griffon-stone from Season 5, Episode 8, in the style of *Bygone Griffons of Greatness*.

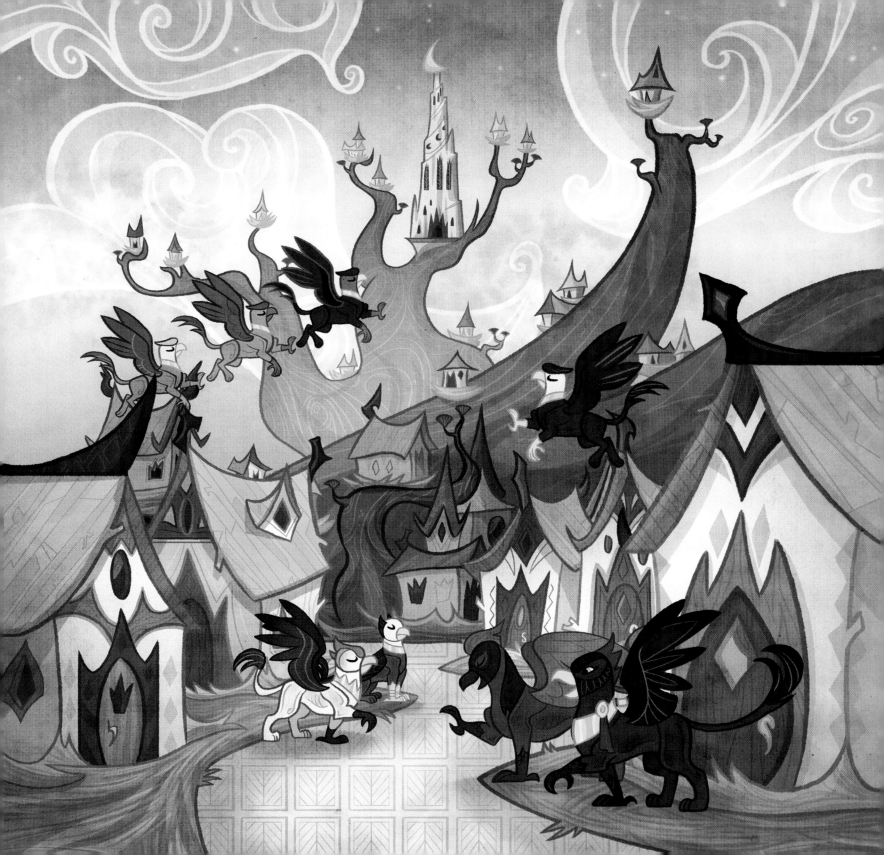

THUNDER HOOVES
AND LITTLE STRONG HEART

In creating characters for "Over a Barrel" (Season 1, Episode 21) that are based on real animals, designers studied the body shape, proportions, and movements of buffalo. It took many more drawings and variations on facial features, stylization, and overall balance of body shape to land the right combination for Chief Thunderhooves. The facial structure tells so much about the content of his personality—changing the nose shape and its relationship to the eyes creates very different impressions.

Little Strongheart went through a few iterations, with the final result suggesting more of a baby calf than a buffalo.

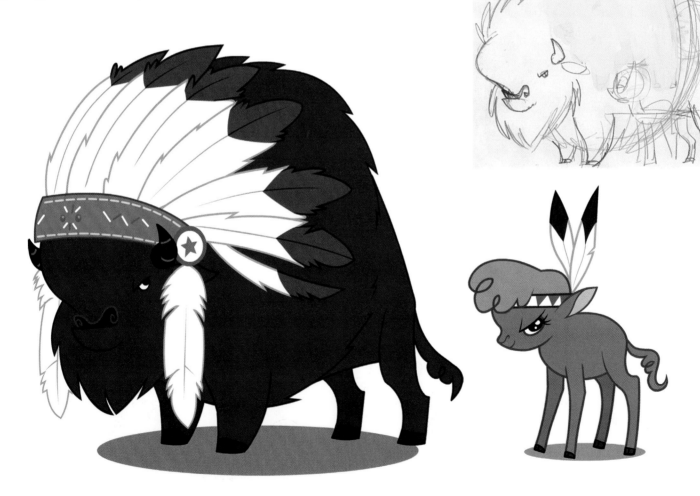

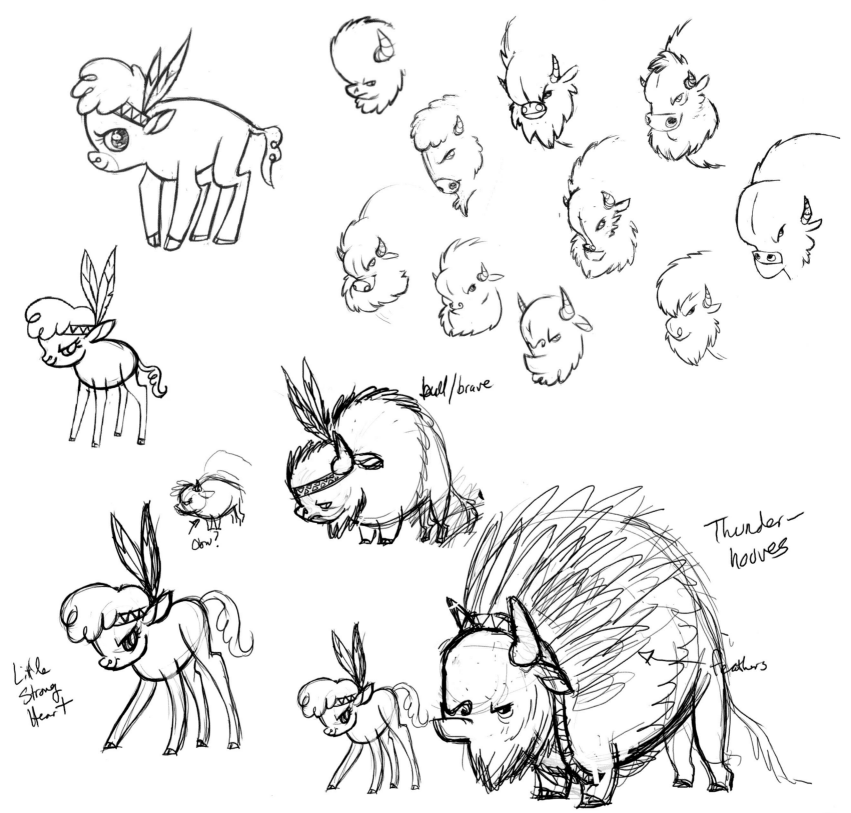

bull/brave

Thunder-
hooves

Little
Strong
Heart

Oow?

feathers

131

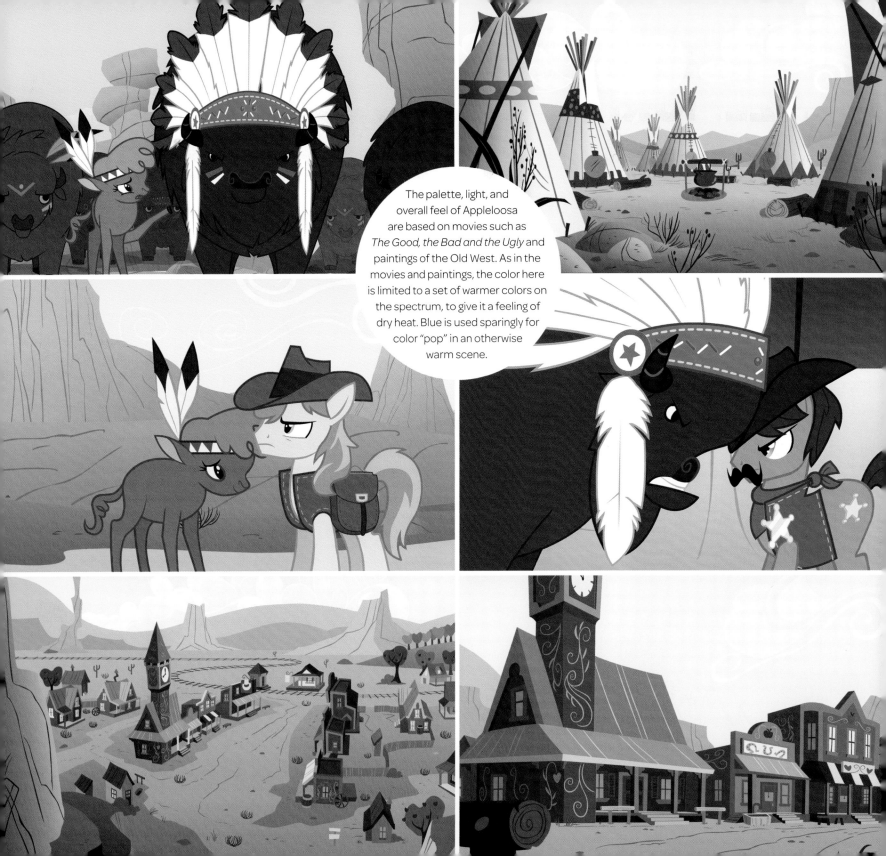

The palette, light, and overall feel of Appleloosa are based on movies such as *The Good, the Bad and the Ugly* and paintings of the Old West. As in the movies and paintings, the color here is limited to a set of warmer colors on the spectrum, to give it a feeling of dry heat. Blue is used sparingly for color "pop" in an otherwise warm scene.

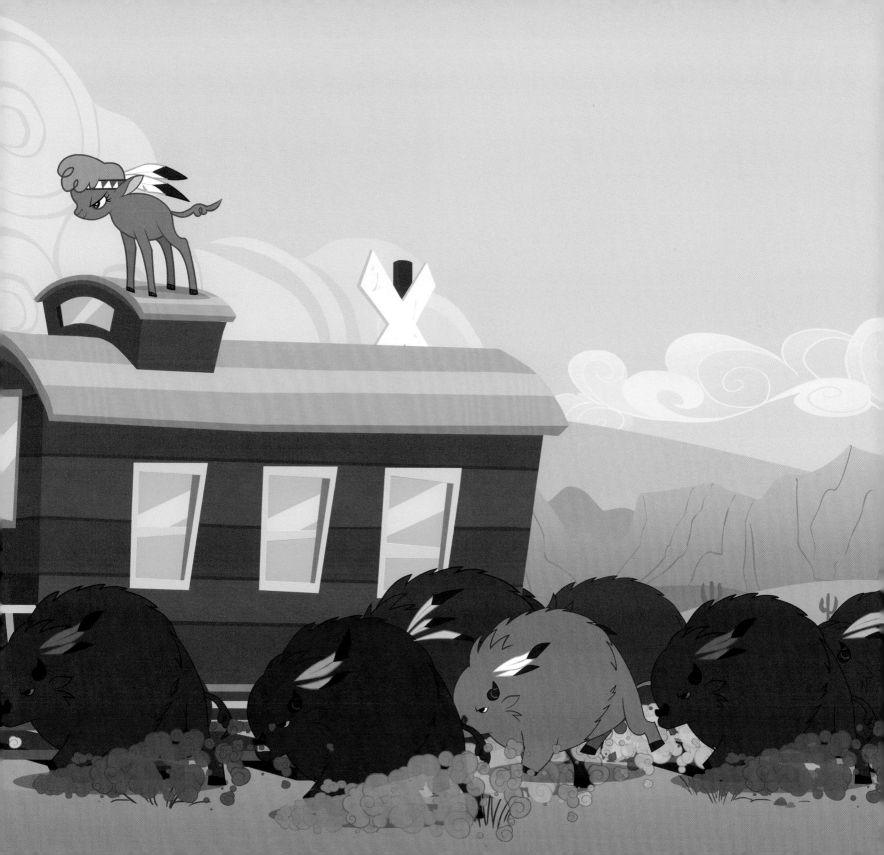

BREEZIES

The Breezies are magical creatures modeled after classic fairies from fairy-tale lore, combined with some of the features and expressions of the ponies. Their transparent wings, wee size, and rounded body form create the impression of a very delicate creature capable of being easily blown off course from home by a good gust of wind.

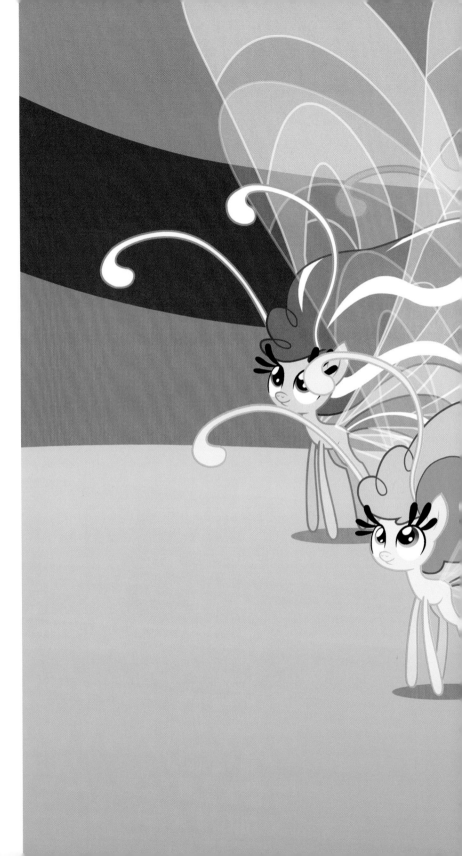

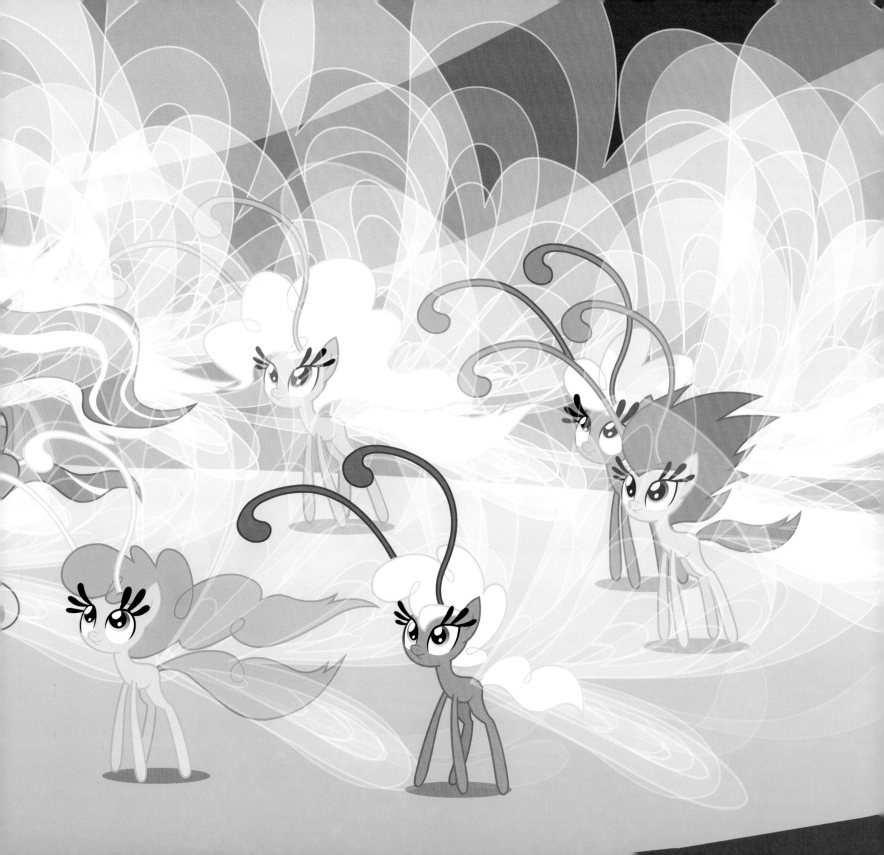

PRINCE RUTHERFORD
AND THE YAKS OF YAKYAKISTAN

The costumes and attention to detail for the Yaks of Yakyakistan provide a particular flavor of the East. The warriors' uniforms, headgear, and even their horns are adorned with patterns of the region, providing a ceremonial air and seriousness to their demeanor.

Season 5, Episode 11 explores contrast—bright color against neutral, silly against serious, and stillness against movement—to play up the humor of the story. The deadpan expression of Prince Rutherford creates an ironic and amusing contrast to the balloons tied to his antlers.

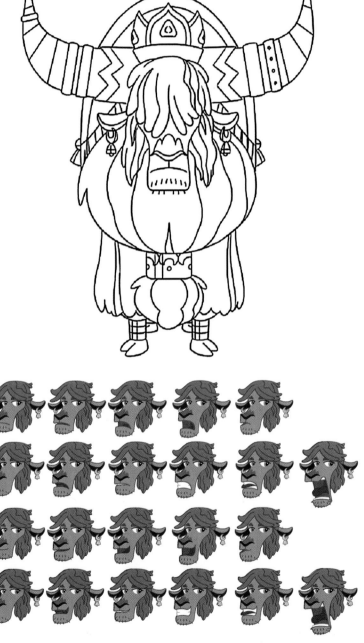

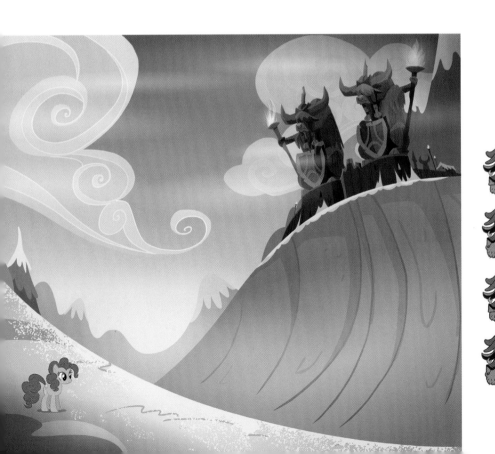

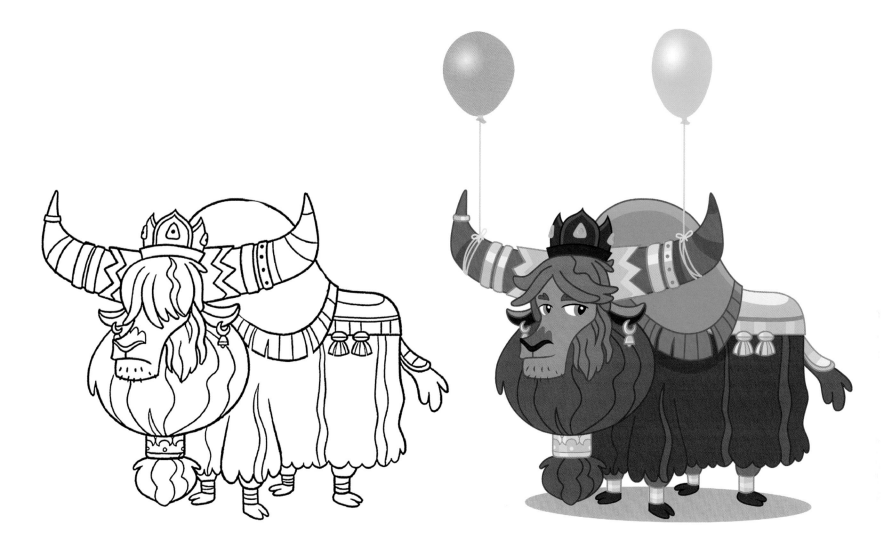

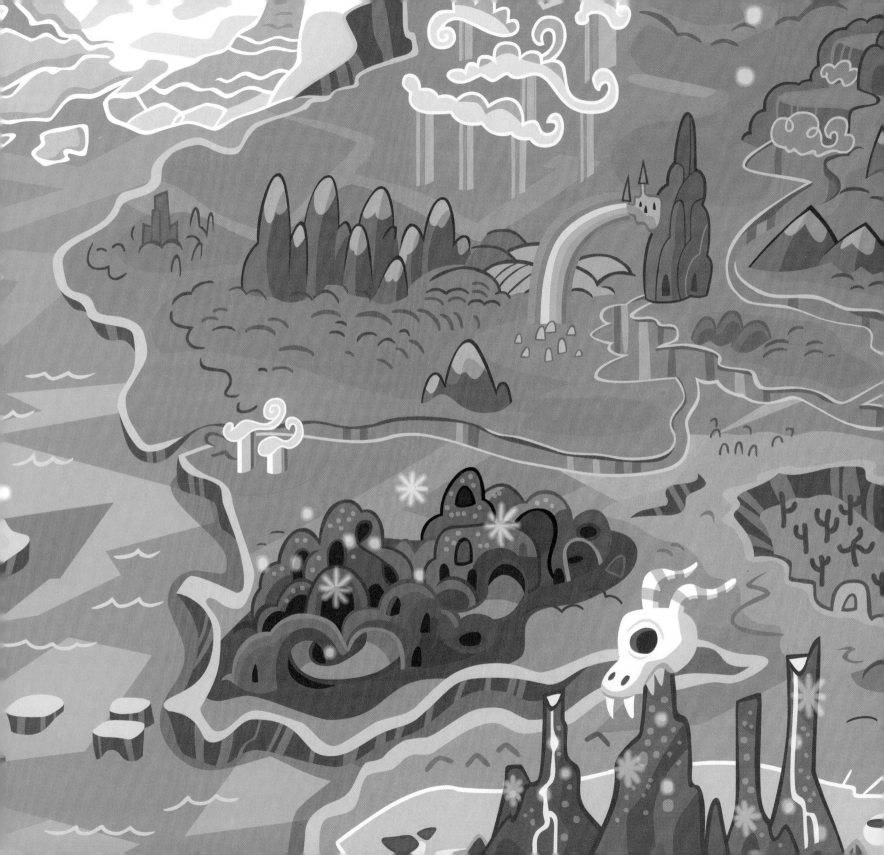

5

EXPLORING EQUESTRIA

EARLY DEVELOPMENT ART

Martin Ansolobehere and Paul Rudish, who had previously worked with Lauren Faust, developed the first versions of pony locations, the color palette, and character designs. Each brought a personal sensibility to the emerging world, with the result being a visual collaboration that gave *My Little Pony: Friendship Is Magic* its own unique style.

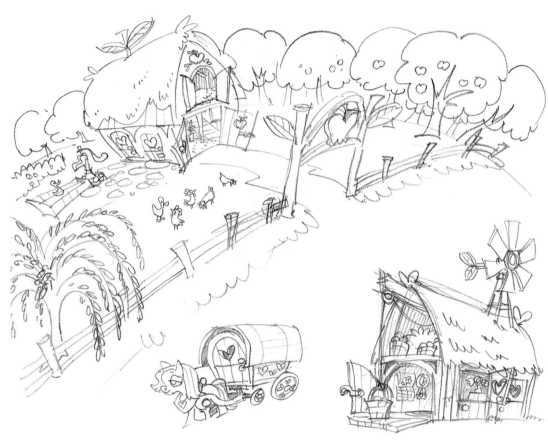

The original style development of the pony world was influenced by Pennsylvania Dutch design, steampunk fantasy art, old European fairy tales, and Bavarian folk art.

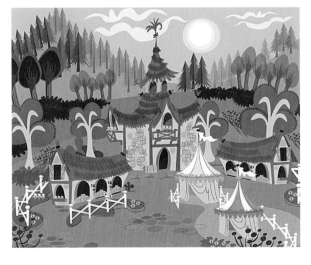

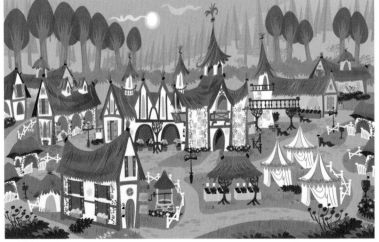

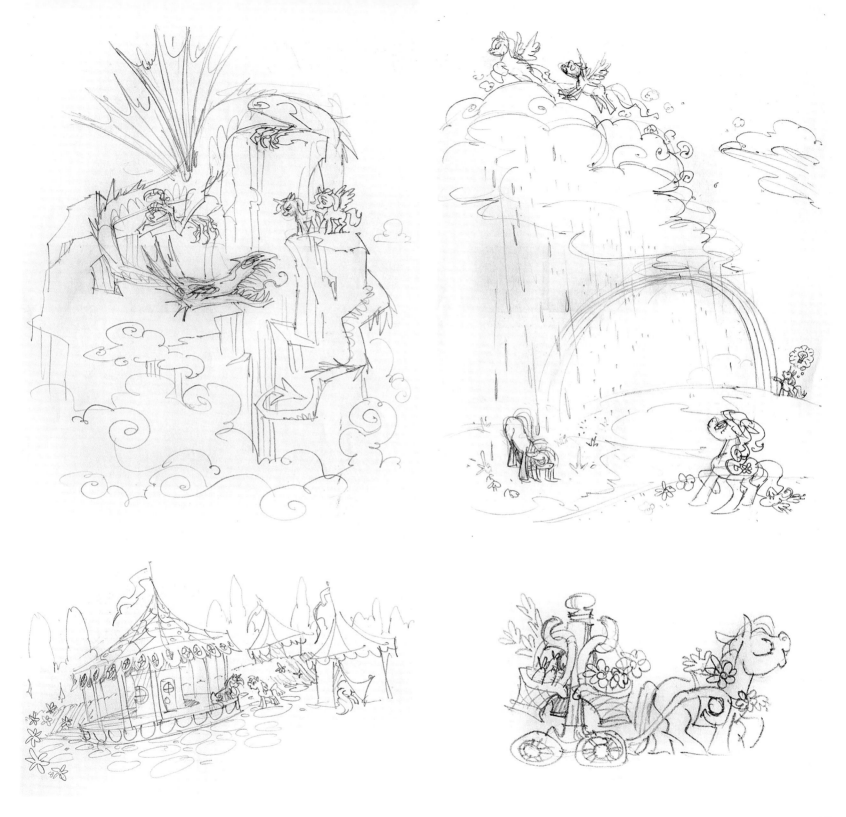

PONYVILLE

Ponyville's more celebrated residents include Twilight Sparkle, Spike, Pinkie Pie, Rarity, and Fluttershy. Although the decorative treatments of their home locations reflect their characters, the look and feel of Ponyville has its own style and palette.

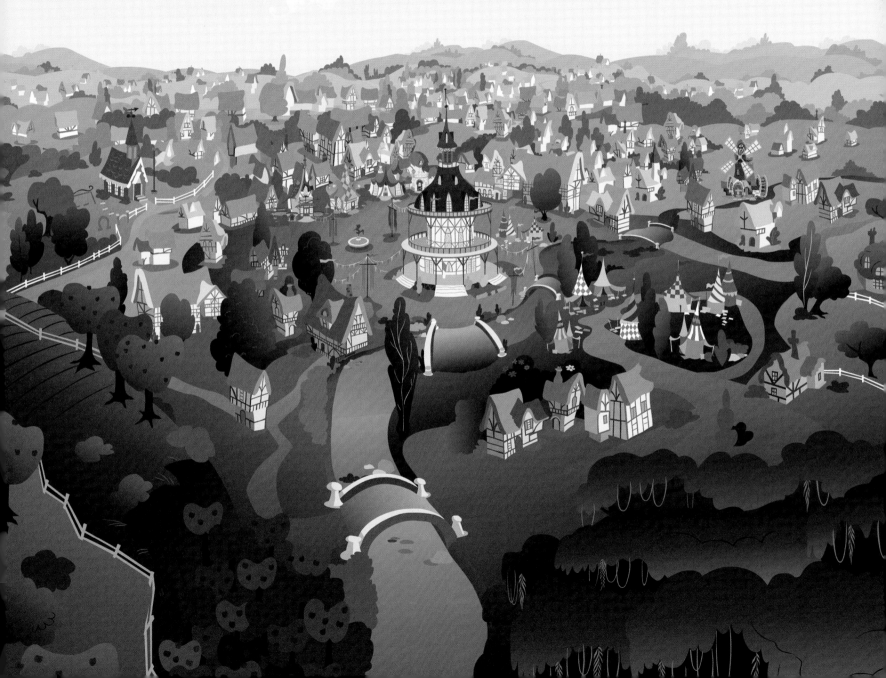

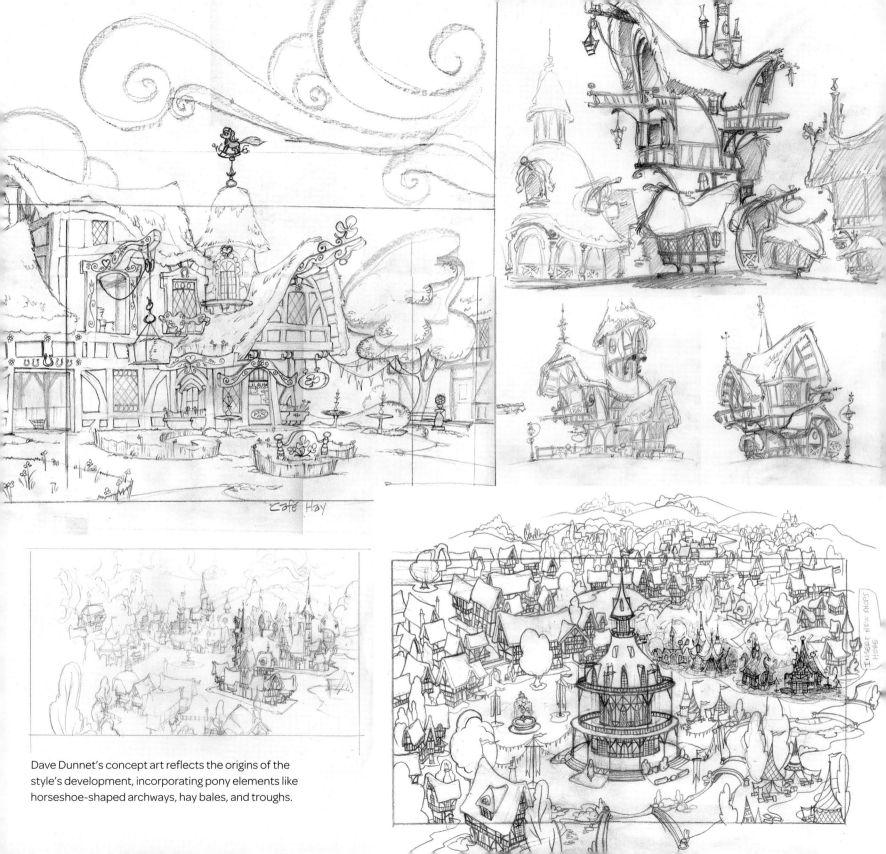

Café Hay

Dave Dunnet's concept art reflects the origins of the style's development, incorporating pony elements like horseshoe-shaped archways, hay bales, and troughs.

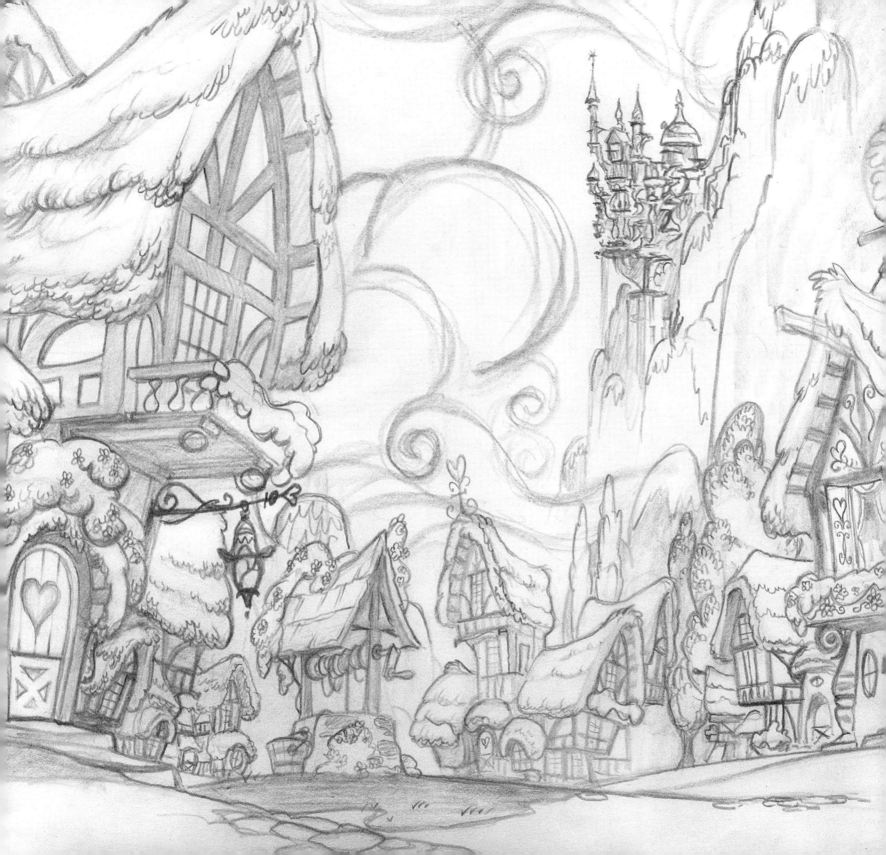

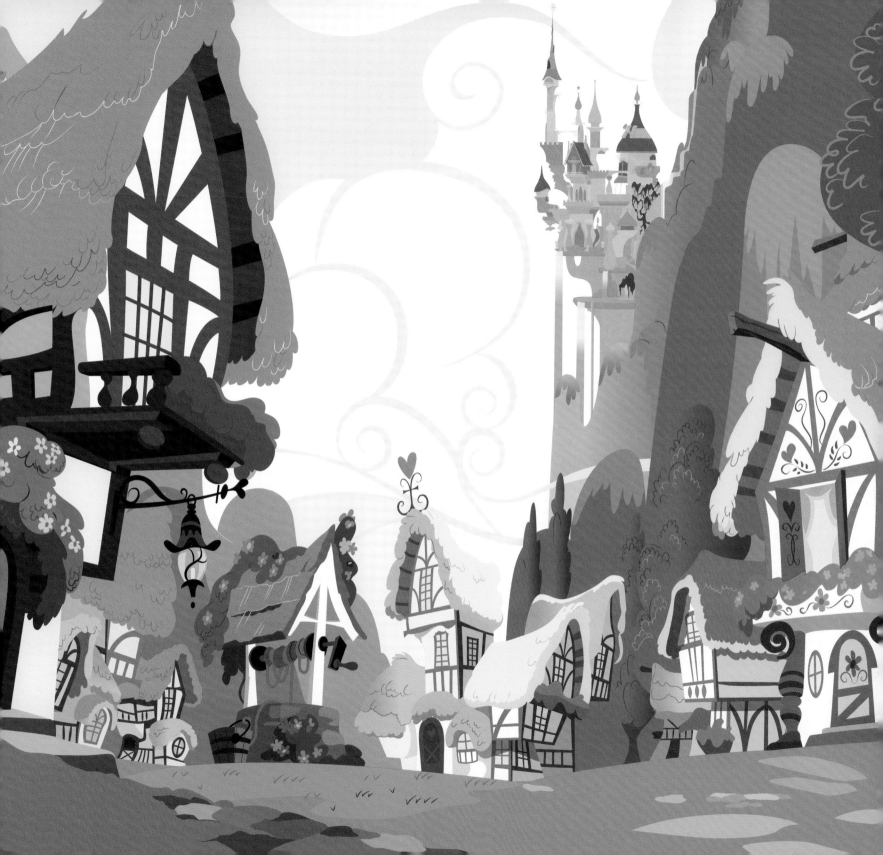

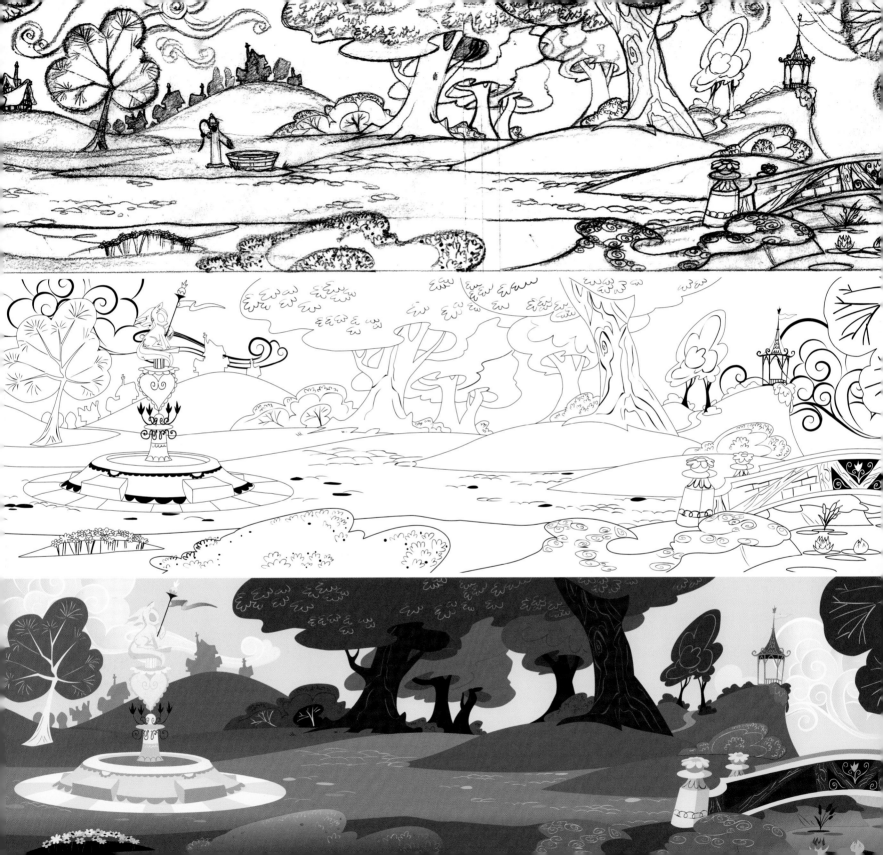

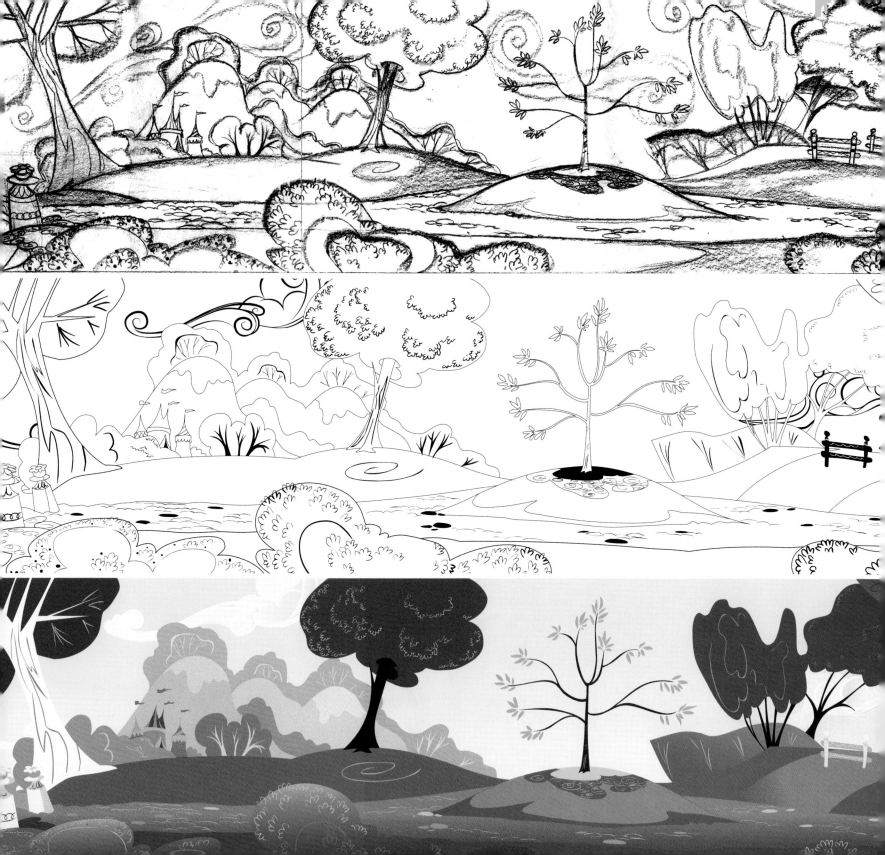

GOLDEN OAK LIBRARY

The Tree of Knowledge or the Tree of Life is a common motif in many mythologies around the world, meant to represent connection between all forms of creation and understanding. It's a fitting choice for a seeker of knowledge like Twilight Sparkle.

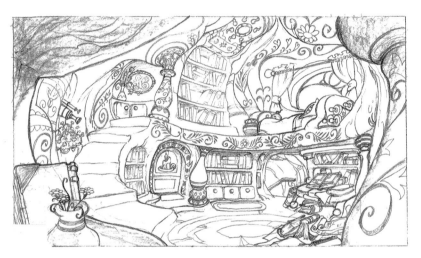
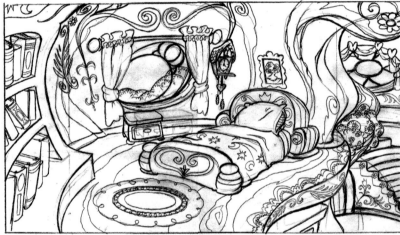
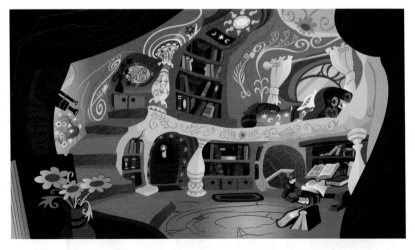
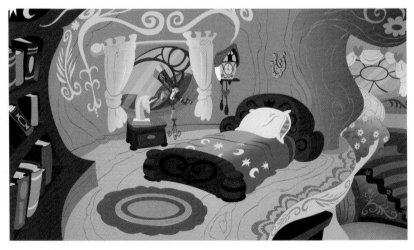

Twilight Sparkle's domain reflects her varied interests in books, the stars, magic, and a quest for knowledge. The curved, organic interior of the tree suggests a mind with its many nooks, storage cubbies, and stairways.

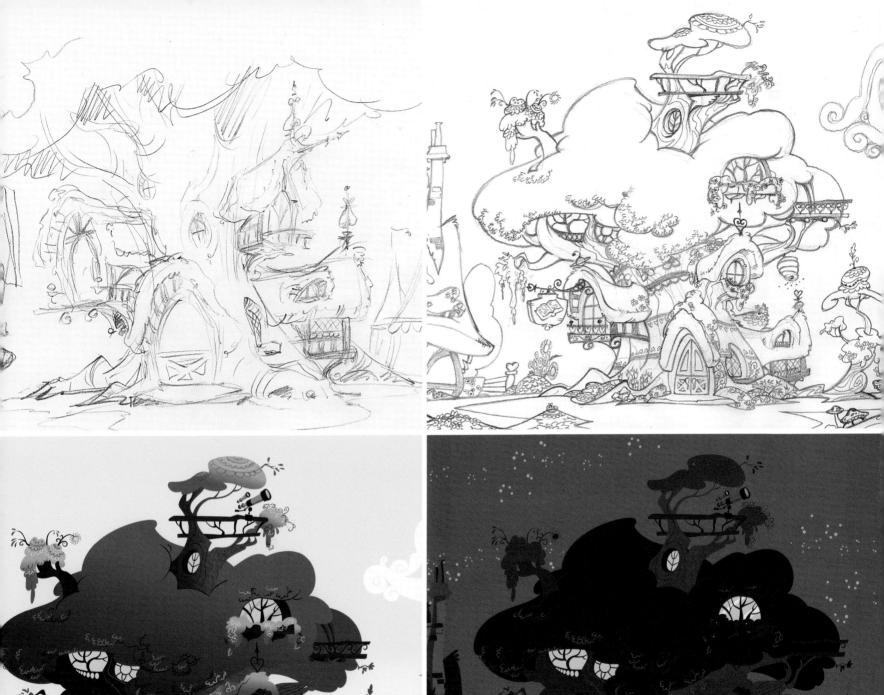

CLOUDSDALE

Cloudsdale has a kind of Greek influence, with pillars and columns. These choices are always based on the needs of the story, where we're going with the narrative, and as a team what we decide the look of that place is going to be.

—PHIL CAESAR, DHX MEDIA

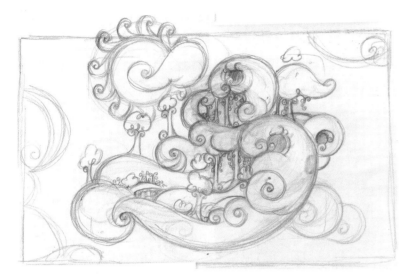

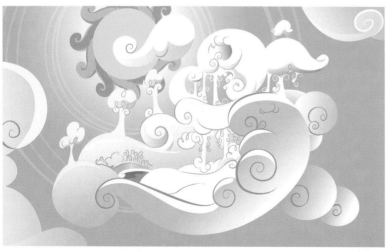

Cloudsdale, with its Greek and Roman influences, harks back to the original Olympic Games, where tests of speed and agility were showcased and celebrated—a fitting reference for Rainbow Dash.

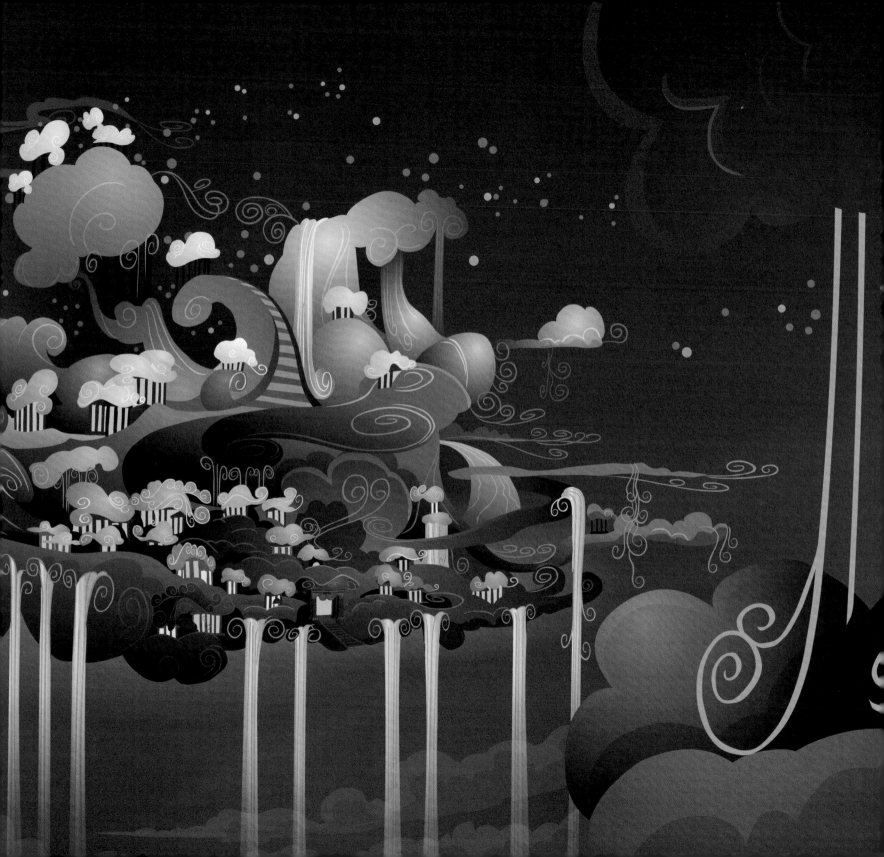

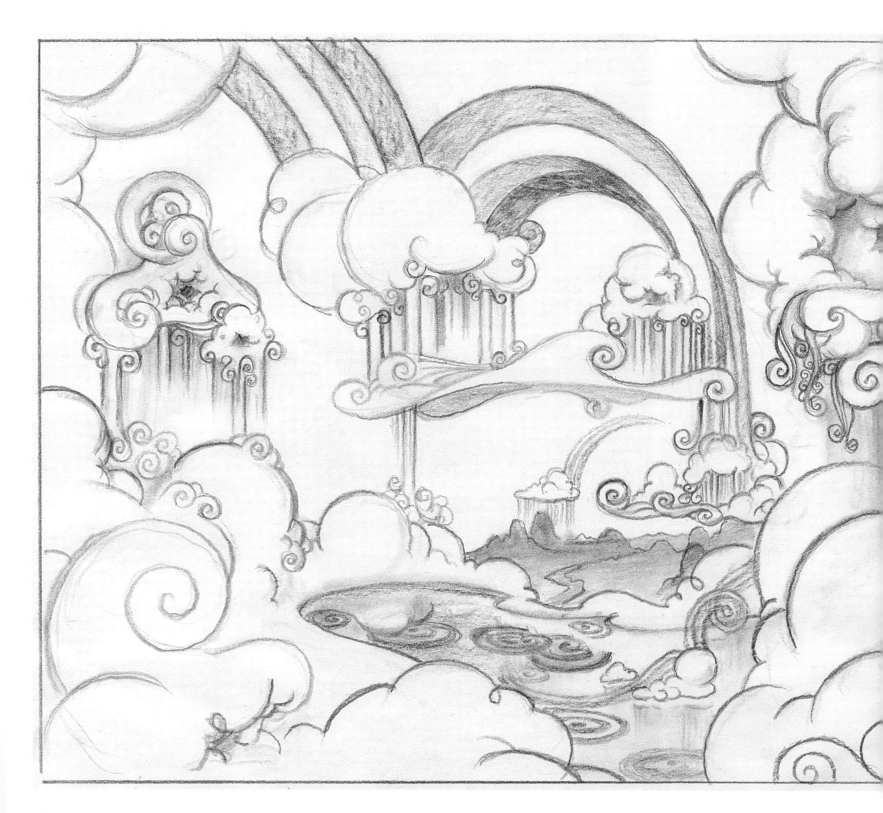

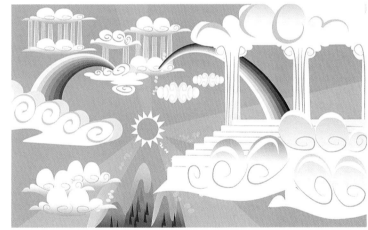

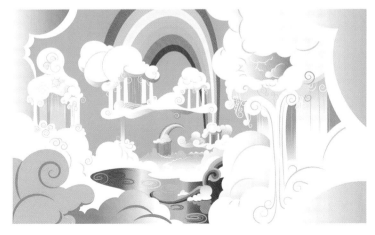

FLUTTERSHY'S COTTAGE

When I designed Fluttershy's home, I thought about the fact that she loves animals and takes care of these little creatures. Everywhere in her house, there are little stairs, like little Habitrails, because she's accommodating as many creatures as she can. There's a softness through all of her environments because she's very caring and nurturing.

—PHIL CAESAR, DHX MEDIA

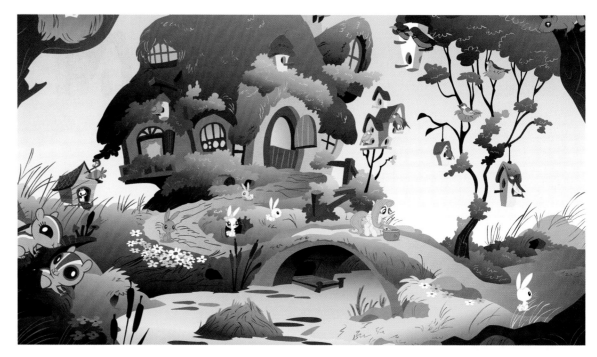

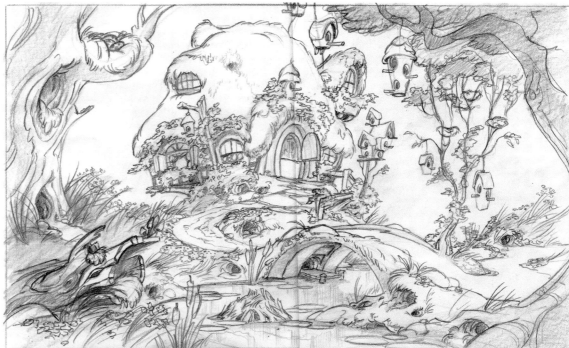

Fluttershy's cottage was designed to reflect the feeling of a country cottage where many woodland animals might make a home for themselves.

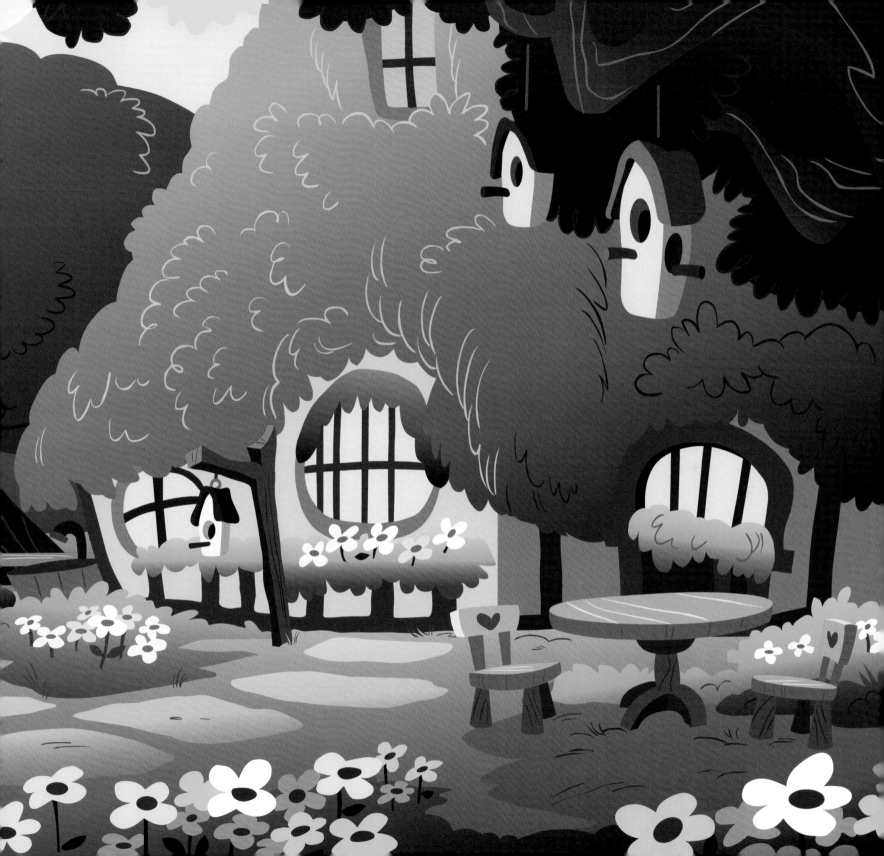

SWEET APPLE ACRES

Sweet Apple Acres, the home of Applejack and her kinfolk, has a decidedly homespun feel and apple-focused palette. The colors of Sweet Apple Acres reflect the passing of the seasons, especially appropriate for a region focused on apple picking. The development sketches by Dave Dunnet reflect a world with crisper edges and a more orderly arrangement than Ponyville.

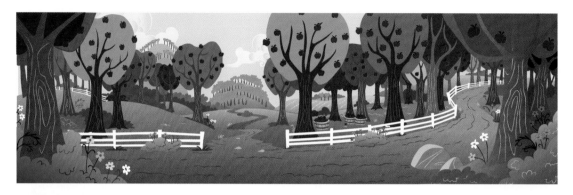

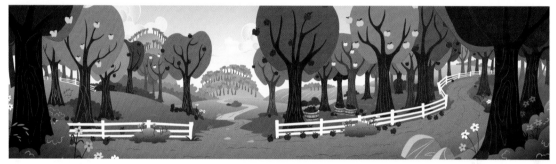

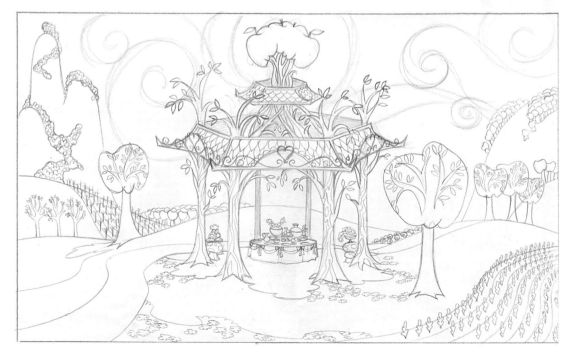

Sweet Apple Acres explores a distinct reflection of Pennsylvania Dutch motifs and designs, from the curly appliqués on the house and barn to the stylization of the trees and farmland.

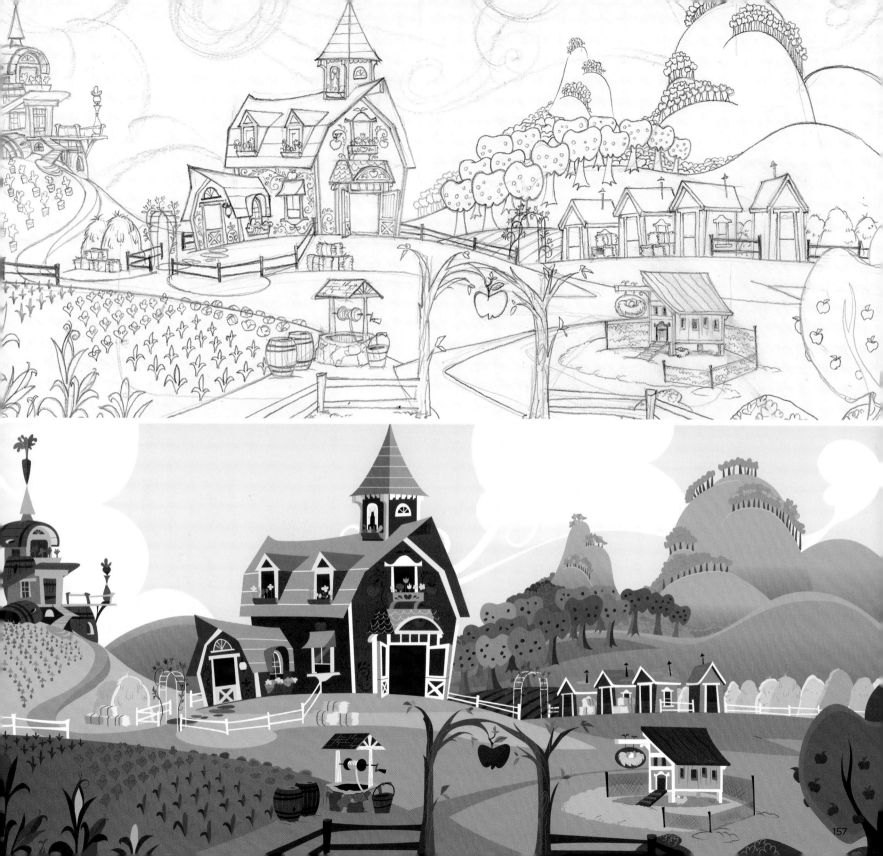

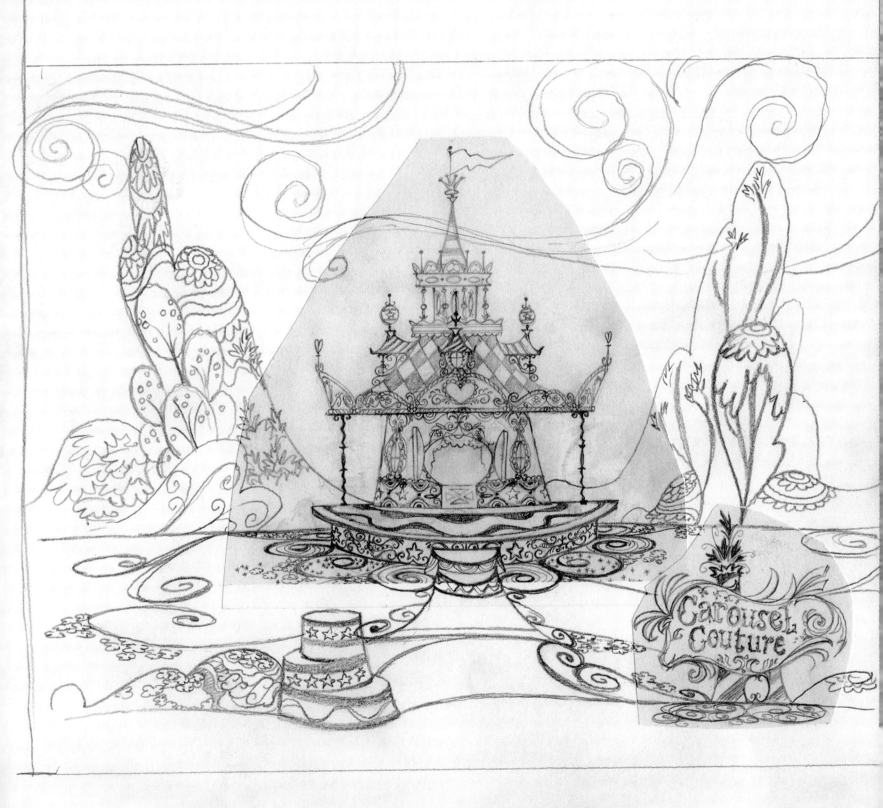

CAROUSEL BOUTIQUE

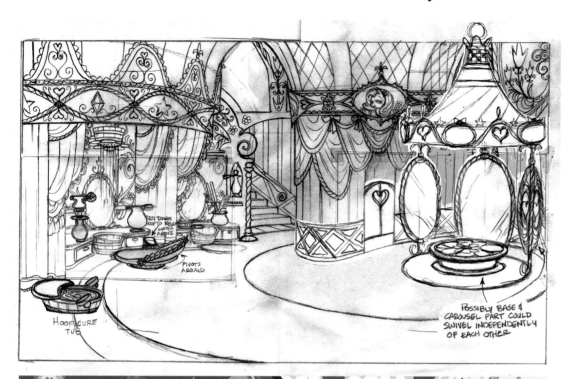

Rarity's home is designed to look not only like a carousel, but also like her as well. The windows of the boutique are reminiscent of her eyes, with half-hooded lids and long lashes resembling the shades and window shapes. Her hair design flows like the curvy decorations found at Carousel Boutique, inside and out.

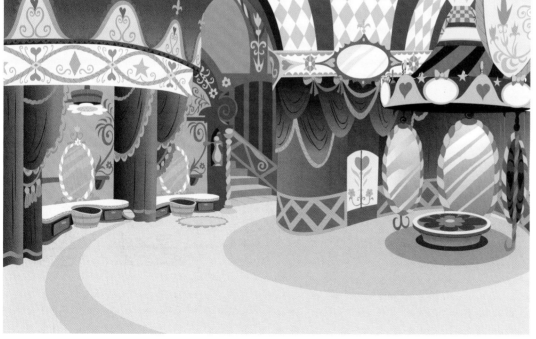

Carousel Boutique is loaded with detail and flourishes and looks less organic than the homes of the other Mane Six characters. The crispness and symmetry speak to Rarity's control and discipline as a designer remaking the world to suit her tastes.

SUGARCUBE CORNER

Sugarcube Corner looks more like a sweet dessert than an actual home. Influenced by European fairy-tale design and reminiscent of the gingerbread house in the story of Hansel and Gretel, Pinkie Pie's house feels both delicious and a little off-kilter, with its asymmetrical design reflecting Pinkie's sweet and scattered personality.

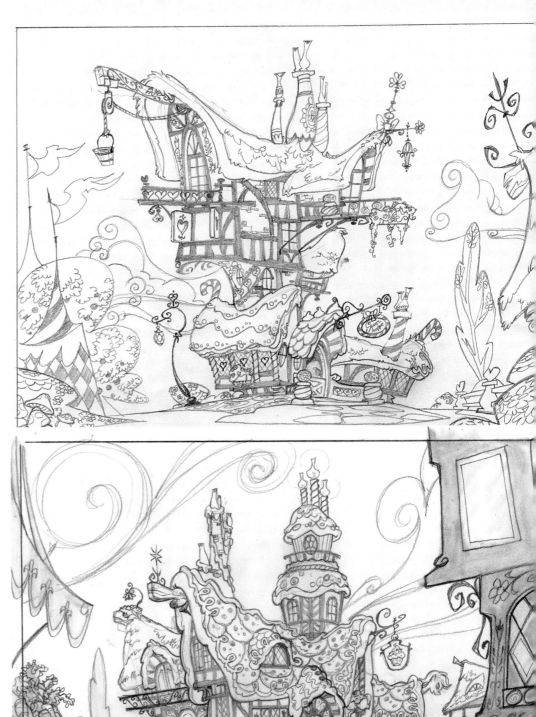

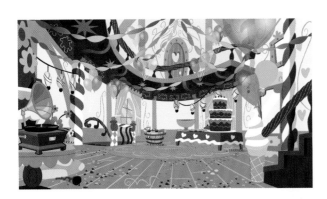

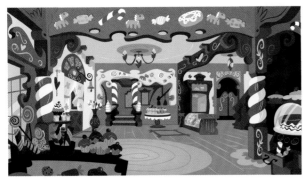

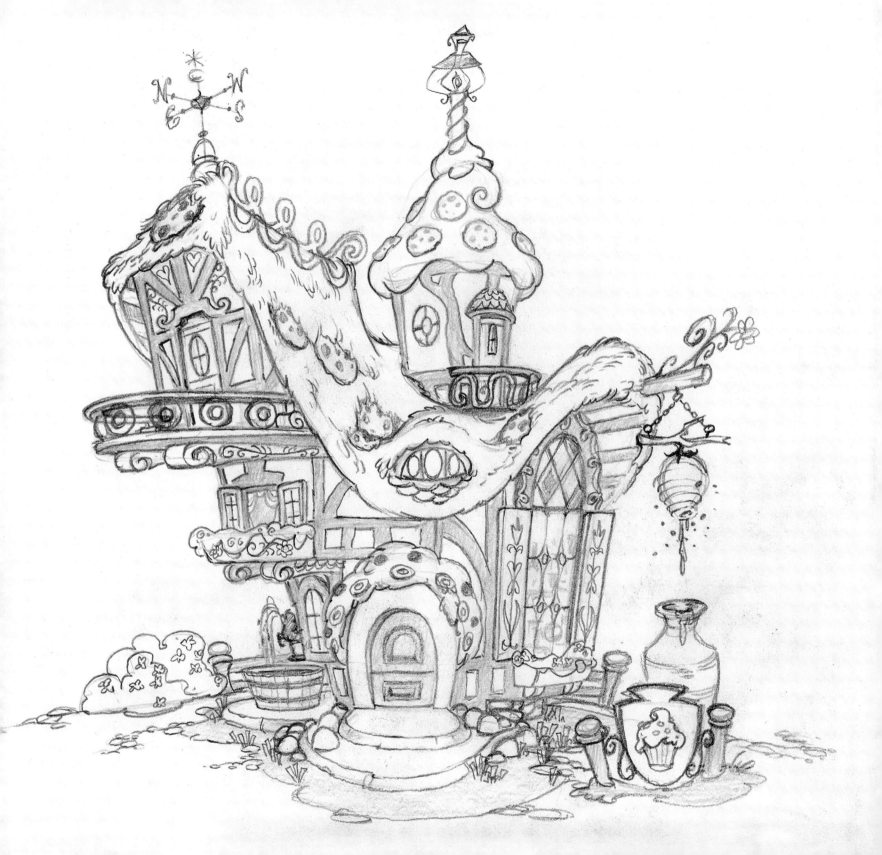

CANTERLOT

Princess Celestia and Princess Luna keep watch over all of Equestria from this mountainside castle. With elaborately decorated turrets and spires, it's as lavish and legendary as the Arthurian castle of Camelot that inspired it.

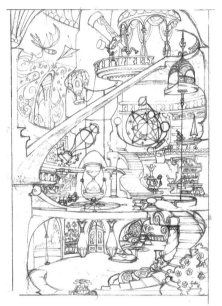
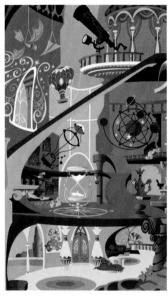

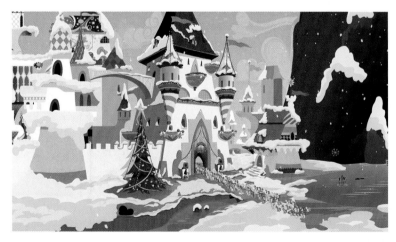

Canterlot's position high on a mountainside and regal purple-and-gold palette both reflect the sensibility of royalty and aspiration for the pony world.

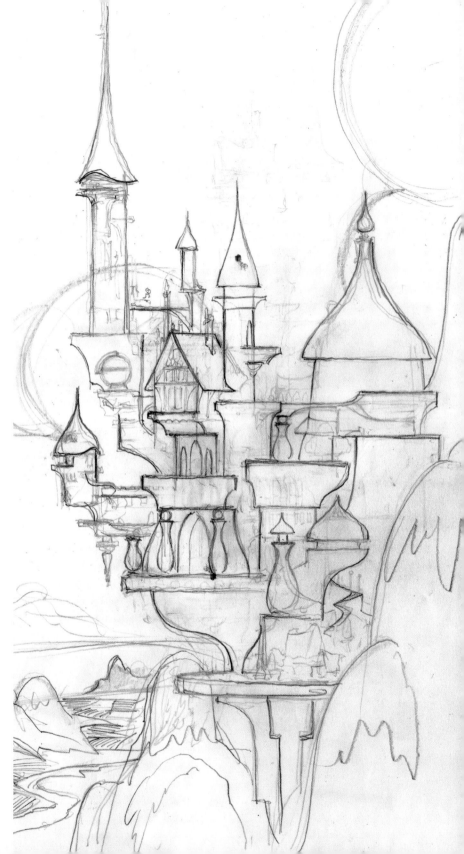

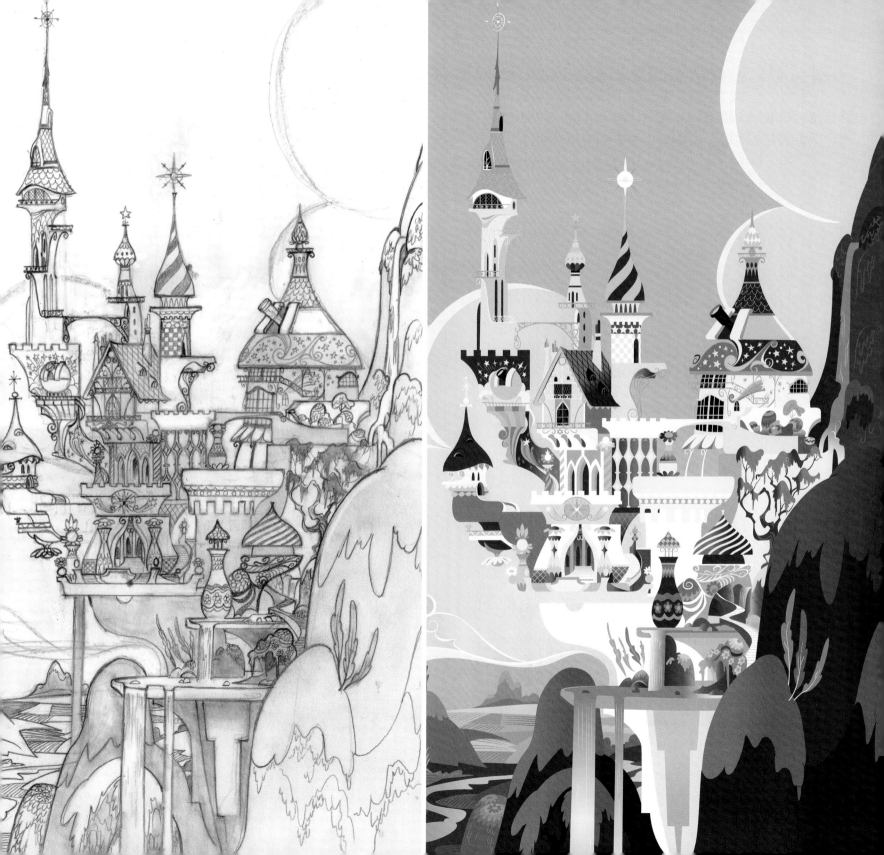

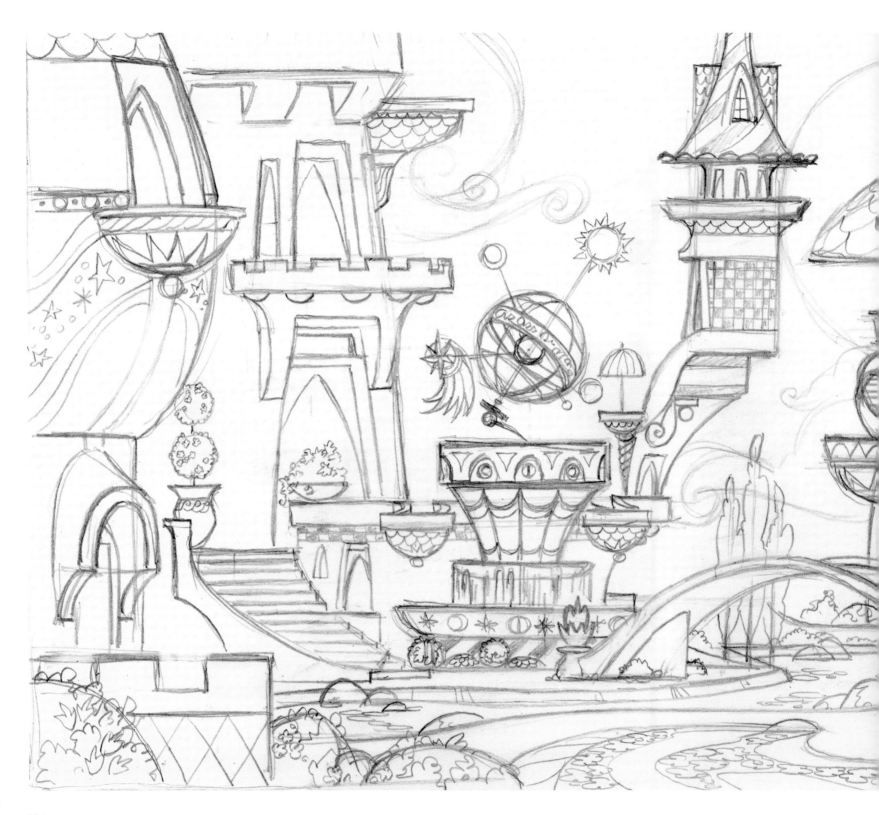

164

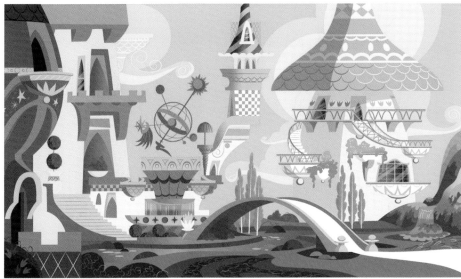

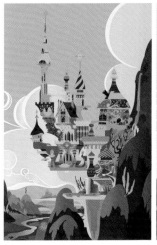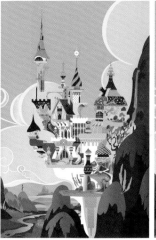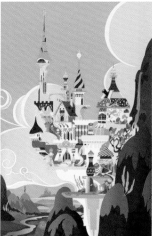

The color of a world or region is explored in several ways to see which color conveys the most accurate message about the place.

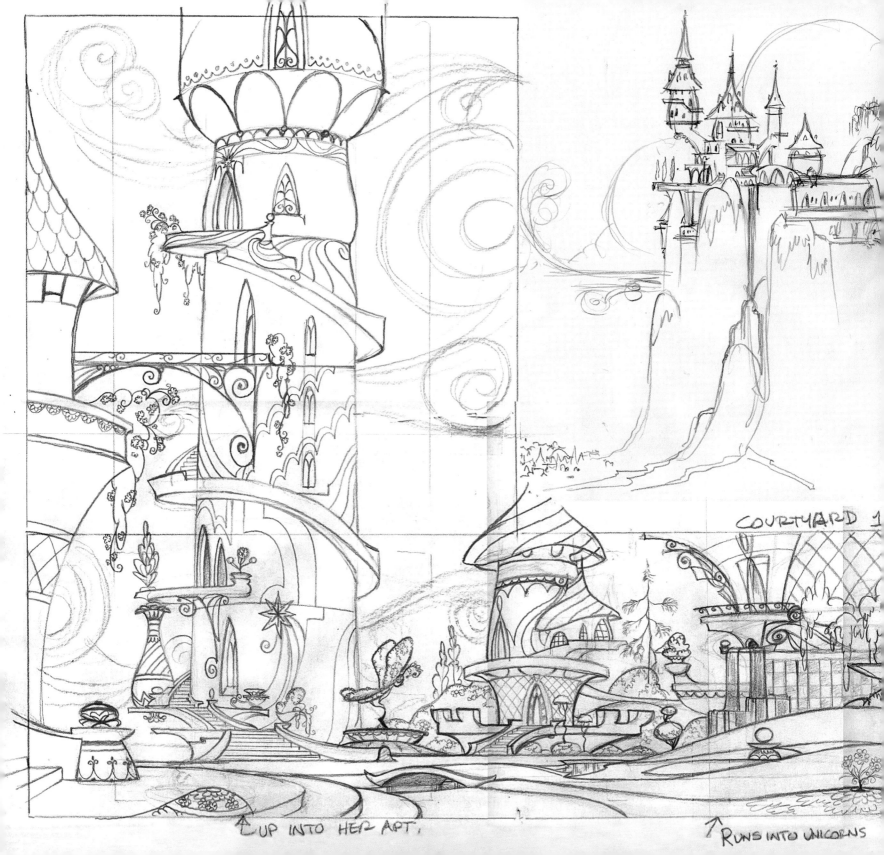

Up into her apt.

Courtyard 1

Runs into unicorns

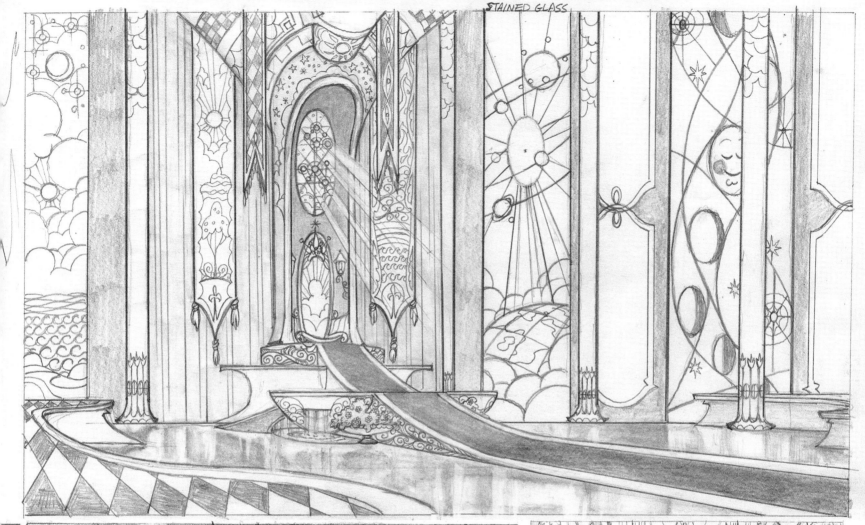

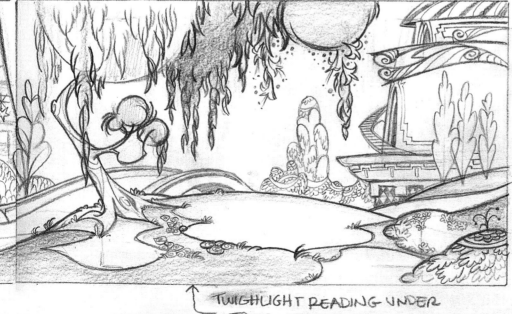

TWIGHLIGHT READING UNDER
TREE

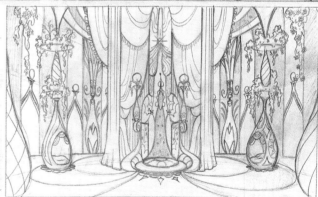

Dave Dunnet's sketches reflect a kind of inspirational and
inviting domain that is both royal and inspired by knowledge.
The stained-glass windows in the castle explore awareness
of the celestial world and how it functions.

EVERFREE FOREST

Home to Zecora and a multitude of wild creatures, this enchanted wood defies the need for pony intervention, and it grows freely on the outskirts of Ponyville. Because the region is meant to represent a wild, flowing, jungle-like environment, its plants, trees, and overall color palette are the opposite of Ponyville.

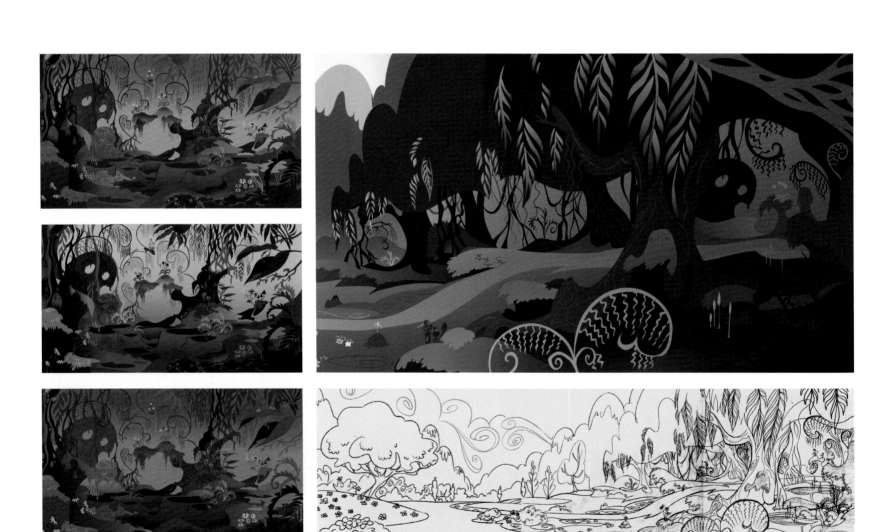

The early palette variations explore different moods and flavors, depending on the hue used.

The design sketches for Everfree Forest suggest a more open use of line and less formalized control in the shapes of the flora and fauna.

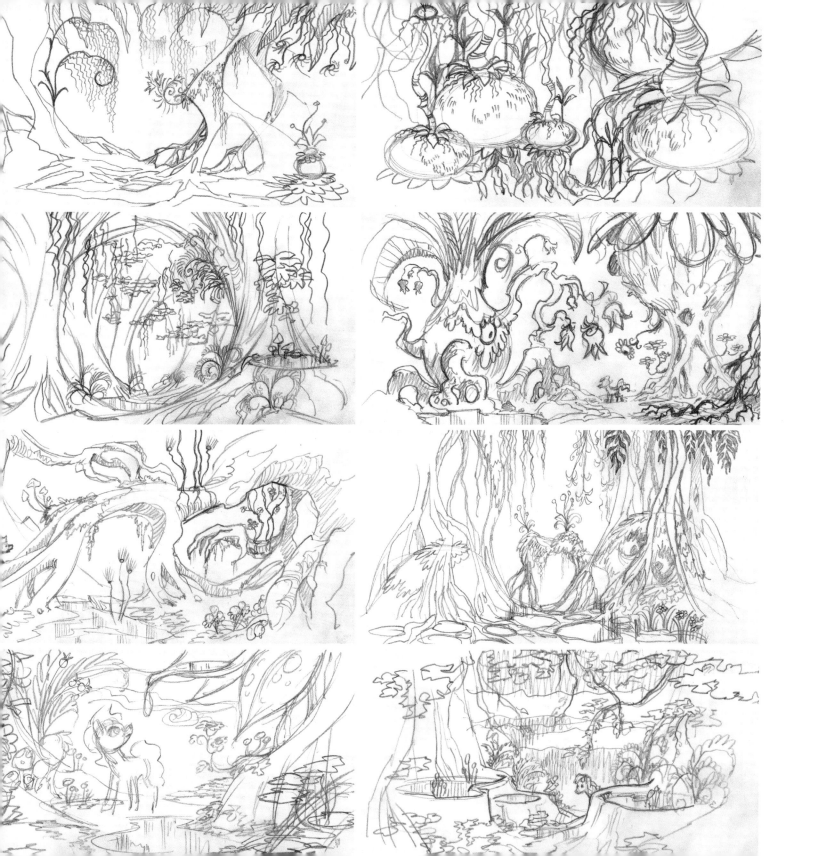

CASTLE OF THE TWO SISTERS

One thing that's kind of a benefit on this show is that the designs of the world and the characters are typically very cute, so that even if we go pretty scary, it's always still very fantastical, so it remains whimsical and never gets grotesque. That appealing quality balances out the scariness of it.

—JIM MILLER, DHX MEDIA

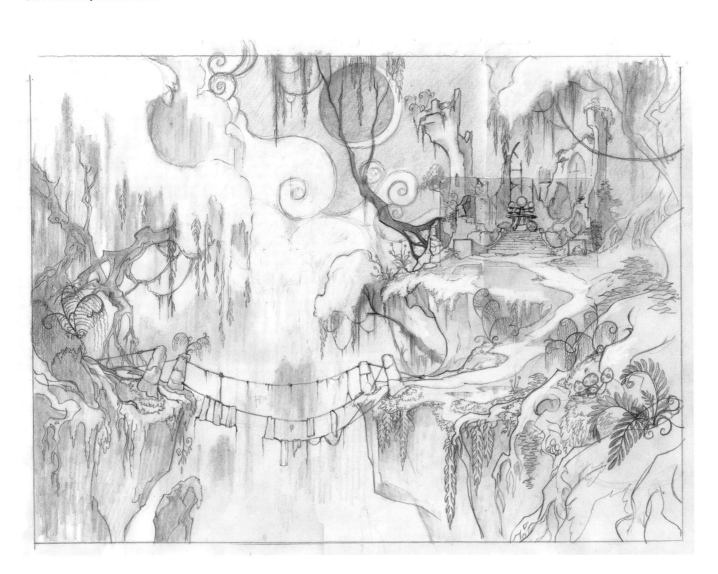

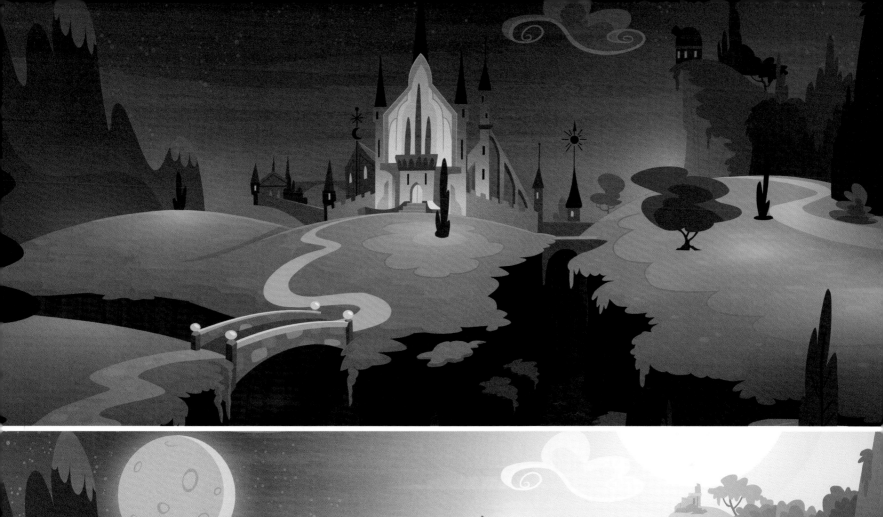

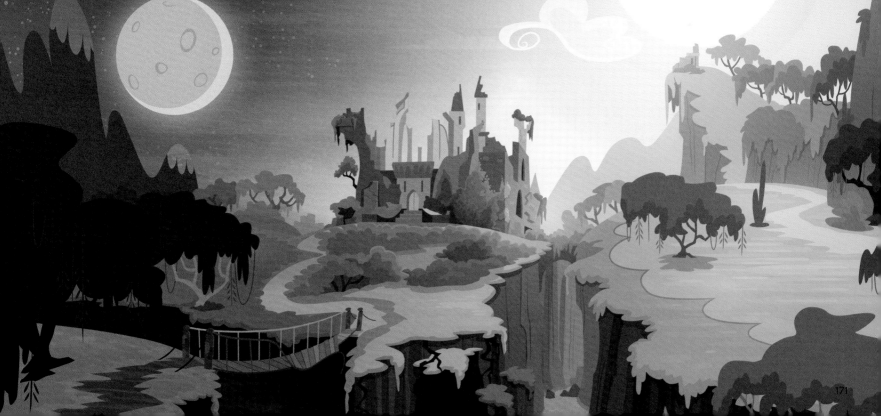

171

MANEHATTAN

I tried to think of Manhattan at the turn of the twentieth century, and there are plenty of historical references for that old-timey feel. It is difficult to know how much technology to bring into it, but I tried to stay away from electronics. I tried to think of things that would be wind powered or steam powered.

— PHIL CAESAR, DHX MEDIA

In terms of the taxicabs and stuff, we don't have combustion engines. We know that there are no street-lights, for example. If we had streetlights, there would be fireflies or lightning bugs or magic lighting them. We have kind of set rules about technology—you can't have anything that's post-1900s.

—JIM MILLER, DHX MEDIA

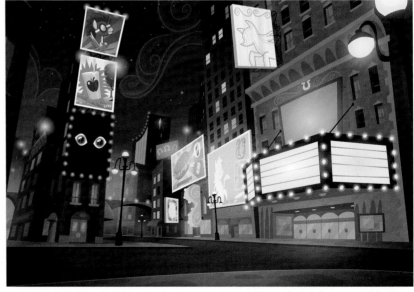

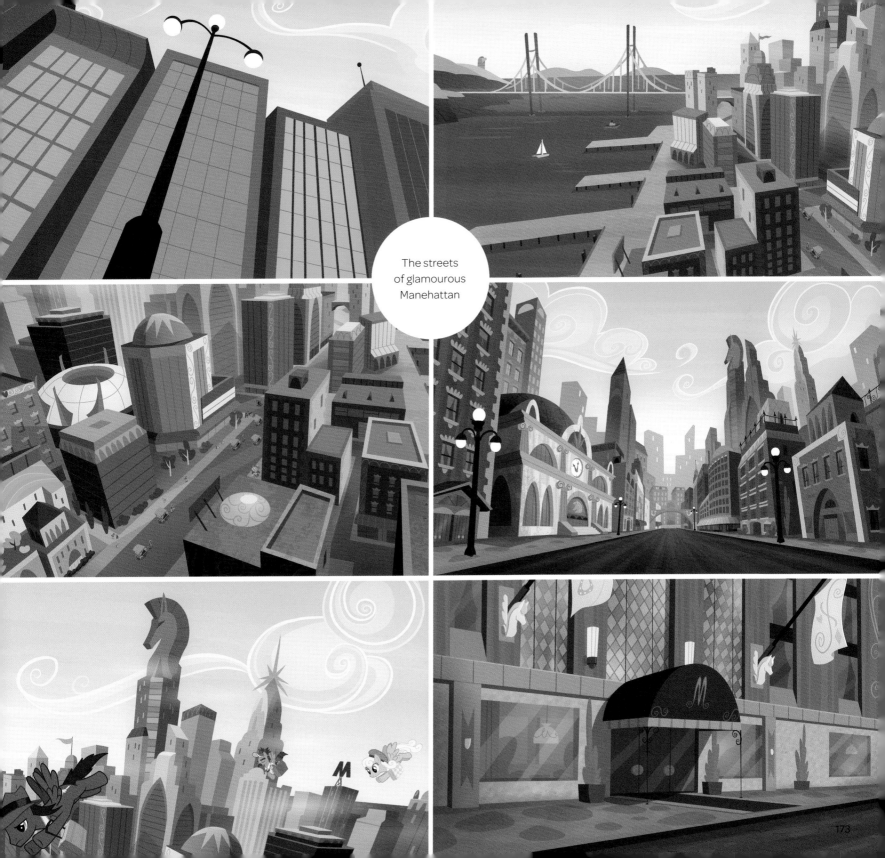

The streets of glamourous Manehattan

173

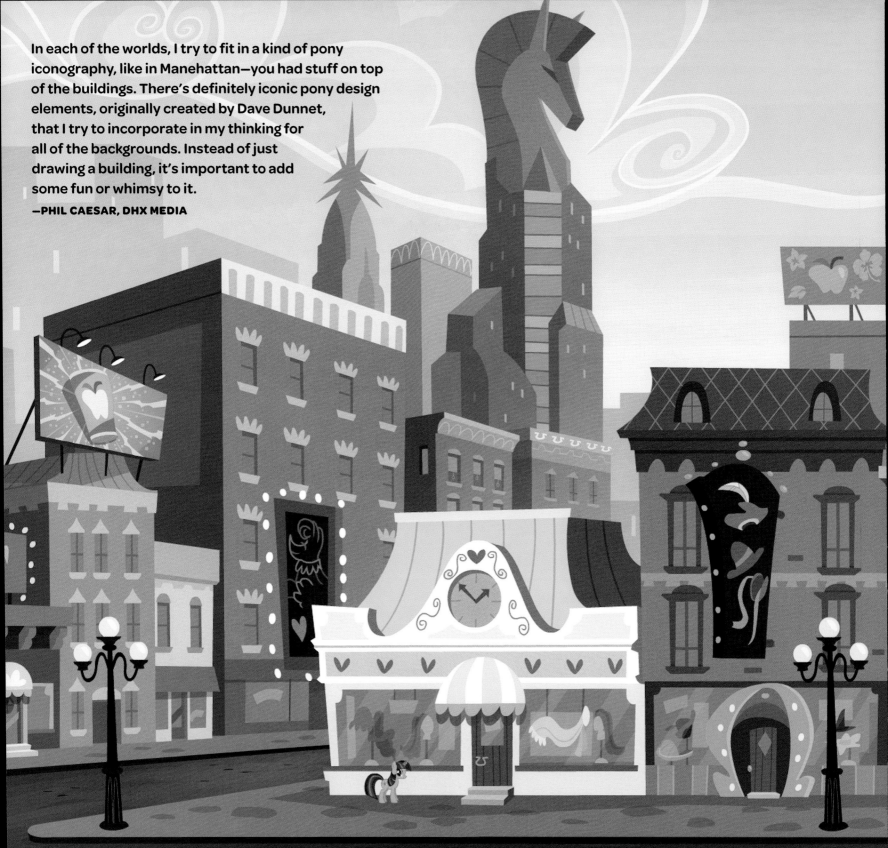

In each of the worlds, I try to fit in a kind of pony iconography, like in Manehattan—you had stuff on top of the buildings. There's definitely iconic pony design elements, originally created by Dave Dunnet, that I try to incorporate in my thinking for all of the backgrounds. Instead of just drawing a building, it's important to add some fun or whimsy to it.

—PHIL CAESAR, DHX MEDIA

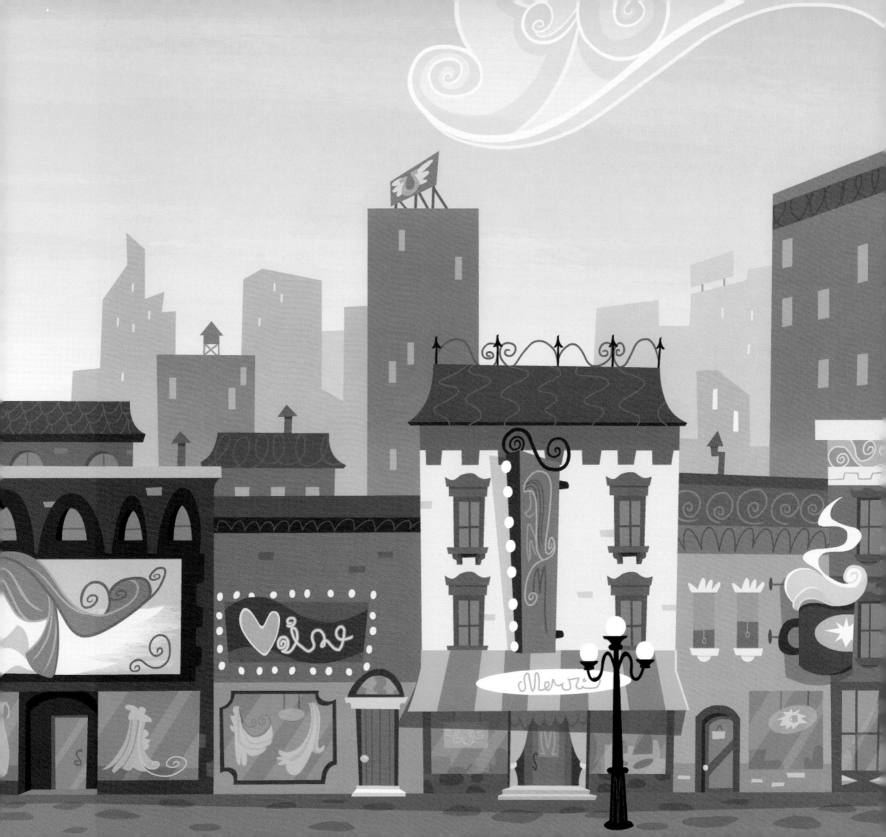

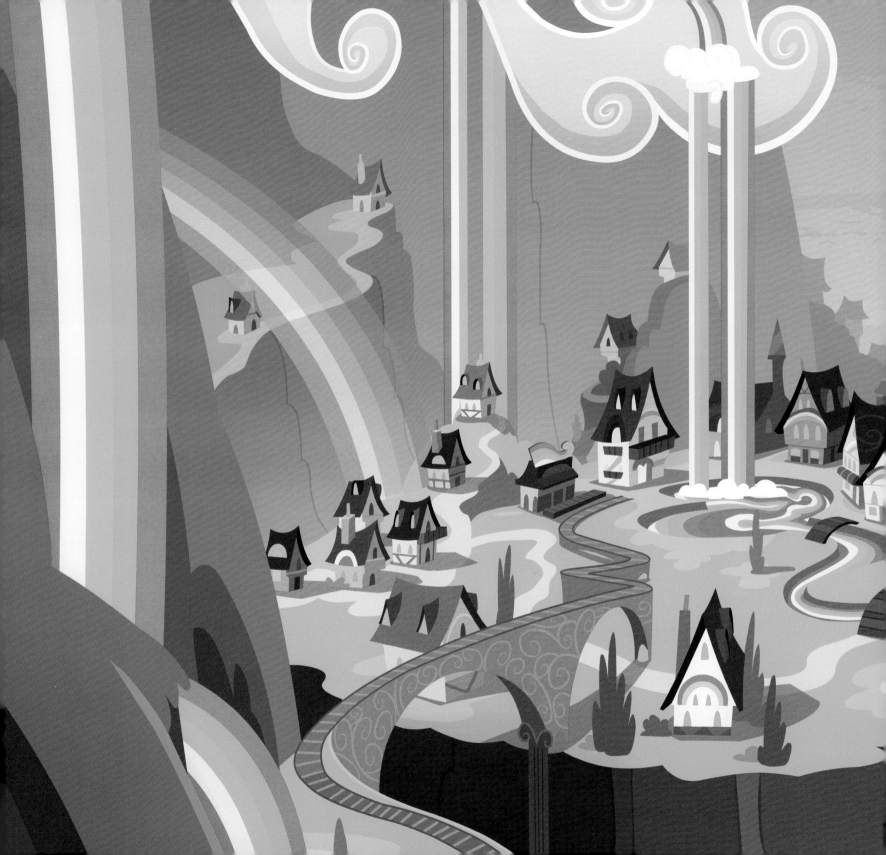

6

BEHIND
THE SCENES

HASBRO STUDIOS AND DHX MEDIA ON PROCESS

HASBRO

Once a script is locked—meaning there will be no more revisions to the text—DHX goes into the design phase. We will get batches of art from them, starting with black-and-white roughs, then color character and prop designs that are finalized, including the backgrounds. After that, we receive the animatics, followed by the rough cut, which is the first animation that we see of an episode, and based off of our notes, they lock it. After that, they do the score—or a music screener that we review to make sure that the music works.

—BRIAN LENARD, HASBRO STUDIOS

DHX MEDIA

It starts with the premise and getting a nugget of a story to build upon. When we get it to the storyboard and design process, we go through it all together, figure out what we need to do, create a dialogue record, and then the board artist can pull from the voice acting of the voice record to create a storyboard animatic. We then build on that previous stage through a lot of meetings and discussions. It's a lot of grown-ups talking about the intricacies of the socioeconomic politics of this imaginary world. If you just walked into a room where these meetings are going on, you'd think we were all insane. The amount of thought and effort that's put into some of these things that sometimes are on screen for only a split second is astounding.

—JIM MILLER, DHX MEDIA

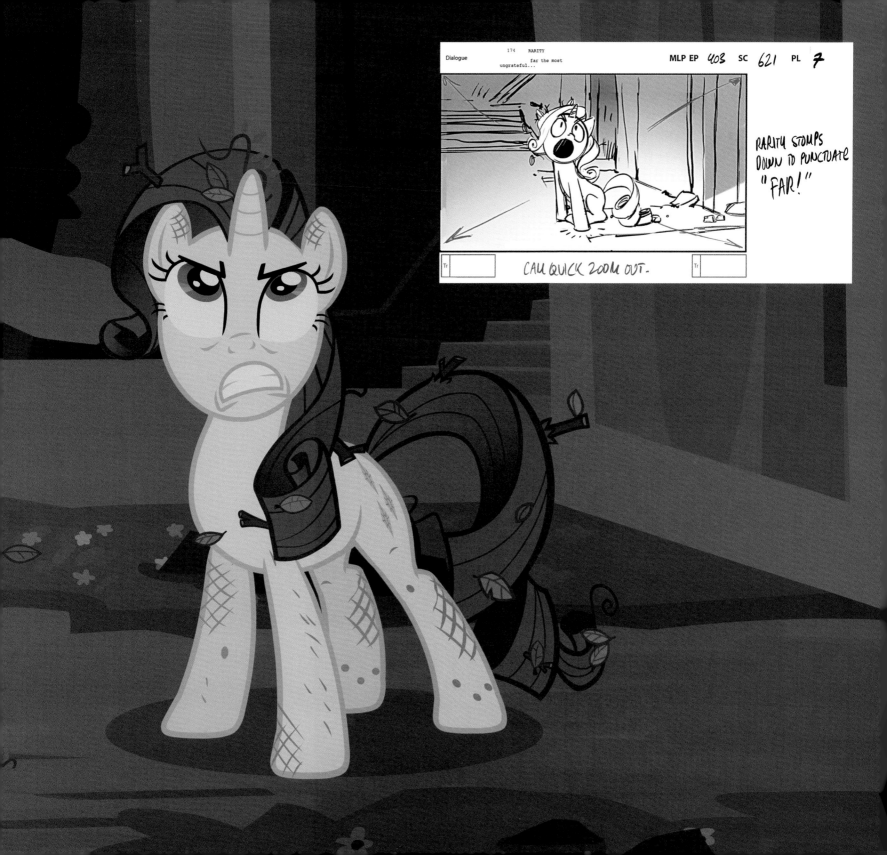

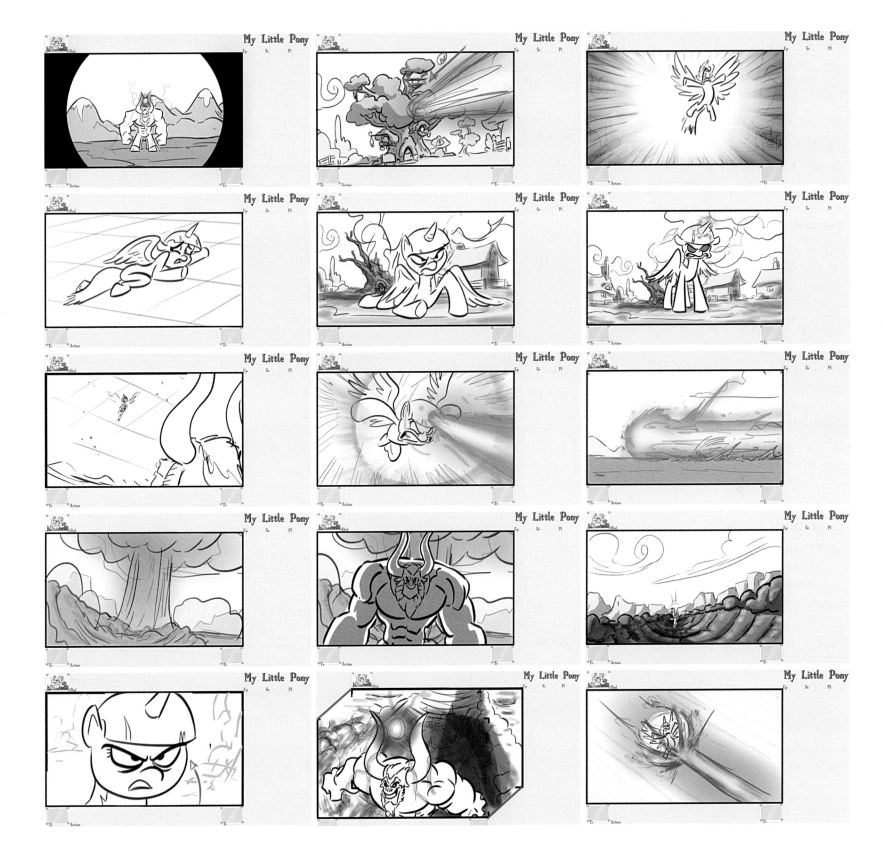

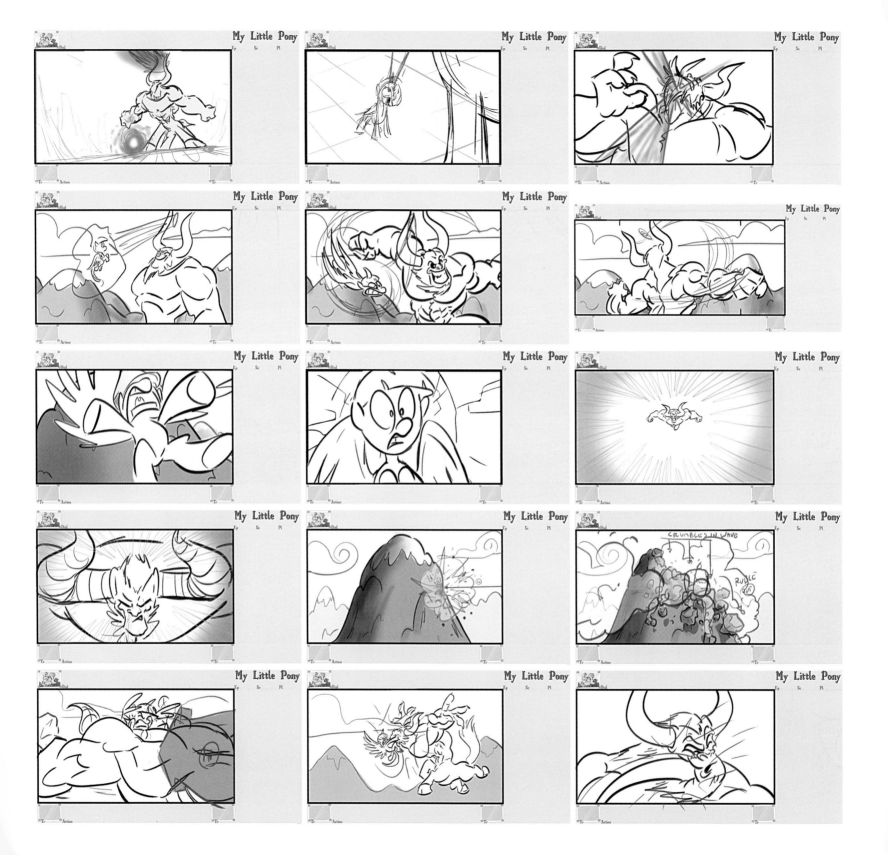

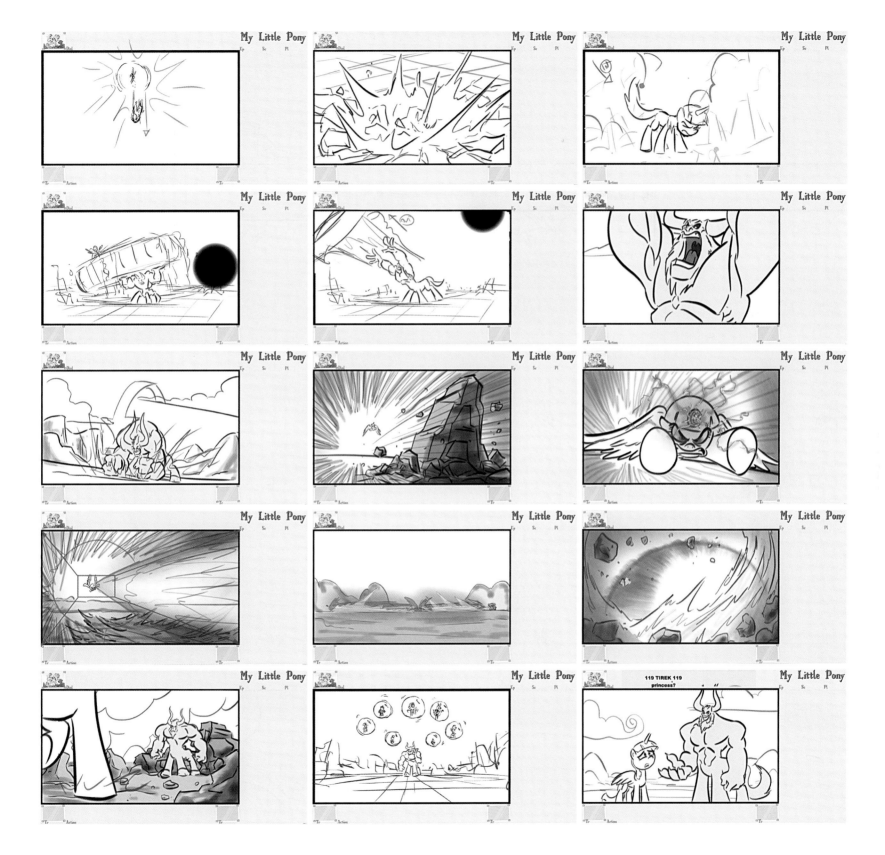

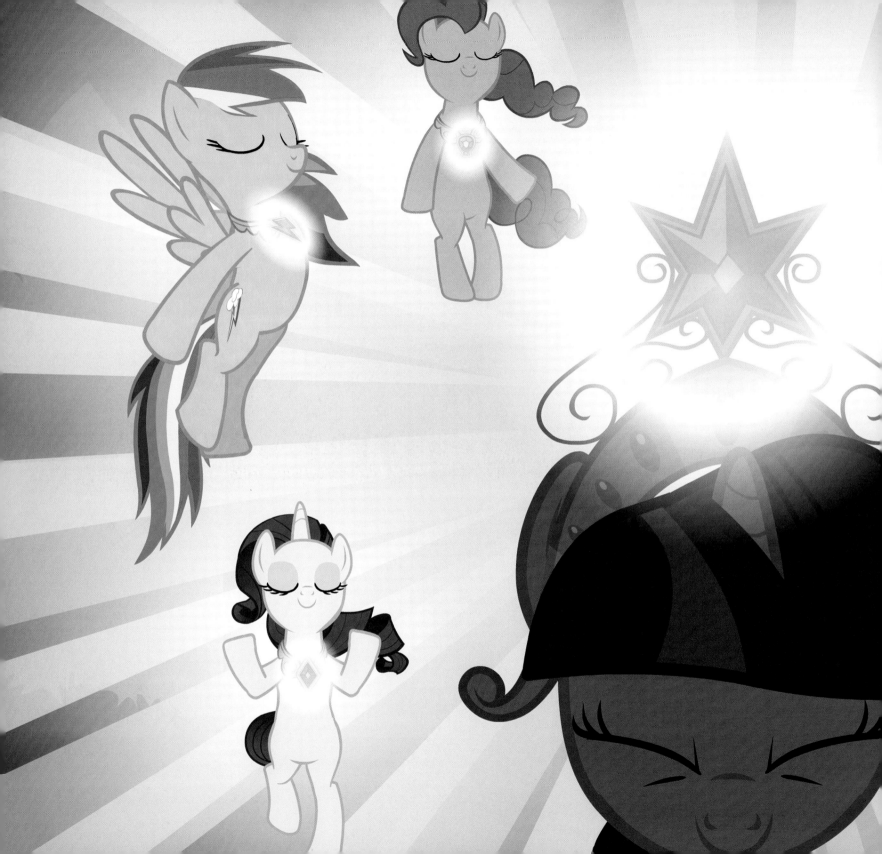

7

PONY REVOLUTION

WHY ARE YOU A BRONY?

INTERVIEW WITH MATT MATTUS
**PRINCIPAL DESIGNER, GIRLS, AT HASBRO, WHO HAS
WORKED ON THE MY LITTLE PONY BRAND SINCE 1987**

When I attended the first BronyCon in New York City, I wasn't certain what to expect. Part of me expected to find it a little strange. But instead I was blown away by this fandom. For instance, I thought the title of the show—*Friendship Is Magic*—might be too sweet and might limit the viewing audience that an animated TV show could attract. I couldn't have been more wrong. I saw twenty- and thirty-year-old men, wearing *My Little Pony* T-shirts, shouting "Friendship is magic! Whoop, whoop!" Sure, dads were there with their younger children, but mostly it was a group of very passionate young men who were somehow connected by these characters and stories that seemed to resonate with them in a very profound way. It actually was pretty moving.

When the Brony movement first came on the scene a few months after the show debuted, we knew very little about the fandom. Heck, most people didn't even know the word "fandom." It became clear that this was something really different and really special. In a few closed-door meetings with key brand leaders, we felt an overwhelming sense of "wow" and "excitement." Clearly, few brands have ever experienced anything like this before.

The best thing about working on this brand during this time was that no one said "No." Rather, we were encouraged to learn as much as we could about this social phenomenon, and then react in a thoughtful way. I don't think that people outside of a toy company realize the daunting issues that need to be carefully addressed when designing experiences and products for young children. Yet here we had this fan base so engaged with our brand that they were creating backstories and products themselves. I was impressed with how the entire company reacted once it began to understand what was happening; it was brilliant.

In so many ways, the *My Little Pony* brand helped people express themselves in a way that no other brand could do, both socially and artistically. The brand facilitates a very special, creative connection among folks who sometimes find it challenging to connect. In a wonderful way, Hasbro has created a friendship toolbox with these characters that just happens to include rainbows, unicorns, and a rubber chicken named Boneless. And you know what? Everypony loves it.

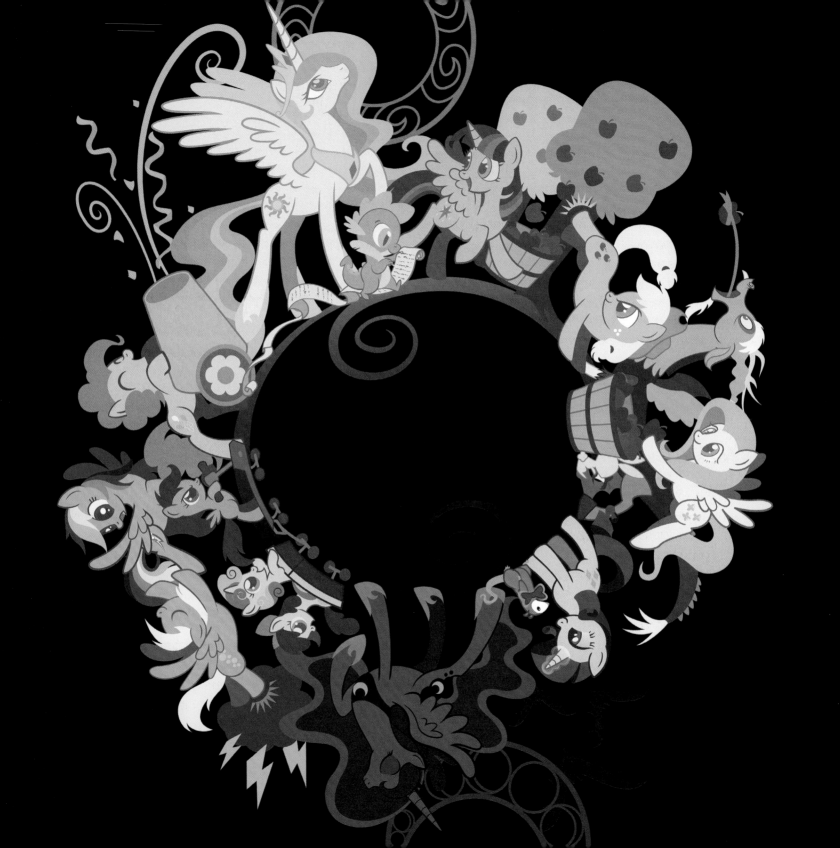

A MESSAGE FROM WELOVEFINE'S COUNTESS OF CONTESTS

BY BETH LOVE

WeLoveFine has been honored to collaborate with Hasbro to hold a wide variety of *My Little Pony* fan design contests since 2011. In fact, *My Little Pony* was the very first design contest we ever held, and it was a huge success thanks to the excitement and dedication of you, the *MLP* fans around the world. Since the launch of that first contest, fans have been letting their creativity flow and artistic talents shine by creating some of the best *My Little Pony* fan art out there. We have had almost five thousand pieces of *My Little Pony* art submitted to contests and almost four million fan ratings by you at the time of this writing. This speaks volumes about how dedicated the *My Little Pony* fan base is.

Both fans and guest judges, such as Lauren Faust, Tara Strong, and Andrea Libman (just to name a few), have had the tough job of selecting the winners in these contests. The winners receive cash and prizes, and their designs become *officially* licensed *My Little Pony* designs that the rest of the *MLP* fan community will come to treasure. And we couldn't be more pleased to do our part to make it happen.

It has been a special thing to work together with the fans of the My Little Pony brand over these past years. I have seen these artists show an amazing amount of devotion to their craft and to the show. It has been wonderful to see these fans merge the two passions to create amazing designs for all of us to enjoy. It truly is a community of artists who support and encourage each other. Working with you has been

Wes Jones (hwango)

a privilege for us. We can't thank each of you enough for the time, energy, and love you've poured into your art.

We look forward to working even more with Hasbro and you, the *My Little Pony* fans, in the future. We feel like we're old friends now. And you know what they say—"Friendship *is* magic." Thank you for making our days a little bit more magical, and keep on creating!

(opposite) All Together by Lexi P. (SambaNeko), winning entry for 2015 *MLP* Team Up design contest

Heidi Ruff

Paige Cicione

Eriphyle

Eric Omega

Chris Farmer

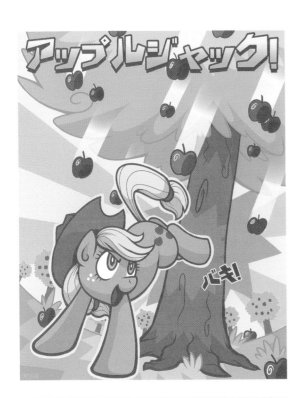

(this page) Anjila

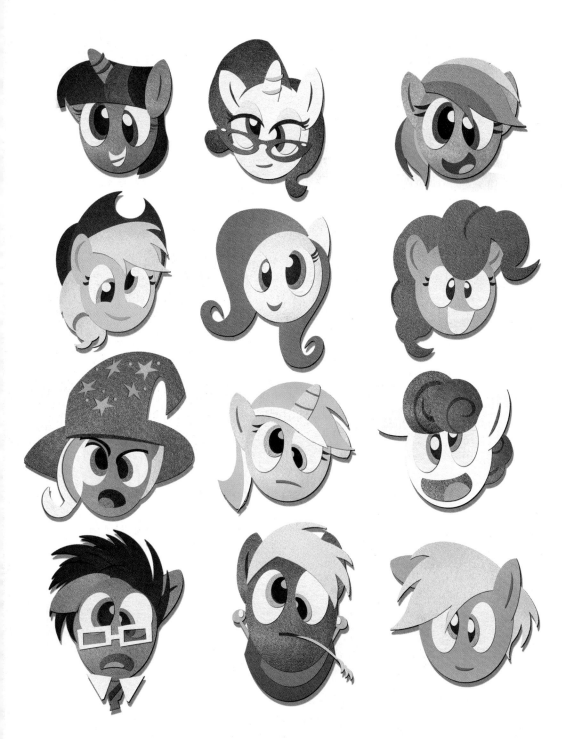

Pixelkitties

Necro Balam

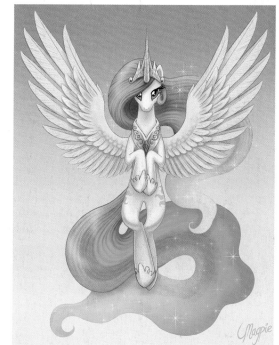

Lauren Magpie

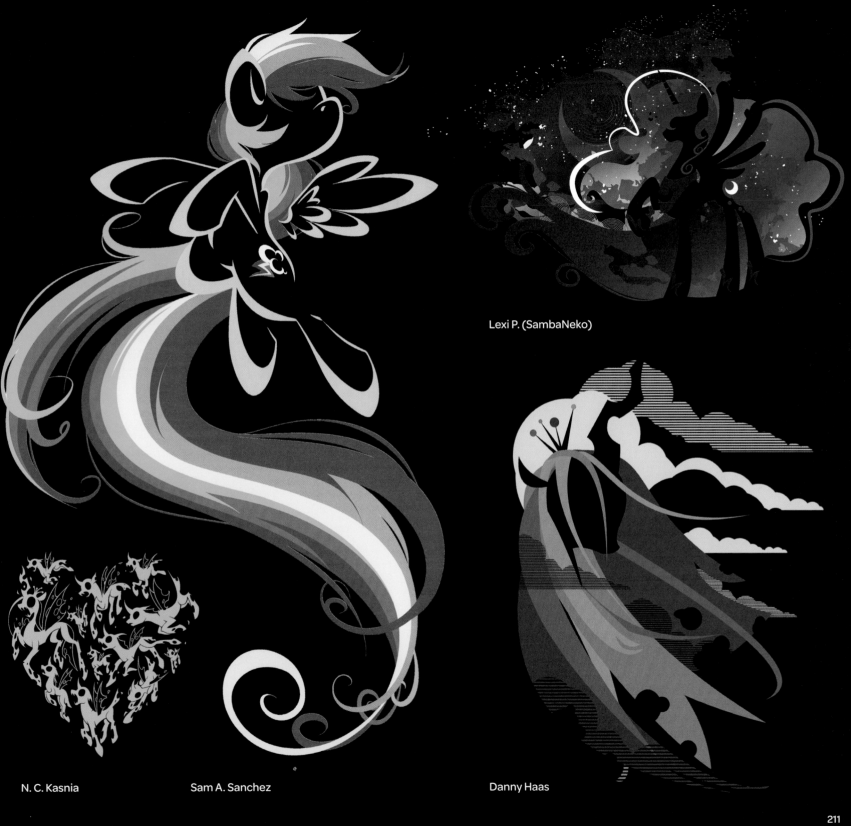

Lexi P. (SambaNeko)

N. C. Kasnia Sam A. Sanchez Danny Haas

Valerie LeMaster

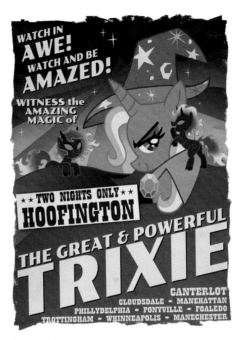

Scotty Arsenault

Cari Corene

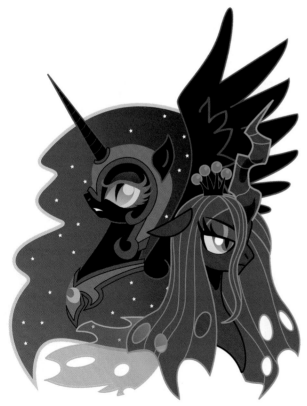

Carmen Limon

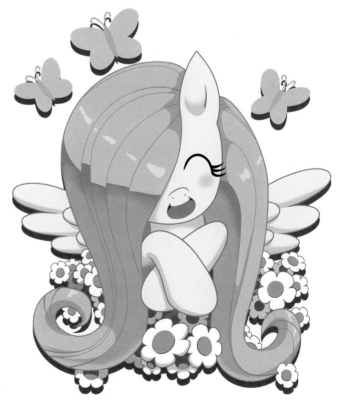

Ruben

aJVL

Lexi P. (SambaNeko)

kevinsano

Lukas Häag

Janet Gilbert

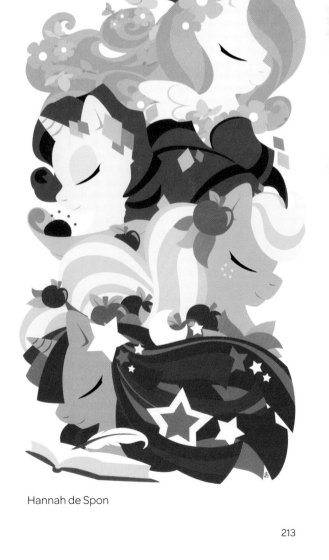

Hannah de Spon

213

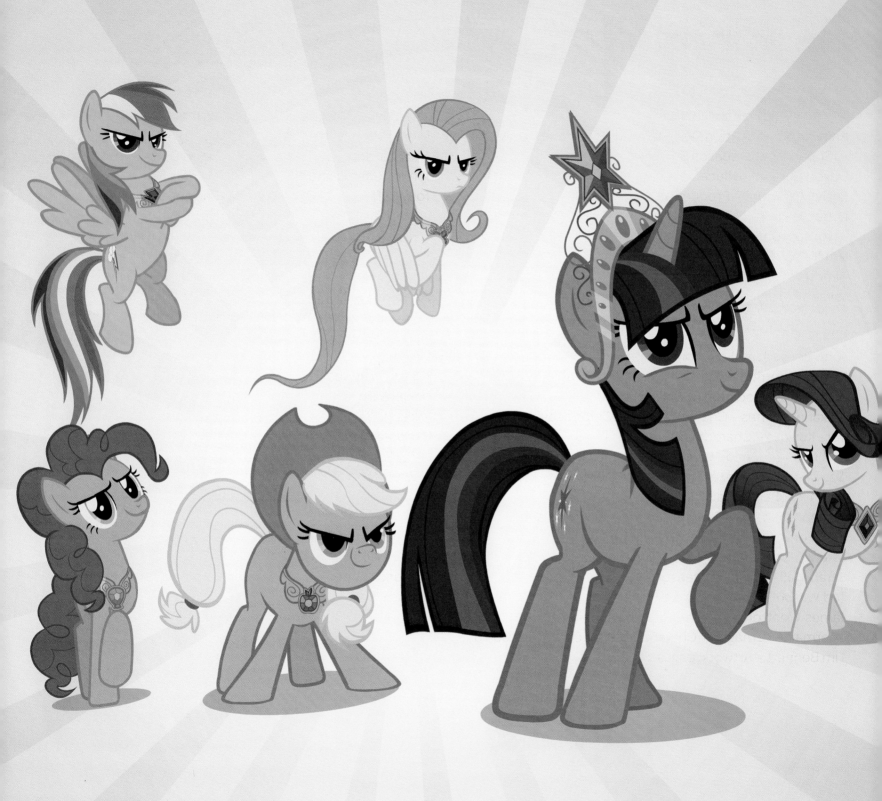

ACKNOWLEDGMENTS

DHX INTERVIEW CONTRIBUTORS

Phil Caesar – Location Designer, and Background Build
Supervisor for season 5
Devon Cody – Producer
Lesley Crawford – Production Supervisor
Rebecca Dart – Character Designer, and Art Director
for season 5
Jim Miller – Director
Timothy Packford – Storyboard Supervisor
Jayson Thiessen – Supervising Director

DHX MEDIA

John Beveridge – Location Clean-up Artist
Matthew Herring – Character Rotations, season 5
Krista Huot – Location Color, season 5
Alexandra Jones – Character & Prop Color, seasons 1–4
Kora Kosicka – Character Design, season 5
Hyoji Lee – Location Color, season 5
Geoff Manson – Location Color, seasons 1-4
Robin Mitchell – Character Designer, season 1
Fernanda Ribeiro – Character & Prop Color, season 5
Ridd Sorensen – Art Director, seasons 1–4
Jeremy Tin – Character Designer, season 4
Sarah Wall – Producer, seasons 1–3
Ted Wilson – Prop Design, seasons 1–4
James Wootton – Co-director, seasons 1–3
Charmaine Verhagen – Character & Prop Design, season 5
Tim Bennett – Artwork, pages 74–75

STORYBOARD ARTISTS

Sabrina Alberghetti
Andy Bartlett
Johnny Castuciano
Tony Cliff
Steven Garcia
Sherann Johnson
Tom Sales
Steve Sanderson
Scott Underwood
Mike West
David Wiebe

HASBRO STUDIOS

Daniel Barnes
Mikiel Houser
Brian Lenard
Kathy Page
Melissa Scott

HASBRO PUBLISHING

Heather Hopkins
Michael Kelly
Edmund Lane
Marissa Mansolillo

HASBRO

Nancy Braga
David Dubosky
Michael Fater
Pat Jarret
Laura Rodzinak

MIGHTY FINE

Guy Brand
Jessica Del Pino
Beth Love

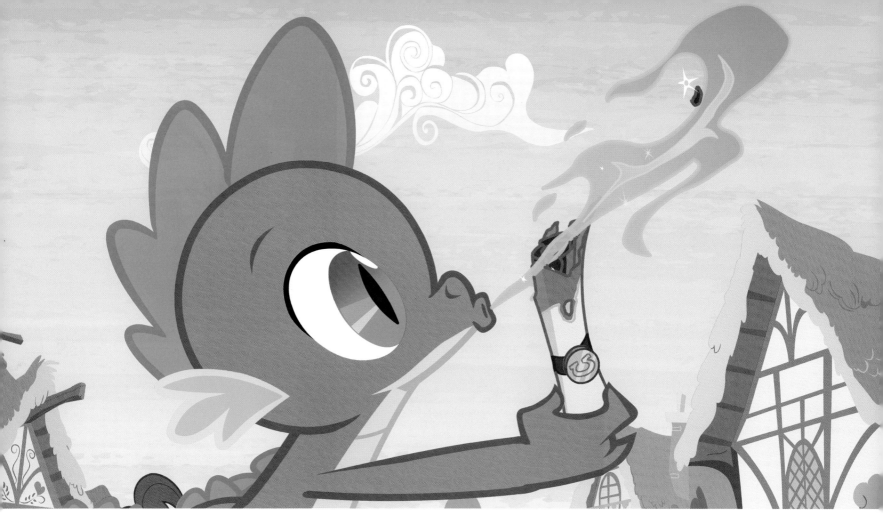

Editor: Samantha Weiner
Designer: Danielle Young
Production Manager: Kathleen Gaffney

Library of Congress Control Number: 2014942735

ISBN: 978-1-4197-1577-8

Licensed By:

HASBRO and its logo, MY LITTLE PONY and all related
characters are trademarks of Hasbro and are used
with permission. © 2015 Hasbro. All Rights Reserved.

Published in 2015 by Abrams, an imprint of ABRAMS. All rights
reserved. No portion of this book may be reproduced, stored
in a retrieval system, or transmitted in any form or by any means,
mechanical, electronic, photocopying, recording, or otherwise,
without written permission from the publisher.

Printed and bound in the United States
10 9 8 7 6 5 4 3 2 1

Abrams books are available at special discounts when
purchased in quantity for premiums and promotions
as well as fundraising or educational use. Special editions
can also be created to specification. For details, contact
specialsales@abramsbooks.com or the address below.

ABRAMS
THE ART OF BOOKS SINCE 1949

115 West 18th Street
New York, NY 10011
www.abramsbooks.com